Giovanni Intra
Clinic of Phantasms
Writings 1994–2002

T.J. McNamara on ART

6th October '80

Hilda Scum
UN-SEXY VEST
91A Karepa St
Brooklyn
<u>WELLINGTON</u>

Dear Hilda

Where should the viewer go from here? A separate visit should really be paid to the modern English and American painters.

Dominating the recent work is a huge, powerful canvas by Francis Bacon. It is a portrait of a man twisted, gripped and held by circumstances of guilt. He can see himself only as a distorted reflection in something that is at once mirror and television.

love

Terry.
Terry.

P.S.
The audacity in the handling of the paint is climaxed by a linking streak of white, like a great spit across the image. (sic).

Giovanni Intra
Clinic of Phantasms
Writings 1994–2002

Bouncy Castle | Semiotext(e)

This book was kindly funded by

Barbara Blake

Chartwell Trust

Mary Flaws and Jonathan Flaws

Michael Lett and Andrew Thomas

Pollen Contemporary Art Foundation

Contents

Introductions

The Light that Burns Twice as Brightly

Robert Leonard

Giovanni Intra will always be remembered for going out on a high in New York on 17 December 2002, following a friend's opening at Metro Pictures. An overdose cut short the life and work of this charismatic artist, writer, and gallerist from whom so much more was expected. He was just thirty-four. In the space of a few years, Intra's art-world odyssey had taken him from Auckland to Los Angeles, from the provinces of the art world to one of its new centres.

Back home, writing his obituary for the *New Zealand Listener*, Tessa Laird observed:

> Giovanni Paolo Intra was fond of telling people that he was born in May 1968, the year and month of the famous Paris uprising, when art and anarchy ruled the streets. What Giovanni usually omitted from this romantic tale was that he was raised in Tūrangi.[1]

Today, the North Island town has a population of 3,650 (fewer than Twin Peaks).

●

I first met Intra in 1990, while I was working as a curator at the National Art Gallery, in Wellington. He was completing his BFA in sculpture at Auckland's Elam art school. He was five years younger than me, but it felt like a generation. Back then, Intra was fusing punk references with the aesthetic of the wayside shrines he had observed on a trip to India the year before.

Intra's best-known work from then is the studded suit he made to wear to the Elam ball. 'The outfit was a huge success—even if the fastenings did leave the bare-chested Intra

lacerated and bleeding by the end of the evening.'[2] Intra exhibited his suit on a hanger, as Joseph Beuys had shown his dour felt suits. Where Beuys's uniform exemplified an idea of artist as healer, Intra's was transgressive—part punk, part S'n'M, part Liberace. The suit crossed over into fashion, featuring in an iconic fashion spread in *Planet* magazine, worn by a female model accompanied by a bewitching black cat. After Intra died, the suit was jointly acquired by the Chartwell Collection and Auckland Art Gallery.

•

Intra was blessed with entrepreneurial can-do—a kiwi DIY attitude. In 1992, with a circle of artist friends, he founded Teststrip in Vulcan Lane. It may not have been the country's first artist-run space, but it was new and dangerous. It proved the perfect platform for Intra's subcultural inquiries and alternative activities. For the disorienting 1993 installation *Waiting Room*, Intra and Vicki Kerr surgically altered the space, curving walls, ceiling, and floor into one another, dousing them with antiseptic, and cranking up the lights. Space evaporated in a hygienic white out, leaving nowhere for germs or shadows to hide. Visitors were asked to wear covers over their shoes.

Relocating to sleazy K Road the following year, tiny Teststrip would become the most talked-about gallery in the country—a treehut for the wannabe avant-garde. On the other side of the world, *Artforum* would publish an enthusiastic notice about the startup from supporter, collaborator, and publicist Stuart McKenzie:

> Teststrip shows often tread a fine line between reporting and celebrating social dysfunction. There is a Nietzschean amorality here, and also a strenuous Romanticism in the style of Keats' promise that until we are sick, we we understand not.[3]

•

Linking punk, situationism, and surrealism, Intra's art took diverse forms: a still-life arrangement of punk attire—Doc Martens, a studded cuff, and a cut-throat razor—in a vitrine; a *Blood Mobile* of red glass drips—a nod to Hans Bellmer; drawings with arcane citations and gimmicky hand lettering; product photos of medical paraphernalia indexed to the stations of the cross; a rotating CT scan of a pelvis accessed through a peephole viewer; a lab rat scratching away behind a wall of pink fibreglass insulation; X-rays and installations of smashed cameras. There were always lots of medical references, reminding us that the surrealists André Breton and Jacques-André Boiffard had been a doctor and a medical photographer respectively. And there were endless drug references, which now seem sadly prophetic.

As a young artist, Intra was provocative but successful—a rising star. Despite the punk posturing, he had supportive dealers, including surprisingly classy ones, such as Wellington's Brooker Gallery and Auckland's Claybrook Gallery. His work was acquired by prominent collections (public and private) and included in important exhibitions (featuring on the cover of the catalogue for the Museum of New Zealand's 1994 survey show *Art Now*). While Chris Kraus emphasises the Teststrippers' fuck-you attitude in her intro later in this book, Intra could really work a room. He was a charmer.

•

Writing became important early on. Intra's art needed words. Texts featured in his hand-lettered, collaged, and photocopied drawings, posters, handouts, and fanzines. And, in 1989, he started contributing to the bFM student-radio magazine *Stamp*, cutting his teeth reporting on art, bands, comics, even a comedian. Between 1989 and 1992, he wrote for most issues: twenty-seven pieces in all. In addition to reviews, there were creative-writing experiments, including an invented interview with Picasso and an account of an imaginary historical woman artist who had slept with Picasso. A real artist took umbrage at being the subject of an invented interview, worried that fiction may pass for fact, requiring a disclaimer.

Stamp enabled Intra's experimentalism and tolerated his in jokes. His writings there demonstrate his flair for parody. His piece 'When You Sell Me' was particularly scatterbrained:

> At the opening I wore my tweed coat, my polka-dot tie, my green trousers, my armour plated knickers, and I painted my nose red.
>
> The artist rejects symbolism and borrowing from indigenous cultures, rather he attempts through a process of reduction and distillation to penetrate a common level of collective consciousness.
>
> We know our positions too well. There is enough measured contempt and praise to keep our frustrations and pleasures balanced for a lifetime.
>
> I'll do the mail-out, you do the mail-out, she got sent a mail-out, he's on the mail-out list, let's hope the mail gets lost in the mail.
>
> I fuck you and spit at you, you ruin me, you sell me, and this is the best art there ever is.
>
> Everything would be totally different if the opportunity to sell out actually existed.[4]

By 1993, Intra had quit writing for *Stamp* and was head down, completing his MFA dissertation *Subculture: Bataille, Big Toe, Dead Doll*, becoming more disciplined as a writer and reader. His text mapped the web of concerns he was exploring in his art— subculture and the iconography of revolt—via the now-available writings of Georges Bataille and the new commentaries on surrealism by Rosalind Krauss and Co. that appeared in their wake.[5]

In writing *Subculture*, Intra hit his stride as writer. In 1994, he began contributing to *Midwest*, a magazine I co-edited. For us, he wrote on painter John Hurrell, on surrealism and skin disease, and on Ava Seymour's rubberist collages. He was always precocious and opinionated. He wrote about art that intersected with and extended his interests as an artist, but, if subjects didn't fit, he could make them fit. In his Hurrell piece, he rejected the older artist's concerns—postmodernism and provincialism—preferring to discuss the work in terms of situationism. *Midwest* also profiled Intra's own work. We took him on as an artist-writer package. In 1994, Intra also met LA-based Semiotext(e) publisher Sylvère Lotringer. He was visiting his partner, the writer and filmmaker Chris Kraus, who was in Auckland making a film. Lotringer suggested Intra embark on a master's degree in the fledgling Critical Theory programme at ArtCenter College of Design, Pasadena, where he was teaching. Escape became Intra's plan.

In 1995, Intra began writing for the Sydney-based magazine *Art and Text*, becoming their New Zealand reviewer and review wrangler. It would become an important relationship. After doing just one review, Intra got to write a profile on fellow Teststripper Denise Kum. *Art and Text* had outgrown Australia and aspired to become a key international art journal. Looking for a bigger context, it too was plotting a move to LA. In 1996, it announced its arrival with its 'Los Angeles' issue. After frantic fundraising and securing a Fulbright Scholarship, Intra also landed there that year.

In LA, Intra stopped making art to focus on writing. At ArtCenter, he embarked on a thesis on Daniel Paul Schreber, the paranoid schizophrenic German judge who penned *Memoirs of My Nervous Illness* (1903).[6] Intra quickly assimilated into the LA scene, but he kept exercising his New Zealand connections, and they him. He continued to write on New Zealand artists and for New Zealand publications, while taking on reviewing gigs for *Artforum*, *Artnet*, and *Flash Art*. For a while, his head was in both places. Oddly, it wouldn't be until 2000 that he became a regular contributor for *Art and Text*, writing for them like clockwork.

•

In 1998, during a rave in the desert, Intra and ArtCenter friend Steve Hanson cooked up a plan to start a gallery. With some friends, they found a space in Chinatown, taking their

name from the sign left by the previous tenant. Opening in January 1999, China Art Objects Galleries was instantly influential, elevating a new cohort of LA artists, including Jon Pylypchuk and David Korty, and leading the transformation of Chung King Road into a gallery district. Early shows included Laura Owens and Scott Reeder, Jorge Pardo and Bob Weber, Sharon Lockhart and George Porcari. There was a Stephen Prina record release, a Mike Kelley poetry reading, and a Mia Doi Todd concert. Intra was a midwife to a moment. Like Teststrip, China Art Objects was a platform. But, even after the place became successful, Intra's existence remained precarious, his clothes op shop, his apartment grubby, his car impounded. Intra was no trustifarian, but he was energised by the game, continuing to hustle, banging out essay after essay on his old laptop.

•

Intra remained New Zealand art's go-to person—our base camp in LA. He was forever hosting New Zealanders, and sponging off them—quid pro quo. His ethos was 'transactional'. Intra parlayed Slave Pianos and Teststrip co-conspirator Daniel Malone into the China Art Objects programme and wrote on them. He also accessed LA artists for New Zealand galleries. He curated *Span*, with Diana Thater and Jessica Bronson, for me in 1998, when I ran Artspace, Auckland. He helped place Eric Wesley into the Govett-Brewster Art Gallery's 2000 show *Drive*, and David Korty and Paul Seitsema into Allan Smith's 2001 Auckland Triennial *Bright Paradise*. He also wrote essays for all three shows.

Intra wore many hats, sometimes simultaneously. His texts were often advocacy and promo, written to support artist friends, artists he represented, artists he loved. His 1996 preview of Ann Shelton's photobook *Redeye* describes it as 'a charismatic exposé of the hideous truths and self-conscious mythologies of unemployed psychopaths who frequent Verona cafe and actually believe in drag'.[7] He neglected to mention that he and Ann had been an item, that he was the subject of many of her images, that he was no stranger to Verona, and that he had been photographed in drag. But, as Intra became established and earned the opportunity to write on heavy hitters, the stakes got higher, and he couldn't take as many liberties. His last pieces included insightful but respectful essays on Julia Scher and Isa Genzken.

•

Intra's writing was informed by his appetite for theory, but it was never dense or abstruse. His writing had wit and verve; his insights felt intuitive and immediate. He also enjoyed mimicry. He had an ear for the edgy, disruptive prose of dadaists, surrealists, situationists, and punks, but also for their pompous, conservative critics. He enjoyed the battlefield rhetoric of manifestos and takedowns, toggling between formality and informality,

snottiness and spit. The piece that opens this collection, 'Journalism', sets the scene. Made for a photocopied 'micrograph' to accompany a Tony de Lautour show at Teststrip, it has little to say about its subject, offering instead an absurd, adolescent mash of art criticism and pulp fiction. The text incorporates a patronising rejection letter from the editor of *Harper's Bazaar*, Louis Leroy:

> Sure, De Lautour has shrewdly reclaimed the moral high ground—head and shoulders above the usual chic critiques. But, as much as he inflates his own fame with his grin-and-bear-it portraits of disease, his basic thickness repudiates what he has done so much to justify in painterly terms. It is largely for intellectual reasons that we would not consider publishing commentaries on this kind of work.[8]

In reality, Louis Leroy was the nineteenth-century art critic who christened an art movement by satirising its practitioners as 'impressionists'.

Fictocriticism returned in 1997's 'For Paranoid Critics', which casts the art world as a theatre of cruelty and payback for the critic:

> One by one, each of your victims takes their revenge: Walter de Maria pelts your earlobes with one-thousand brass rods! Daniel Buren peels stripe-width strips of skin from your naked body! The Nutty Professor, played by Eddie Murphy, lowers the full weight of his body onto your right arm! Colin McCahon tattoos unspeakable passages from *Revelation* on your forehead! Lynda Benglis throws you into a vat of boiling foam rubber! And Donald Judd drops you into a steel cube and then welds it up personally![9]

Intra was always drawn to the idea of the world as a paranoid projection. In 1995's 'Discourse on the Paucity of Clinical Reality', he had recalled Breton's formative experience as a doctor in a World War I field hospital:

> Cases of mental distress, even acute delirium. These psychic casualties of war were the kind of cases that passed through the centre. One in particular struck Breton's attention. A well-educated man, straight from the front, who had an astounding confession: the war, he said, was a complete sham. This testimony, which he elaborated in the most literary terms, did nothing but utterly convince Breton of

the paucity of our own reality. This unnamed patient insisted that the gruesome hack jobs of the battlefield were nothing but skilful applications of prosthetic makeup, the shells flying overhead were only make believe, and the battlefield itself was the false counterpane of a set dresser. Upon hearing this, the soon-to-be leader of surrealism jumped back in his seat. The movement followed soon after.[10]

Schreber also suffered from hallucinations. The paranoid Judge believed God was turning him into a woman in order to impregnate him and repopulate the planet. Schreber constructed a vast, novel cosmology to support his fears. His *Memoirs* is disorienting, detailing his experiences and accusations with surprising lucidly, scrambling insight with insanity. Intra called it 'a cross between Napoleonic battle strategy and the Starr Report'.[11] This mad, impossible book would become the basis of a case study by Freud that would prove foundational for psychoanalysis. After Freud had his way with Schreber, other theorists—including Jacques Lacan, Gilles Deleuze and Félix Guattari, and Elias Canetti— took turns making an example of him. As much as he wanted to rescue Schreber from their clutches, Intra would also make use of him, writing Schreber into essays on Slave Pianos and Julia Scher, as well as devoting two essays to him.

Schreber haunts other Intra pieces where he isn't named: in Intra's discussion of Salvador Dalí's paranoid-critical method (where insights emerge in conflating inner and outer worlds), in his account of John McCracken's minimalism (inspired by alien contact), and in his description of Mike Kelley and Paul McCarthy's *Sod and Sadie Sock* (with its *Salo*-esque debauches).[12] Intra's interest in Schreber was keyed to paranoia as the engine of the art world, underpinning the way artists build their own worlds in their work as well as the wider scene's sado-masochistic machinations.

In his obituary for Intra in *Frieze*, Will Bradley describes Intra's Schreber thesis as an attempt 'to suggest ways that art writing might be reinvented'.[13] Intra certainly saw art writing as an invention, a game. A fine example is the reviews and CV of Pat Scull, a fictional artist. Intra ghost wrote them for a 1997 Danius Kesminas solo show, which posed as a two-person show with Scull. Casually presented in the gallery as a set of xeroxed documents, they supported the art-nerdy hoax. Aping the bogus fluff of reviews, they say everything but nothing:

> Content to deliver quietly powerful work which is highly ambiguous in content, Scull provides a new form of artistic thinking for those of us who remain in the gallery, and retain our belief in the gallery.

Intra's Scull reviews and CV were the last pieces I found for this collection, and I only discovered them as a result of fact checking Intra's Slave Pianos essay, which I had assumed to be a more-or-less straight piece of art history. In it, Scull is mentioned alongside real, canonical figures. Only by googling Scull did I uncover the con. Intra had playfully smuggled him—and, perhaps, a few other furfies—into the account, echoing the liberties Slave Pianos itself took with art history.[14]

•

The title spread of Intra's 1995 Teststrip micrograph *Untitled: The Poetics of Modern Reverie* features a prophetic Samuel Beckett epigraph: 'It's suicide to be abroad. But what it is to be at home? A lingering dissolution.' It's juxtaposed with an image of the sealed souvenir glass phial of exotic-erotic Paris air—an atmosphere present but invisible and inaccessible—that Marcel Duchamp gave to the American collector Walter Arensberg.[15]

Intra's thinking was informed by distance in space and time: being provincial (coming from New Zealand, away from the action) and belated (too late to be a real surrealist, situationist, or punk). Writing on Daniel Malone, he mapped cultural cringe as both malaise and strategy:

> In New Zealand and Australia, segments of the population are afflicted by what is referred to as cultural cringe. Although this syndrome appears in many countries, these nations boast their own regionally specific varieties, as with tropical diseases. A complex that has not yet yielded a master list of diagnostic criteria, cringe is nonetheless a burgeoning field of study, and, indeed, practice … Paul Hogan of *Crocodile Dundee* fame is the patron saint of cringe, not for downplaying himself— as his identity is already paradoxical—but for the opposite reason: a hyperbolic intensity of character performed to sickeningly theatrical proportions. Cringe is to identity what wealth is to debt: the hallucination of prosperity, sophistication, and authenticity ascertained through an ironic hall of mirrors. Not so much the opposite of national pride, it is a perversion of pride.[16]

Intra may have left New Zealand in search of a bigger context, but the transition wasn't quite what he was expecting. It was more of the same. As much as he aspired to escape his small-town origins, in LA he simply found a larger village. In his catalogue essay for a New Zealand art show presented in out-of-the-way Missoula and Maui, he confesses:

> My first wish for Los Angeles was that it wasn't anything like New Zealand with its small, insular art world. Of course, my hopes were dashed as I rapidly discovered

that all art scenes are horrifically regional in their imperatives: Los Angeles, just like New Zealand, is most significantly intrigued by the development of its own artistic mythology and, again like New Zealand, in the export of its mists to foreign shores. The doctrine of exoticism applies equally in both places.[17]

Back home, Intra would himself become exotic (a figure of dinner-party rumour and speculation) and an exemplar (proof that escape was possible). Megan Dunn—director of Fiat Lux, an Auckland ARI that opened in the wake of Teststrip—remembers a mail-art work pinned to the wall of a Williamson Avenue flat in the late 1990s. It read: 'Who is Giovanni Intra?'

A new generation of New Zealand artists would follow in Intra's footsteps, many enjoying success offshore. Intra's posthumous profile in *Metro* magazine would be titled 'Golden Boy'. It was riddled with errors—as befits a legend.[18]

•

After Intra died, friends in New Zealand and the US began talking about publishing a collection of his writings. The idea was repeatedly picked up, but stalled. It has now happened, twenty years on. More time has now elapsed since Intra died than he was writing for, making this book a time capsule—a guide to artists and ideas that animated the New Zealand and LA scenes of the 1990s—the way we were. In the intervening years, Intra's writings have become even harder to find, being dispersed through defunct journals and obsolete catalogues, shipwrecked in library stack rooms and mouldering in vertical files. *Clinic of Phantasms* not only puts them back into circulation (giving them a second wind), it gathers them for the first time (exposing Intra's trains of thought like never before).

In selecting the pieces for this collection, I bypassed Intra's juvenilia and started in 1994, after his *Subculture* dissertation. I was keen to stress his voice over his subject matter, so I left out pieces where he simply served his subjects, preferring those where he could stretch out, saying something of his own in his own way. Towards the end, I included almost everything. It's a variety show. There are informative pieces on key New Zealand and LA artists. There are think pieces, front-line reports, and a few blistering take-down reviews. There are also observations upon airplane terrorism and Mexican food.

Clinic of Phantasms will doubtless have a split audience. New Zealand readers may head first for familiar New Zealand stuff, and Americans for the American stuff, but I hope some readers will be energised by the quirky journey that linked them—Intra's singular adventure as a writer, his personal wormhole.

1 Tessa Laird, '34: A Tribute to Giovanni Intra, 1968–2002', *New Zealand Listener*, 8 February 2003: 54.

2 Kelly Carmichael, 'Forget It, Jake. It's Chinatown.', *NZ Edge*, www.nzedge.com, June 2002. No longer online.

3 Stuart McKenzie, 'Junk Joint', *Artforum*, March 1995: 40.

4 'When You Sell Me', *Stamp*, no. 13, September 1990: 4.

5 The publication of Georges Bataille's selected writings in English—*Visions of Excess: Selected Writings, 1927–1939*, ed. Allan Stoekl (Minneapolis: University of Minnesota Press, 1985)—precipitated an explosion of interest in the work of the dissident French surrealist.

6 Intra doesn't seem to have completed his thesis. His academic transcript doesn't list it and no one can find it in the ArtCenter library—although he graduated in 1999 anyway, a straight-A student.

7 'Ann Shelton: Drive-By Shootings', *Pavement*, no. 10, 1996: 10.

8 'Journalism', *Tony de Lautour: Bad White Art* (Auckland: Teststrip, 1994), np.

9 'For Paranoid Critics', *PreMillennial: Signs of the Soon Coming Storm* (Sydney: Darren Knight Gallery, 1997), 16.

10 'Discourse on the Paucity of Clinical Reality', *Midwest*, no. 7, 1995: 40.

11 'Daniel Paul Schreber: Memoirs of My Nervous Illness', *Bookforum*, vol. 7, no. 2, Summer 2000: 15.

12 Intra taught a course on 'Hallucination' at the University of California, San Diego, in Fall 1999. He published the course outline: Giovanni Intra, 'Contemporary Critical Issues: "Hallucination"', *Log Illustrated*, no. 9, Summer 2000: 20.

13 Will Bradley, 'Giovanni Intra 1968–2002', *Frieze*, no. 73, March 2003: 54.

14 'Slave Artists of the Piano Cult: An Introduction', *Slave Pianos: A Reader: Pianology and Other Works 1998–2001* (Frankfurt: Revolver, 2001). I'm reminded of an anecdote: 'In a certain French convent, today, the novices permit themselves a perverse literary amusement. During the evening meal, as the others eat, one novice is entrusted with reading, out loud and in Latin, the *Lives of the Saints*. The game is to add additional tortures to the multitude already suffered by the martyrs in such a manner as to escape notice of the spiritual director supervising the reading.' Allen S. Weiss, *Iconology and Perversion* (Melbourne: Art and Text Publications, 1988), 9.

15 See Marcus Moore, 'Marcel Duchamp and New Zealand Art, 1965–2007: By Means of Duchamp's Peripheral Vision: Case Studies in a History of Reception' (PhD thesis, Victoria University of Wellington, 2012), 209.

16 'Daniel Malone: Triple Negative', *Art and Text*, no. 70, 2000: 42.

17 'Leaving New Zealand: The Question of New Zealand Art Abroad', *Te Ao Tawhito | Te Ao Hou: Old Worlds | New Worlds: Contemporary Art from Aotearoa | New Zealand* (Missoula MT: Missoula Art Museum, 2000), np. This essay also opens with the Beckett epigraph.

18 Tim Wilson, 'Golden Boy', *Metro*, May 2003: 66–73. 'Friends and colleagues' of Intra's wrote a letter correcting Wilson's errors. 'Record Straight', *Metro*, July 2003, 7–8.

Quick Study

Chris Kraus and Mark von Schlegell

Chris Kraus: Giovanni Intra arrived in Los Angeles on a Fulbright Scholarship in 1996 to study at ArtCenter in the new Critical Theory program. He was twenty-eight at the time and had been dying to get out of New Zealand. It was as if the programme had been formed just for him. At its peak, it had no more than four students, and it withered away soon after he graduated.

Before that, he'd been living in Auckland and was mostly known as an artist. With the artists Kirsty Cameron, Judy Darragh, Et Al., Gail Haffern, Denise Kum, Lucy Macdonald, and Daniel Malone, he had founded Teststrip—an artist-run gallery that started in a big upstairs room on Vulcan Lane in the central city. The gallery was a success. Auckland had never seen anything like it. Mostly recent art-school graduates, the Teststrip collaborators combined an old-fashioned Kiwi work ethic with a confrontational fuck-you, post-punk aesthetic. They were naturally at odds with Auckland's artistic establishment. They were decidedly not currying favour or using the gallery as a stepping stone to institutional recognition. They couldn't care less if people liked them. Which seems, retrospectively, like a pretty reasonable and realistic attitude. At the time, the rewards available to artists who stayed in New Zealand were paltry and laughable. Still, it's worth pointing out that Giovanni had an exhibition career outside of Teststrip, with solo and group shows with dealers and in museums. The ever-astute New Zealand collectors Jim and Mary Barr began acquiring his work early.

A 1995 photo taken by the artist Ann Shelton at Teststrip shows the artist Guy Treadgold and Giovanni crouching with drinks behind a disco ball. Giovanni's dressed almost as a parody of an opening attendee or a senior schoolboy: blue blazer, beige chinos, white shirt, even a plaid tie.

I met Giovanni in Auckland in 1993–4 through mutual friends. Some of the Teststrip people were working with me on my independent feature film *Gravity and Grace*. There was no question that Giovanni would work on the film, but we clicked immediately. He was clearly the most personally and intellectually ambitious member of that Auckland cohort. Sylvère Lotringer, who joined me briefly in Auckland, was a great influence on Giovanni. Sylvère, the critic and theorist who founded Semiotext(e), was teaching critical theory at ArtCenter. He and Giovanni cooked up the idea that Giovanni would apply and become one of the programme's first students. Giovanni was already a great reader of critical theory, and his conversations with Sylvère were wildly stimulating. Sylvère had edited, published, and collaborated with many of the French theorists Giovanni was reading: Jean Baudrillard, Gilles Deleuze, Félix Guattari, Jean-Francois Lyotard, Michel Foucault, and Paul Virilio.

Reading through some of the early work that Anna Rankin recovered from Giovanni's old hard drive, I was surprised to see a long, serious essay published in the New Zealand literary magazine *Landfall* in 1993 on a 1666 still-life painting by Abraham van Beyeren that had recently been shown at Auckland City Art Gallery. The painting depicted an assortment of fruits and vegetables, and Giovanni's meditation on this work can be read through one lens as a prank—'a permanent chiller has been developed in the form of the museum … These are vegetables in their own platonic heaven, tricking death'—and, through another lens, as a brilliant extension of Hal Foster's essay on Dutch still-life painting and fetishism. Giovanni's piece, though it's not included in this volume, seems prescient of his interests.

Mark von Schlegell: I first met Giovanni late in 1998, I believe. I used to visit LA seasonally with my partner, the writer Veronica Gonzalez Peña. She introduced me to the group of artists working at and hanging out at the ArtCenter Library: George Porcari, Amy Yao, Steve Hanson, Frances Stark, Jorge Pardo. Still not quite part of their scene, Giovanni was also working there. Like me, he identified as a writer.

I had no idea that he had been an artist of note in New Zealand until some years later, when I began to get filled in by the amazing New Zealand artists and personalities who constantly arrived in and departed from his minuscule Hollywood Boulevard apartment, no matter what else was going on. Eventually, he showed me his art, which involved writing, and traded with me. He was proud of it, but made it clear he stopped making art to begin his writing life.

When my partner and I finally moved to LA full time in 1999, our relationship fell apart. I considered moving back to New York, for LA society was still so strange. But my first solo invitation came from Giovanni, who I didn't yet know as well as I'd have liked. He had me over

to a house he was caretaking in Mount Washington, the same mysteriously charming working-class hilltop neighbourhood between Pasadena and LA where I was currently stranded. He cooked one of his extravagant, oven-centred meals and informed me, with a delicious smirk, that this was your place, Chris. He was taking care of it while you were away.

Your first novel, I Love Dick (1997), was one of the reasons I had relocated to Los Angeles. It breathed the air of a kind of writing world that wasn't happening in New York. At this time, to be a friend and supporter of yours in LA was dangerous and controversial. LA's art scene was entirely controlled by the narrow hegemony of its art schools, and your breaking conventional literary structures of publication and permission angered many powerful people.

As two Taurus writers, Giovanni and I hit it off. We were both finishing interrelated academic essays. I was thrilled and seduced by the non–New York world of possibility he belonged to. He was attracted to my East Coast roots and was a fan of my father, the sculptor David von Schlegell. I enjoyed his outsider's perspective on LA. He told me he had writing jobs for me. He was proud to be connected to Semiotext(e) and its radical history.

Approaching the art business in the light of Sylvère's move into the publishing business, Giovanni joined the ArtCenter library people in starting the artist-run gallery China Art Objects Galleries in LA's Chinatown in 1999. Within two years, he and Hanson were managing the booming little business themselves, with Giovanni identifying as an up-and-coming gallerist. Yet, even so, he kept writing fiendishly, as if it were an addiction. He worked extremely hard on his texts, often extending deadlines to the point of breakdown.

To the list of writers you mention transforming him, I add Guy Debord. Giovanni was born in May 1968 and he took on the situationist project as if it was his birthright. He was interested in critical theory's street-level social and political possibilities and aristocratic self indulgence, in punk rock's trumping of philosophy, and in the flower children's gentlest hallucinations. All drugs drew his interest. This was the postmodern moment where you could be a fan of Baudrillard, whose ability to be a 'prick' appealed, and Dr Dre, who Giovanni once accidentally sat near in Musso and Frank's. Giovanni approached and made friends with the rapper/producer. That boundary-crossing approach was part of that time and place. LA art was as multidisciplinary and wide open as it was local and focused. We loved that LA still offered the possibility of transformation, that I could move there and become a science-fiction writer, as Giovanni himself had come here and changed.

As a Chris Kraus fan and collaborator, Giovanni wanted to provoke and break apart lingering taboos with writing. He was able to build a body of work quickly and accurately. Today, it's hard to believe such an open, lively positive tone towards the common project of art and writing could be maintained in an art publication. New Zealand artists often used to

have what Giovanni's friend, the artist Michael Stevenson, playfully called a 'marginalisation complex'. But I wonder if the marginal position wasn't more powerful than we understood.

Do you remember that moment of LA art and art publishing (1996–2000) as a special moment for us pulp-art writers working between criticism and fiction, open to any idea, in your footsteps as it were? Art and Text, *a magazine that came out of Australasia, was crucial in that regard.*

Chris Kraus: There was definitely a sense of possibility during those years, that half-decade, that Giovanni stepped into, that made the kind of writing we were doing—'art writing', 'pulp criticism', 'critical fiction'—possible. The art world is less conservative than the literary world, and there was an opening then, where our writing could be read favourably, sympathetically, comprehendingly, by artists. There was the terrible hegemony of the high-profile art-school programmes, but, for those affiliated with them, things seemed wide open. There were all kinds of pop-up shows, motel shows, Dave Muller's Three-Day Weekend, and then China Art Objects, the gallery Giovanni started with friends in 1999. Locally the stakes seemed very low, but, paradoxically, seductively, there was more money and more access available than in other, truly provincial centres. Within months of its inception, China Art Objects was being written about in *W* magazine and doing exchange shows with major galleries like Sadie Coles. But, beyond the magic of the moment, its success had everything to do with Giovanni's charm, ambition, and intelligence. He was extremely credible at everything he set out to do.

Of all the writers working in this parasitic relation to the art world at that time, Giovanni strikes me as the most serious. Re-reading the pieces collected here, I'm struck by Giovanni's formidable, comprehensive knowledge of art history and his intuitive genius for making connections between art works and critical theory. Critical theory, at that time, was often wielded in a naive and heavy-handed way that's since been parodied—as if citations from whatever theorist-du-jour gave us permission to make or enjoy a certain artwork.

Reading this collection is like an adventure game. Through their chronological arrangement, you follow Giovanni's intellectual process, step by step. Concepts arise organically through his consideration of art works, but become subject to intense investigation. Ideas appear briefly in one piece to become fully elaborated later. For example, ideas about movement, speed, and centrality in his hilarious 'TWA 800: A Dada Manifesto' (1996) are elaborated in major essays like *The Mobile* (1999), moving from a soberly wry discussion of plane crashes and black boxes to an analysis of the nineteenth-century chronophotographs of Étienne-Jules Marey and the phenomenon of motion itself.

Giovanni became the foremost critic of a new kind of video art—he called it a 'hallucinogenre'—that was being devised by artists like Diana Thater and Jessica Bronson.[1] As he wrote,

> Thater's work began in 1990 with a fork in the road of video art that she herself created. Dividing off from the major video artists Bill Viola and Gary Hill, who were producing heavy and psychologised annexes of darkness, Thater built a language of light and spatial properties, an architecturally sensitive, non-transcendental video on an epic scale.[2]

Early on, he decided to take stands at the risk of making enemies. He did this in a courageous way that was almost taboo within the LA art world. Few people cared enough about ideas to risk the social consequences. Giovanni was clearly appalled by the voyeuristic, apolitical 'true crime' exhibitions he reviewed in 1998 for *Afterimage*. This was not a popular opinion. Ralph Rugoff was a powerful curator at the time, and people were mostly gratified and charmed to see this pulp, true-crime content imported into the gallery. Porn-star chic was having a similar artworld moment. Taking a contrarian position in such an articulated, restrained, but ultimately venomous way was a very East Coast thing to do.

And what about his work on Schreber, paranoia, and hallucination?

Mark von Schlegell: The rumination on Schreber that runs through this volume helps lift Giovanni's work into a unified rumination on the art of criticism. Schreber helped him live with and use the paranoia that came natural to an art-world career at this time. Most of the years I knew him, he was engaged on his master's thesis project for ArtCenter's Critical Studies programme, which attempted to liberate the German lawyer and cybernetic visionary's Memoirs of My Nervous Illness *(1903) from the clutches of its powerful interpreters. In essays included here, we find Giovanni celebrating* Memoirs *as a self-aware schizophrenic text breaking taboos and sexual boundaries with precise and devastating clarity in its own time, a published object of real-world magic power. For, despite its bisexual 'madness', the book's publication successfully liberated its lawyer author from the hold of a psychotic and pathological mental-health industry masquerading as enlightenment.*

The whale surfaces grandly in the splendid 'Paranoia and Malpractice' essay Giovanni wrote for the 2001 Hallucination of Theory *anthology, which he also helped edit. Here, he unveils his dream of a free book, an imprinted fractaliser, a generator of the very possibility of reason and discourse itself, resisting all but its continued unfolding. To the artist, critical*

discourse is a paranoid disease. Giovanni hopes to indulge in criticism's 'misplaced sexuality' and redeem it in the pleasure of the text. Via delirium, trained assaults on decency, asides, and non sequiturs, we follow our liberated judge through a discourse that never means to be pinned down. Giovanni here goes so far as to identify the critic with Schreber's sun god, each of whose rays constantly prick the subject into conflicting directions.

Schreber resurfaces in the Julia Scher piece 'Pulverised by Light', one of Giovanni's last major texts. After moving out of LA to Cologne in 2005, I met and befriended Scher, also an oft-bewildered Californian immigrant to this town. I am struck by the clarity with which Giovanni's essay gets to the heart of her practice, which continues strongly on just these terms today. Giovanni's luxurious use of Schreber in this text bravely dislodges Foucault from the centrality of all discussions of surveillance. He is right to locate in Scher the revelation of the deconstructions already built into surveillance, cracks of Schreber-like possibility showing up in the supposed infinite power of the panopticon with which theory makes itself inviolate.

As Giovanni the critic walks through local LA shows by Evan Holloway or Lisa Lapinski, it is through a labyrinth of paranoid intercourse of the artists' and his own obsessions. Nevertheless, we walk through the real-world experience of encountering the exhibitions in contemporary LA. In these shorter criticisms, Giovanni never ends with a certain judgment; the reader is left with the living city. Beyond art criticism, this is also a book about friends and friendship, and a larger cultural critical engagement with LA. Giovanni only lived there some six years, and I detect a cooling as things go on, a re-negotiation.

How do you read Giovanni as an LA writer?

Chris Kraus: I think, for a long time, Giovanni saw LA in much the same way I did when I first arrived, as a place of magical possibility—psychically, if not geographically, located halfway between New Zealand and New York. For at least two years before he finally bought a car, he rode the bus from East Hollywood to Pasadena, entailing several connections and a mile-long hike from the bus stop on Linda Vista to the ArtCenter campus each way. He walked around all parts of the city, exploring the Hollywood Hills, Pacific Palisades, and Malibu, long before he was a guest at various parties in the homes of gallerists, curators, and collectors there. He explored East LA and the notorious Rampart Division around MacArthur Park too.

I remember when he was starting out to establish himself as an authoritative critic, he considered making an enemy of Mike Kelley. Every serious critic, he reasoned, needs at least one powerful enemy. But he changed his mind and became one of the most intelligent interpreters of Kelley's work. In his 1999 book review, he favours the professionalism of

Phaidon's *Mike Kelley* book, with its essays by John Welchman and Isabelle Graw, to a clubby earlier collection of appreciations by Kelley's friends. He picked up on Kelley's own critical work, motivated by a desire to defend his practice from clueless misinterpretations, and he went on to do this with his own work on Schreber—liberating Schreber from Freud, Lacan, Deleuze, and the rest of the Schreber industry, and discovering a primary, hallucinatory pleasure in the text. He attended a lot of desert raves that, from the acerbic tone of his writings, you'd imagine that he might view cynically, but he was an enthusiastic participant in all kinds of experiences, including the community of LA artists forming at that time. He was smarter than almost everyone, but he was not a snob.

There was a feeling among a lot of LA friends that, by the early 2000s, Giovanni was getting tired of writing art criticism and thinking about pursuing other forms. One of my favourite pieces in this book, 'El Gran Burrito!!', isn't about art at all, but about eating greasy meats at crowded tables under a sidewalk canopy on Sunset Boulevard. The gallery, which eventually was run just by him and Steve Hanson, began making new demands on him as the art market changed. The fissures between those with independent means and those who had to make do with their own resources began to show. While initially the trips to international art markets were a giddy fluke—who would have thought they'd be taken seriously?—three years later, they'd become more like a high-end travelling-salesman job.

The essays in this book brilliantly chronicle a half decade of social and intellectual escalation in Los Angeles that would soon be halted by astonishingly rapid gentrification. But they also show the possibilities of art criticism. They chronicle a vivid intellectual adventure, in which it is possible to be at once rigorously analytic and personally transparent and eccentric. Two decades after his untimely death, Intra's writings lead the way.

1 'La Struttura Mobile', *Tema Celeste*, no. 72, January–February 1999: 51.

2 Ibid.

Everything You Read
about Giovanni Intra Is True

Andrew Berardini

Everything you read about Los Angeles is true. The city adapts to its own mythology. It's such a ludicrously discussed place that I always feel slightly idiotic in my attempts to produce a serious discourse about it. Raves in the desert, however, are superb. And ecstasy is a great drug. Also, if you hadn't heard, music sounds better when you're high. And the desert surrounding LA is wondrous.

—Giovanni Intra[1]

When I first read these lines from Giovanni Intra's essay, 'LA Politics', they were exactly what I needed.

I was sitting in the office of China Art Objects Galleries in the summer of 2006, twenty-three years old and recently graduated with my MFA in Writing from CalArts. Steve Hanson had run the gallery with the legendary Giovanni before his passing and had taken me on as a gallery assistant, which, somehow, mostly jokingly, transmogrified into 'archivist' (which I, of course, put on my subsequent resumes).

One of my tasks was to parse Giovanni's library, kept in a closet just off the gallery. There I found the exhibition catalogue for *Circles*, published in 2002 by Christoph Keller for ZKM in Karlsruhe, where 'LA Politics' appeared. As I looked through Giovanni's books, read his writings, and heard the unbelievable stories from Steve and the other characters that made up Chinatown's community of artists, collectors, critics, and galleries, I grew to know Giovanni and admire his voice.

I read through his love affair with Georges Bataille and his obsession with Daniel Paul Schreber's *Memoirs of My Nervous Illness*. I studied his reviews, both acerbic and generous,

marked with an unfettered passion and cutting intelligence. Giovanni emerged the radically elegant punk—whip-crack smart and charming as hell—that I imagined I was, or, at least, might one day become.

In Giovanni's writing, I found a fellow traveller and bon vivant who had traversed the shadowy thoroughfares of art that I was so keen to discover. And he had done so with candour and style. He knew that raves in the desert are superb, that ecstasy is a great drug, that music definitely sounds better when you're high, and that the desert surrounding LA is truly wondrous. I had found in reading his work a friend and predecessor—an inspiration when I dearly needed one.

Giovanni had been gone for four years when I first read him, yet I felt his vitality everywhere. As I plodded along as an assistant/archivist at China Art Objects, I also took up an internship at Semiotext(e), the storied press of radical fiction and theory, only to see Giovanni had been there before me, co-editing a book. In the first graduating class of ArtCenter's Critical Theory master's programme, Giovanni had been in almost the same place I was. I felt, at that juncture in my life, the shadow of his reputation and the luminosity of his spirit.

Giovanni's 'LA Politics' essay remains my favourite. I return to it when I need to remember that someone else stood where I stand now and saw it all so clearly. In that essay, along with meditations on the perils and fluidity of LA, he wrote about Steve's and his coming down from the exquisite pleasure of MDMA in a full-moon rave in the desert and inventing a gallery that, in their fevered, exhausted joy, they called Expressions, imagining a silhouetted coyote jumping over a moon as the logo. Even as the gallery emerged with more chic, the story felt to me exactly like the sort of mad, ridiculous thing I would do.

To me, Giovanni's hilarious honesty and sharp intelligence was a breeze, a knife, a wonder. Before encountering him, I thought being an intellectual involved drudgery in some obscure academic position, decoding grand theoreticians for their gnomic wisdoms, and not having fun (in her diaries, Susan Sontag admonishes herself for smiling too much, thus risking not being taken seriously). And, though a writer for all seasons, I was endeavouring to start a career as a critic, and most of the art writing I read lacked verve.

I had come to art and literature looking for lunatic revolutionaries, sensuous poets, and sexy weirdos (which I found later on, to be sure), but at that moment I mostly knew browbeaten adjuncts, banker-bro art dealers, and eagerly commercial artists. The writers I met were mostly meek, workaday strivers, networking more than living. Most everyone seemed to be on some hustle for self aggrandisement, soft position, or hard currency, and there seemed only old stains of the spit and cum and acid and joy that I hoped would drip

from the tongues and fingers of my lost tribe. I had mortgaged my future with a fantastic student-loan debt, only to end up a highly educated retail clerk in the culture industry. It's a place to which I am now grateful, because it's where I encountered Giovanni's writing.

From Giovanni:

> disoriented by LA's post-graduate-school environment, from which professionally enthusiastic twenty-eight-year-olds emerged from a boot-camp-like education with an $80,000 student debt … Underneath this was a layer of pure financial terror substratified with humorous and cunning levels of industrial espionage … If I keep returning to this 'alternative' point, it is because of the pleasure I have taken in betraying its principles. Selling art is a lot of fun. To make money from art is a kind of revenge against the expense of graduate education and the political imperative that suggests it is compulsory for young artists to attend school for extended periods and go into debt.[2]

When I took my job with Steve at China Art Objects, I was only just beginning to see all this, through the mist. Encountering Giovanni there—in his legacy and through his friends—was a miraculously timed gift.

At the gallery, I grew to understand my boss Steve—Giovanni's friend and business partner—as a wholly unlikely dealer, who kept the place going out of love for a time and energy he found with his late friend. An angelic upstart, Steve was less a hard-knuckled businessman and more an Emersonian artist who leapt out of a library and into art dealing, only later in life to find his true medium as a painter of of comic, mystical landscapes, under the name Leo Mock. I can't imagine Giovanni and him running a business with discipline, but I can imagine these two charming men waking up one day to find themselves being successful art dealers.

When I worked in the gallery in 2006, Steve was doing his best to be a commercial gallerist, but the costume never really fitted him. People loved him and the memory of Giovanni so deeply that they helped the gallery to get along anyhow. I got the feeling that Steve kept the space going out of love for what Giovanni and he had made together (even as sundry others had also started and supported it), but also out of memory for Giovanni, for whom, in 2006, he was still grieving and likely still is. 'Most days, there's a lot of laughter in our gallery', Giovanni wrote, 'and it often surrounds the perversion of the art system and our part within it.'[3] I felt this laughter and love from Steve and so many of Giovanni's friends and admirers in LA. I felt his perverse magic in the living memorial of an art gallery.

It might have otherwise been a dead end for me, but there, sitting behind the counter of his gallery, Giovanni pointed a way forward. I pored through his library, reading his *Art and Text* pieces and catalogue essays. I felt his presence in the gallery and the importance of his library tucked into it. I learned from reading him that there is no right way to live an artful life; that writing can be full of intellect and humour, vulnerability and honesty; that it doesn't have to be a game of half-understood erudition or crass commercial hustling. It can be any and all of these things or none of them at all. Life and art can be something you make up as you go along, a virtuoso improvisation composed with raw bravery and panache.

In those days, I started to put together an archive of all Giovanni's writing, returning to it again and again over the years. I hired the late Emi Kuriyama to help me gather it. Illness and life always kept me from finishing it. After more than a decade, I dragooned Giovanni's friend, the brilliant writer, editor, and filmmaker Chris Kraus into the dream. And, through a dozen other circuitous stories and the dedication of Robert Leonard, you now hold this book in your hand. I can't describe the debt I feel to Giovanni, and to have played a part in the publication of these collected writings gives me scintillating pleasure.

With wry beauty and renegade brilliance, Giovanni contained multitudes. He could billow with romance or cut with economic acuity, and he could run an alternative space born at a desert rave as a commercial art enterprise while reviewing exhibitions, and totally get away with it with grace, as few others could. In others, these contrasts might have cancelled each other out, but in him they took on a tense and mythic wonder. And, as with all myths and mythic figures, everything you say about Giovanni is true because there was more there in him than a human body ought to contain, and his writing is a record and expression of that. Although I never knew Giovanni Intra while he lived, here, in his writing, he shimmers with life.

1. 'LA Politics', *Circles: Individuelle Sozialisation und Netzwerkarbeit in der Zeitgenössischen Kunst* (Frankfurt: Revolver, 2002), 133.

2. Ibid., 135.

3. Ibid, 139.

Intra's Writings

Tony de Lautour: Journalism

Tony de Lautour: Bad White Art (Auckland: Teststrip, 1994).

Exhibition-catalogue essay: *Tony de Lautour: Bad White Art*, Teststrip, Auckland, 23 November–3 December 1994.

Tony de Lautour: Painter of White

> *White [trash] culture has killed millions. Not since Hitler, Stalin, Lenin, and Mao Tse-Tung have we seen such mad slaughter ... drowned in static, murdered, saturated, and starved ... credit and sugar are to blame ...*
>
> —Stan Rose, *Cry for Help*

'Punch-drunk portraits of Casper the friendly ghost.' Those were my first words when I saw the *Bad White Art* paintings by Tony de Lautour in that Soho loft he called home during those dark, early-early years before he got onto the commercial-gallery circuit. In other words, before he became an intellectual.

Me? I was working at the University of California at Berkeley, completing my doctoral dissertation—a rather lengthy work named *Slow Hot Love: Epistemologies of White Trashism in the Post-Reagan Era*, chapters of which were being published in *Artweek* as a kind of syndicated serial. So, my career was on the up, I guess you could say. But shucks, I was naive. I was up the duff with Benjamin and God knows what else.

Unable to completely dismiss Marxist principles—which at the time were being brutally pummelled by M.F. and others at Berkeley—my dissertation, in the final analysis, was, shall we say, *sociological* ... The brunt of my argument was an account of racial conflict as depicted in the boxing tournament between Mr T. and Rocky Balboa in *Rocky III*. I studied this exemplary scene over several chapters, my argument resting upon it being a spectacle of American racial conflict: a full-scale virtual gladiatorship that acted as a glamourising catharsis for problems that had existed since the slave trade in the eighteenth and nineteenth centuries. White versus black in the World Series of trash.

Beyond this, my project was to figure out what was *really* happening in the underbelly of mid-American culture. What on earth goes on in the minds of those sick fucks?, I asked.

I consulted with numerous scholars of American art and current East Coast magazines and went on several exciting field trips (hence my nickname, the 'Road Scholar'). I wanted to discover the *meaning* of what was most ambiguously being described at the time as 'white trash', or, variously, 'derisive culture' and 'bad white art'. What did these terms have to do with anti-ethno-egalitarianism and post-intoxicated totalitarianism?, I wondered.

And why was the phenomenon at such a premium? The situation was so extreme that the *real* white trash (the Californian art collectors) were beginning to take interest.

Needless to say, I surveyed the field. B. Wize's contribution to whitetrashism, *Ovens and Fridges: Stuff that Folks Leave on the Side of the Street*, was published by Verso in London and was quickly fashionable in the usual sense: sexy but utterly unreadable. Other scholars were as opaque. Seymour Gater, in his now-classic *Coffee Lounge: The Journal of Rock Noir*, had already famously noted:

> I always hated smoking in bed, but here I was again. And then she asked if we could do it doggy—I said 'sure'. So we did. She wasn't dope about my sudden outburst of crowing. The whole ridiculousness of fucking suddenly came down on me.

Gater's self-congratulatory methodologies and critical onanisms somehow characterised the white-trash genre I was analysing. But Kingsley Anis's asubtle mixture of Bakhtinian demonology and Keithian canonism licked the West Coast dry. The opening lines of his 1993 collection of essays, *Can I Hit You up for Ten Bucks Mate?*, was the quintessential hit of the genre:

> We were at the opening of my latest exhibition. I left and strolled up to Brownie Point. The sea was spewing all over my Carhartts. Some dame was spewing into the sea. I put her in my next show. I didn't have any choice.

It was somewhere in the middle of the writing of those thousands of pages—close readings of Gater and Anis, and the endless replays of the visceral taxonomies of Stallone's bad white art (boxing)—that I came across Tony de Lautour's paintings. Needless to say, they made a lot of sense to me.

Tony de Lautour: Painter of Fright

But how were De Lautour's paintings to be analysed, given that most critical apparatus is nothing but psychopomp with middle-aged spread?

Paint, to Middle America, means only coats of lacquer on the Chevy and coats of liquor on the trachea. It is pointless to mention the dividends of thinking to those freaking fat billyos who suck the scum off the superhighways. So, instead of looking in the cultural gutter for clues, my thoughts went straight to Monet when I saw De Lautour's works. But Monet gone right! Monet BMWs with brow-beaten Warhol portraits superglued onto

their bonnets. Monet hot rods adorned as fluorescent fauves of post-consumerism. Butt ugly but completely cogent of the Paris School they were the ultimate equals of.

Impressionism invented the description of glow: the rendering, not of the object, but of the caress of the immaterial on its surface. For this, Claude Monet became known as the Painter of Light. De Lautour, it struck me, during the last orgasmic beats of T. Rex's 'Solid Gold Easy Action', was a man after Claude's own heart. He was an impressionist in tune with a very pongy world. To my wide postgraduate eyes, De Lautour's dripping, indelicate propensities offered a vision of the insides of our stomachs post-bubblegum. Horrific cancers of graphic irreduction, they were the ultimate reflection of a planet besieged by creamy caramel and candy-coloured clowns.

The raw red heads of De Lautour's kiwis suddenly became Jamesonean metatypes of Monet's haystacks, his marbled paint slicks polluted lakes of water lilies out the back of some disgusting factory in Alabama. Sick with inspiration. I immediately turned on my Macintosh Quadra and wrote:

> The veils of De Lautour's pointillist obscenities are shot through with hundreds of small brushstrokes, each one an insult to the optical and scientific theories of colour and form that historians attach to the moment. The marbled surfaces of these paintings refer to a great aristocracy that has yet to come. Luxurious skins of paint battered with the world's abuse but still possessing the arrogant upper lip of grandfather's collection of antique bibles. Secure and leather bound, they split from their seams like massive out-of-hand tsunamis and anthropomorphic liquid unconsciouses of perverted long-distance truck drivers.

Flattered by the intensity of my own mythogogic ecstasy, I sent a draft to the that-time editor of *Harper's Bazaar*, Louis Leroy.

Tony de Lautour: Painter (Not Bright)
Louis Leroy's reply was on my desk the following week.

> Harper's Bazaar (Inc)
> 113 West Broadway
> Cal 90210
>
> Dear Dr Whyte,
> We would hope that a painter promises to discover truths in painting, and commits

himself to saying them. Tony de Lautour's strength lies in the emphatic surfaces of his pictures, and it should be his concern to maintain and intensify them. He is not some sort of cultural analyst, as you suggest. The artist reads comics. It is a shame that he does not pay more attention to scholarly texts, as do the rest of us.

Sure, De Lautour has shrewdly reclaimed the moral high ground—head and shoulders above the usual chic critiques. But, as much as he inflates his own fame with his grin-and-bear-it portraits of disease, his basic thickness repudiates what he has done so much to justify in painterly terms.

It is largely for intellectual reasons that we would not consider publishing commentaries on this kind of work. Besides, the heroes depicted in comic books are fascist types—we don't take them seriously at all.

Same goes for your writing, punk.

Yours,

Louis Leroy

Enraged by this dismissal, I called Leroy collect at 4am. Got the asshole out of bed—Ha!

Tony de Lautour: Painter Alllrrriiggghhhtttt . . .

> *I was driving down to Star City. Hung over. Taste of spew in my mouth. Picked up some cocksucker outside Needle-Dick Bar'n'Grill. Dunno what they fed him, but he wouldn't stop talking. He said he was into white trash, so I stopped at Cunt. Funny thing, but he stayed in the car.*
>
> —Melody Hussler, 'Nobody Knows the Trouble I've Seen'

As the 1980s draw to a close, it seems that Tony de Lautour is a foregone conclusion—a standard fixture in every American bathroom.

What once seemed like chaotically interconnecting passages of flesh, pipes, knobs, and slots now have the familiar charm of a nautical bully boy stitched together with the guts of a dead cat. De Lautour's is an art that, like the prose of Melody Hussler, will never become chuddy in the mouth of the bearded whore. Gassed by its own toxicity, De Lautour's hydraulic approach to painting has proven Louis Leroy and all the others wrong.

And me? Well, that dissertation never did get accepted. These days I am often spotted on Skid Row California (the most intellectual place in the world) trying to sell secondhand watches to skate bums and mummy's boys. I look more like a De Lautour painting every day.

De Lautour himself occasionally throws me ten bucks from the window of his pink, hand-painted Cadillac. That painter—he sure got smart.

I guess what happened was the white trash went up and I went down. I can't resent him though. Basically, he's an enthusiast who happens to paint.

John Hurrell: Mental Health in the Metropolis

Midwest, no. 6, 1994.

> *The form a city takes*
> *More quickly shifts, alas, than does the mortal heart.*

—Charles Baudelaire[1]

Killing the past, in architectural terms, is as simple as demolishing a building—an elegant and irreversible gesture that art lives in envy of. Painters regret they have no such option and must be content with a smaller portion of the Cartesian grid. In their frustration, they substitute, for the enormity of urban space, a cleaned-up and depopulated version: the modernist grid. For John Hurrell, this grid has its satirical double in the pocket mini-map—the ground for all his painting since 1984.

The pictorial city—as distinct from the three-dimensional city—finds its apotheosis in the map, which, as we are so tired of hearing, is slave to the evil, isotropic God of Western Logic, and, as such, is undisputedly a 'fiction'. Revelations stemming from this basic assumption populate and limit the criticism of John Hurrell's work, sticking it down like bubblegum to pavement. Consequently, as it continues today, his project is seen as some sort of nostalgic postmodernism—a road to nowhere that has 'changed hardly a jot'.[2]

However, these comments assume a sameness where there is not one, a dead author and a 'depersonalised strategy' when there are no such things.[3] The more the icy borders of so-called 'conceptualism' are examined, the more we see that projects such as Hurrell's, far from being without character, are riddled with all manner of subjectivities. They come to be 'about' many things that they are not 'about'. For instance, the relationship of Hurrell's map paintings to notions of place can be read beyond the simple irony involved in sandwiching together an international image and a local map. Taken literally, these paintings might be considered slightly mad, not in a clinical sense, but in a situationist one. They are psychotic geographies of metropolitan space.

Architecture may breathe a sigh of relief knowing that John Hurrell is a painter and his work is restricted to that field. One hastens to wonder what would happen if Hurrell's map works were taken as a new vision for central Christchurch. Hurrell's paintings show a city without attractions or homes, confirming Guy Debord, who stated: 'One must construct uninhabitable ambiences; construct the streets of real life, the scenery of daydreams.'[4]

Hurrell's intention is to 'create an ambiguity that obliterates not only the regional context, but any suggestion of the anecdotal'.[5] Quite literally, the paintings become

depictions of homelessness. In each painting, Hurrell uses many copies of the same map. They are turned upside down, trimmed, and arranged to suit the image that will be transferred onto their surface. In the first of these works, *43° 32′ 1″ S Pasto Appassionato 172° 38′ 16″ E* (1984), an appropriated figure from the transavantgarde repertoire of Sandro Chia was superimposed onto the surface of a grid of Christchurch maps. Where the Chia meets streets, these streets are followed. The remaining area—the negative space—is painted black in a process of addition-as-subtraction. Chia's original form bleeds off into Christchurch suburbia, becoming a 'cluster of hairy lines'.[6]

In Hurrell's paintings, Chia's figure and its companions—which now include faces and bodies from Carlo Maria Mariani paintings and *Conan the Barbarian* comics—enter the space of Christchurch and other cities to become flâneurs; tourists wandering through an extended, black-lit network of colonial boulevards. The urban spectator's perceptivity to the environment is significant; the body will eventually make an impression upon the space it inhabits, as is the case with architecture. This chance interaction between body and urban space, this trampling over urban space, situationism called the 'dérive', a perpetual wide-eyed nomadism that desublimates the city and recharts it according to the techniques of psychogeography. Situationism invented psychogeography as a deviant form of mapping that considered the city as anything but what it is or is assumed to be. This technique politicises daydream, undermining the authoritarian claims of the city's architect. Similarly, Hurrell's painting recognises the city as a zone where anything can happen.

In *Pasto Appassionato*, Hurrell's Chia is exposed to chance encounters. But what kind of chance? The kind of chance generated exclusively by the urban environment:

> On Tuesday, 6 March at 10am, G.-E. Debord and Gil J. Wolman meet in the rue des Jardins-Paul and head north in order to explore the possibilities of traversing Paris at that latitude.[7]

The way the Chia figure drifts through the cracked cartography could not be considered a 'sensitive collaboration with the contingencies of nature', as earlier works of Hurrell's have been described.[8] There is no nature here, not even by analogy. This is a flirtation with a manufactured chaos—that of urbanism; a pictorial space controlled by economic growth and population control, cluttered with figures and detritus, neurosis and psychosis, agoraphobia and claustrophobia. In short, and despite attempts to the contrary, the map paintings continue to signify a political space where, instead of everything being 'fictional', everything is real. Hurrell's map paintings re-metropolise the grid systems used in modernist painting.

Hurrell's most-recent map paintings, his *Transmutative Portraits* (1994), are based on Rita Angus self portraits and Warhol celebrity snapshots. Of the three works in this series, two have two arrangements, one has three; they are shuffled accordingly for the duration of their exhibition. The 'sitters' become disarticulated, like the cities below them—an exploding and fragmentary population. These works operate as tableaux vivant, where faces become imaginary landscapes, nerve systems, or whatever the eye chooses to discover. As surreal occupations of psycho-art-history's empty lots, the *Transmutative Portraits* explicitly refer to the self and its place within the fractured space of the city—the 'mutate' in *Transmutative Portraits*.

In Hurrell's work, the urban environment becomes an enormous screen for the projection of bodily form. The grid of arrayed maps attempts to objectify these uncontrollable subdivisions, but everything is thrown out further by the next transmutation: a process of construction-as-dismemberment continually experienced by the city itself.

1. 'The Swan', in Charles Baudelaire, *The Flowers of Evil*, trans. James McGowan (Oxford and New York: Oxford University Press, 1993), 175.

2. This flattery was Justin Paton's. 'Hurrell Paintings, Watson Works', *Christchurch Press*, 13 July 1993.

3. For instance: 'A depersonalised strategy is adopted by John Hurrell who problematises the idea of revelation of the authentic self in the process of image making.' Jennifer Phipps and Linda Tyler, *Heart and Land: Contemporary Works on Paper* (Wellington: New Zealand Art Gallery Directors' Council, 1990), 8.

4. Guy Debord, 'Unitary Urbanism at the End of the Fifties', in *On the Passage of a Few People through a Rather Brief Moment in Time: The Situationist International 1957–1972*, ed. Elisabeth Sussman (Cambridge MA: MIT Press, 1989), 144.

5. John Hurrell, artist statement for his exhibition at Photospace, Canberra, 1993.

6. John Hurrell, in conversation with the author, October 1994.

7. Guy Debord, 'Two Accounts of the Dérive', in *On the Passage of a Few People through a Rather Brief Moment in Time*, 138.

8. Andrew Bogle discussing Hurrell's early 'dice' paintings as well as his first map painting. 'Chance in Art: The Indeterminacy Aesthetic, Part 2', *Art New Zealand*, no. 22, Summer 1981–2: 53.

Fiona Pardington: A Case History: Tainted Love

Fiona Pardington: Tainted Love (Auckland: Milk Powder Press, 1994).

Exhibition-catalogue essay: Sue Crockford Gallery, Auckland, 29 March–15 April 1994.

> *No physical or moral misery, no suffering, however corrupt it may be, should frighten him who has devoted himself to a knowledge of man and the sacred ministry of medicine; in that he is obliged to see all things, let him be permitted to say all things.*
> —Auguste Ambroise Tardieu, *Étude Médico-Légale sur les Attentats aux Moeurs*, 1857

Tainted lovers—perverts, that is—are usually the clients of doctors, not photographers. So to see such an exhibition as this makes one want to dial the emergency number immediately. But the answer is already at hand: the exhibition contains both symptom *and* cure.

This, in fact, is an exhibition of medical photography. Or, more precisely, it considers the gaze of medicine when that gaze has been diverted from its clinical path. The appropriated medical photographs and the pseudo-classificatory 'portraits' that comprise *Tainted Love* negotiate this idea in different ways. Clinical vision enters Fiona Pardington's work as a perverse implantation into an already contaminated oeuvre: a pathological meeting of science and the love of looking.

Previously we have viewed Pardington's work as referring to nineteenth-century pornography. Her photographs are seen as gender-corrected versions of fancy-framed daguerreotypes, which are daringly displayed on the photographic historian's coffee table. But, with photography's medical past in mind, we might think more of Charcot or Muybridge and the absurd project of *scientia sexualis*.

To keep the argument entertained, one could speculate that photographic pornography and medical photography began simultaneously. Reliance on the closeup would be the first piece of evidence presented. Next would be the rapid objectification of what is studied. But, from here on, the argument disintegrates: beyond the similarities of their looks, these two types of photograph participate in economies that, in normal circumstances, do not collide.

Thus Pardington introduces the clinical pervert, one for whom 'truth' and 'cure' in medicine are irrelevant. For this unsightly horror of the modern, science is nothing other than a double agent for the service of the gaze.

Tardieu's hopes for a boundless scientific vision could equally be a manifesto for visual art or literature; nothing should be left unseen, nothing should be left unsaid. However, the relationship between the avant-garde and the wider implications of clinical vision is not a question that I have heard asked directly.

It could be said, though, that medical knowledge, realised primarily through its devotion to Hippocratic principles, is also possessed of a scopic drive best assessed in terms of poetics.

There are several ways one could approach this question: What, for instance, are the aesthetics of medicine, and where do they appear in the visual arts? How do analogies of illness operate within the avant-garde, and what can be said of medicine's deployment of visual technologies such as the X-ray and the CT scan?

In the simplest sense of its tactic, *Tainted Love* scrutinises the attention that medical photography has paid the body.

The medical photograph is like the history painting of clinical perception, but, when appropriated as art, its clinical purpose is betrayed. Its science, alas, is forsaken for its looks.

Francis Bacon was not thinking science when he collected volumes of mouth photographs. He was thinking art, and the hyperfocalisation of the medical photograph was quite to his fancy.

Tony Fomison, like Bacon, used the pathology text to picture a vision of human suffering. A selection of Fomison's medical books, incidentally, were included by Ian Wedde in the exhibition *What Shall We Tell Them?* at Wellington City Art Gallery. Has Fomison's interest in the specimen caught up with him?

In assessing this subcategory of twentieth-century culture, we might ask: are these grisly fascinations products of a morbid and puerile avant-garde (the De Sade cookbook of modern imagemaking) or are they forensic reports for the death of idealistic movements in art?

But it is without art that medicine has maintained its own canon, perhaps the most vast and interesting collection of photography ever.

In *Tainted Love*, medical photography plays a strategic role. It draws our attention to clinical definitions of normal and pathological.

In this context, these are the judgments of nineteenth-century psychiatric discourse. Compendiums of anomaly, such as Krafft-Ebing's *Psychopathia Sexualis*, announced the medico-legal genetics of perversion in a style that wandered freely between clinical realism and anecdotal popularism. Through the pages of such books, sadists, masochists, and fetishists first appeared in language. By granting perversion a medical terminology, psychiatry named the act and set it apart.

But the works of psychiatric medicine, for all their efforts to understand and control sexual aberration, rapidly became what Foucault would call 'an entire pornography of the morbid'. Medicine's problem was: How could it describe the pathology of sex without actually becoming pornographic itself? Science tried, but there was nothing it could do to prevent

the inevitable. As perversion was catalogued, it became a lurid object of sensationalism, spreading like a disease into literature, art, and the popular imagination. In Emily Apter's words, 'this quasi-literary medical cabinet, a mixture of doctor's memoir [and] nosological observation … devolved dramatically into the fetishistic conceit of showing and telling what was in principle kept behind closed doors'.

Dramatisations of medical scenarios continue to gain in their virulence. Marc Almond, singer of the early-1980s teen hit 'Tainted Love', made tabloid headlines when he arrived at hospital with a milk-bottle-full of sperm in his stomach. One wonders, though, if his act would be more appropriately located in the *Guinness Book of Records* than in the annals of psychiatric medicine.

The exhibition, *Tainted Love*, reads like a survey of contrary sexual instinct, like quotes lifted from the pages of *Psychopathia Sexualis*. As the subjects of this psychiatric study, Pardington's models are granted interim name suppression. The medical photograph objectifies by naming the symptom and not the subject, and the exhibition avoids the name-to-act logic of the celebrity sex scandal.

The exception to the rule is Pardington's *Christopher* (1993). A name is put to the sticky mess of which Christopher is so proud. The world now knows that out there is a man who will refuse to empty himself on anything other than fine ermine. But who is this Christopher? We would all like to know!

And what about the *Pearler* (1993). Only a forensic specialist such as Paul Richer would be able to put a name to this image. In nineteenth-century France, Richer, subscribing to the principle *similia similibus curantur* (the same are cured by the same), 'collaborated with Charcot in developing an iconography of 'seized-up postures and morphological malformations in hysterics [which] played a crucial role in generating a visual lexicon of the stigmata-ridden medical body'.[1] During his ceaseless quest for anatomical truth, Richer also composed 'Notes on the Fold of the Buttocks' (1889).

In contemporary pornography, ejaculation often takes place outside of the body, a 'pearly necklace' adorning the neck. In an elaborate diversion of their sexual aims, these protagonists, *Christopher* among them, prefer to bejewel the exterior objects of their own private fetishistic pedigree. They drop their load in all corners of the house and garden. On roses, on fox fur, and heaven knows where else. Probably on tombs and in the salad as well (the sick fucks). The love biter, however, would rather attack than anoint the victim, nibbling an ornamental necklace of vampiric lust around her throat.

And then we have the obscure and unfortunate case of the *Bachelor* (1993). Appearing to be a textbook example of autoerotic suicide, it reminds one, remarkably, of the fate of the

eccentric French psychiatrist Gaëtan Gatian de Clérambault. M. de Clérambault, known to have influenced Lacan's theory of the mirror stage, was found dead in his apartment, in front of his shaving mirror.

The photographs refer, then, in their analytical tone, to the classificatory imperative of the nineteenth-century sexologist hungry for a new perve. Pardington's *Choker* (1993), for instance, might be presented in a court of law as evidence of the revival of vampirism and 'proof' that such things exist.

But, contrary to what the photographs would have us believe, there is no doubt that these acts are performed by actors. The whole setup is a sham. Our part-time perverts exist only for the moment, whether it be in front of or behind the camera.

It is pleasing that yesterday's pathology can be read as art, as a clinical genre of light entertainment. But it is disturbing to consider that what has become art can just as soon be repathologised by censorship and science.

Pathology is professionally obliged to represent the unrepresentable: death. But what the medical photograph cannot show is love, a spurious subject best left to art.

1 Emily Apter, *Feminising the Fetish: Psychoanalysis and Narrative Obsession in Turn-of-the-Century France* (Ithaca and London: Cornell University Press, 1991), 28.

Denise Kum: Toxic Taste

Art and Text, no. 52, 1995.

Situated between chinoiserie and rococo decadence, Denise Kum's art engages an anthropological dandyism; it is never what it is supposed to be. Utilising multiple tropes of display, she traffics substances into the gallery from the supermarket and the laboratory, transforming them into essays on the uncanniness of shape and form. Whether food or chemicals, we are confronted with both the delectable and the poisonous.

In this sense, her installations in New Zealand and Australia since 1991 have amounted to a flotilla of migrating materials, a cargo cult of rarefied oddities. Kum arranges alluring concoctions of smell, heat, and movement. The results transport in the same way as the glazed ducks turning perpetually in the windows of Chinese restaurants. But, whereas it is often drenched in its own materiality—literally up to its elbows in what Robert Morris described as the 'stuff' and 'slime' available to artists since minimalism—Kum's work continues to dabble in the phenomenological Play-Doh of sculpture. A sensory encyclopedia, the tactile and olfactory delicacies she offers are considerable. Lotus leaves, for instance, simmer under hot lamps; dried, salted octopuses cast out wretched odours; and gallons of soy sauce are left to develop lacy islands of turquoise mould.

There is always something tasty about what Kum lays before an audience. But hers is not an art of trifling gratification, nor even of disgust for that matter. For these sculptures made from foodstuffs cannot simply be relished as symbolic consommés of Asian culture, or as exotic spices in the seasoning of cultural translation, as some have been tempted to assume. Rather, staple truths are put through a strainer.

It cannot be denied that Kum has suffered from a certain culinary reputation—not an entirely inconvenient category in which to place a Chinese woman artist. It is therefore imperative to understand how her recent work has done much to problematise this apparent essentialism. If cultural orality as told through the figure of nutrition remains Kum's guiding principle, this must now be expanded to include the indigestible byproducts of Western society.

Kum's food sculptures can usefully be conceived as deconstructed, 'unpacked' menus. For example, *Sauce Box*, which was exhibited in *Localities of Desire* at Sydney's Museum of Contemporary Art in 1994, contains the necessary comestibles for a meal of Peking duck. The inventory of this work reads like a recipe: twenty-three kilos of lard; black-bean sauce; soy sauce; soy oil; duck marinade; dried, salted preserved duck; dried duck heads, bills, and wings.

Appearing as a decaying skyline heaped on a street vendor's cart, *Sauce Box* comprises a reversal of the vanitas tradition in Dutch still-life painting. But nothing here forestalls the

threat of decomposition achieved in vanitas painting, which attempts to trick mortality through the virtues of painterly craft. On the contrary, *Sauce Box* revels in the processes of rot and organic dissolution. The materials are left to the ravages of the open air. This erosion of form—the stinking, dripping, and corroding—points to the inevitability of decay, synonymous with the sculptural act.

Sauce Box might equally be commenting on the museological appetite (as stated in the *Localities* exhibition brochure) to 'seek out' and present 'cultural difference'. But, since its ingredients are piled up on hospital trolleys, a pathological hue is cast over Kum's offering. Food enters the scene only to exceed its use-by date; the museum must swallow the bitter pill of potlatch.

Where formlessness becomes too acute, however, Kum resorts to welcome symmetry. For, without these protective glass cabinets, whose pristine geometry belies the disorder sealed safely inside, the aesthetic regime would be defiled. Not only would the content spread to pollute the atmosphere, as in the untraceable journeys of germs or pollen grains, it would cease to be an object of critical reflection as well. In reverse, asserting order requires a new form of vision. Approximating the pixellated depthlessness of a TV screen, Kum's glassed-in, three-dimensional fare shines engagingly through its hermetic veils, like a parody of the contract of museum display. Works such as *Lube* (1994) conjure this spectacle of containment on a grand scale. Exhibited in the Museum of New Zealand's show *Art Now*, a survey of recent 3-D–based art, *Lube*'s swirling, crystalline movement is mesmerising. It has all the charm of a biopsy translated into a disco light show.

Lube rebuts the old saying 'oil and water don't mix'. In essence, it is a fountain—a pump machine that generates enchantment through the motion of liquid. But, as if to negate its appearance, it actually sprays a cascade of toxic waste. Humorously, this sculpture utilises some of the tactics of spatial organisation employed by Rothko: the 'field' is horizontally divided, generating contrasts between light and dark; muted opacities are set off against ecstatic areas of colour. It bloats the flatness of the picture plane by total immersion of figure and ground. The artist, in fact, clambered inside the huge glass tanks, using spatulas and brushes to apply assorted dyes and petrochemical products to its surfaces.

Not oil paints but industrial oils, Kum has acquired her materials on her many visits to the product facilities at British Petroleum, Auckland. In situ in the lab, Kum works with scientists testing, weighing, and sorting candidates for future sculptural use. Frequently, their discourse on petrochemicals admits to opposing points of view. 'Texture', for one, is not particularly relevant to industry.

Often yet to appear on the market, the oils used in *Lube* and elsewhere are either still undeveloped miracle greases or tonics for promoting digestion in sheep and cattle. While these sludgy chemicals and mutagenic tracers might set off alarm bells among artists such as Hans Haacke or the French collective BP, Kum is not especially fazed by them. She prefers instead to ponder their aesthetics, their sheer absurdities. Already part of the kaleidoscope of world pollution, she turns them into new vocabularies of striation, line, mass, and impenetrable darkness.

Chromascope, another work from 1994, plays a similar tactic of pseudo-scientific industrial plagiarism. This time the product in question is petrolatum. A disarmingly versatile material, it has been used as a gynaecological lubricant; just the sort of teratogen one would want to keep as far away as possible from the reproductive organs.

Like blue toxic margarine spread onto a large glass sandwich, *Chromascope* exploits petrolatum for its adhesive and liquid properties. Melted into ripply textures using a hair dryer, the material embeds numerous wobbly glass spheres. These spheres, blown from soda-lime glass, amass into a static, gleaming bubble bath. Thoughts of chemophobia and environmental Armageddon aside, the extreme chromatic intensity of this work ushers in what can only be described as the Willy Wonka effect of contemporary sculpture.

Kum's most-recent contraptions, *Sculpi* (1995), are made of Flabbercast. A flexible polyurethane elastomer developed for cinematic prosthetics, it was used to flesh out the legs of the jogging dinosaurs in Spielberg's *Jurassic Park*. This pretend musculature shudders and bounces back just like real living tissue.

The irony that a brand-new elastomer is used to simulate prehistoric cellulite is not lost on these *Sculpi*. After all, their own anatomies are cast in rubber surgical gloves and condoms. Trussed up in white crepe bandages and perched on stainless-steel autoclave trays, they present a kind of object lesson, which applies generally to Kum's investigations into chemicals and petroleum and synthetic products; namely, that her elusive forms slide off the map of traditional cultural and industrial usage.

Discourse on the Paucity of Clinical Reality

Midwest, no. 7, 1995.

In 1924, the French psychotherapist Pierre Janet made a perplexing announcement in the midst of a critical discussion of Christian Science, a sect that he had little faith in. 'Medicine teaches the denial of hallucinations', Janet stated. 'One tells children that they must not believe in ghosts; why then believe in disease which exists still less?'[1]

And is disease real? I'm stunned by the opportunity this question offers medical heresy. Clearly, Janet is advocating the conditions under which medicine must operate—a clarity of vision, an absence of optical interference. However, in summoning the notion of *belief* in disease, he wilfully invokes the inverse possibility: *not* to believe.

This article discusses surrealism and medical photography insomuch as it proceeds from the trope of hallucination in a doctor's mind. It is an account of a world where diagnosis and prognosis have run amok, where the lesion that appears as the result of the infection is no longer a truth for which medicine can act accordingly. Taking its injunction as the possibility offered by Janet's statement, the article follows a trajectory that begins in the interior of the clinic and moves into the historical space of the avant-garde.

I

To begin this inquiry into nineteenth-century medicine and how it became pathologised in the errings of avant-garde art, I will recount a tale from the annals of surrealism. It concerns a young neuropsychiatric intern by the name of André Breton who had the gall to hallucinate whilst on duty. To be exact, he felt the impact of another's hallucination and was deeply affected by it.

This hallucination has become an oft-quoted example of the surrealist triumph over the real. Every account of surrealism in its right mind will begin with it.[2] My focus however will be its clinical context. Plainly, Breton's experience could not have occurred outside of the space of a hospital, and, as such, it was a radical blurring of the hospital's prescriptive codes.

Surrealism's origin myth was set in a ward, which, from my examination of photographic records, contained eighteen beds. There's the usual clinical furniture: potbelly stoves and wheelchairs. Three Tricolores fly patriotically above the heads of the patients and doctors, posed momentarily for a group portrait. Apart from its whitewashed institutional charm, the ward has a vaulted ceiling. I wonder if it was a temporary installation. This room and its inhabitants have resigned themselves to a duty. It is World War I and we are in the military hospital where Breton is stationed, the psychiatric centre of the Second Army in Saint-Dizier.

Business as usual. Cases of mental distress, even acute delirium. These psychic casualties of war were the kind of cases that passed through the centre. One in particular struck Breton's attention. A well-educated man, straight from the front, who had an astounding confession: the war, he said, was a complete sham. This testimony, which he elaborated in the most literary terms, did nothing but utterly convince Breton of the paucity of our own reality. This unnamed patient insisted that the gruesome hack jobs of the battlefield were nothing but skilful applications of prosthetic makeup, the shells flying overhead were only make believe, and the battlefield itself was the false counterpane of a set dresser. Upon hearing this, the soon-to-be leader of surrealism jumped back in his seat. The movement followed soon after.

Breton had a thing in common with this fabled psychiatric patient. He too would think of his war experience as *primarily theatrical* and would always refer to the hospital ward in terms of a complete psychic detachment. Medical training, which paternal law obliged him to pursue, represented nothing but an alibi pure and simple. From what he tells us of his time in the ward, Breton was blind to the actual scene of psychiatric suffering. His clinical attention was on the blear. Chin up, content, proud, and scientific, wearing the very same scientific frock coat to which Georges Bataille later refers in his essay 'Informe', André Breton's mind is not on his work. He is staring in the opposite direction.

The ward is a place of observation. The doctor is vertical and the patient is horizontal. Their engagement must follow this authoritarian axis. However, Breton's alibi—fascination—made this axis slip somewhat. Breton looks awry and conflates the imaginative protest offered by his patient with a delirium all his own. 'The ward', quipped Breton, 'was literally a poem in itself.'[3]

II

> In the same way that much photographic illustration has the aim of eliminating all description ... the tone adopted for [Nadja] models itself on that of medical observation through everything neuropsychiatric ... without embarrassing itself by finishing up with a lesser kind of style.
>
> —André Breton[4]

André Breton's hallucination had something of the epidemic about it. It spread rapidly onto the discotheque of convergences known as surrealism. With no fixed spot of focus, no pronouncement of truth to offer, and no gravity as such, the visual aberrations that were to be affected by its example became the exemplary forms of the movement.

Surrealism bestowed a kind of glory upon those moments of vision that medicine defined as pathological. The architecture of clinical knowledge, it was found, could be transposed across genres and reactivated for the pleasure of a non-medical audience, following much the same movement as Breton's poetic reading of the hospital environment. The displaced artefacts—which include Lautréamont's ubiquitous operating table, Breton and Louis Aragon's ideological storming of Jean-Martin Charcot's photographic *Iconographie Photographique de la Salpêtrière*, and Jacques-André Boiffard's hyperbolic big-toe photographs—made medical use value glisten with the perverse thrill of ulterior motive. Transformed in bouts of necrotic *flânerie*, the medical text had the power to shock and humiliate. When these incidents are isolated, a specifically surrealist dialectical quackery may be perceived.

However, to effectively illuminate surrealism's appropriation of medicine, an analogy with the visual sphere must be established. In this case, it is the terrain of the photograph. It is well known that the surrealist insult to the epistemological privacy of the medical profession was both critical and parasitic; this has been discussed extensively with regards to psychoanalysis. I am interested in extrapolating the medical camera's understanding of pathology to cast a new reflection upon the photography of surrealism.

For nineteenth-century medicine, the most perspicuous visual technology was the photograph. And, as anatomical illustration relies upon its ability to describe, the invention of photography led scientists to proclaim for it an almost mystical status. It was commonly assumed that photography had exceeded the physiological limits of the human eye, making it capable of presenting a universe of latent sights. Scientists enthused of the photograph as offering an *absolute* knowledge of the visual world, some going so far as the astronomer Janssen, who considered it 'the true retina of the scientist'.[5]

From 1856, clinical photography proliferated on the assumed redundancy of previous methods: sickness must be exposed to the new technology of the camera. The dimensions of illness, reduced to pattern, light, and shade, meant that pathology could be cogitated *as* photography. This process shifted one imagic reality into another; for disease, in the painfully pictorial forms that it manifested itself, was already an iconography of visual organisation: dermatitis/Rorscharch; decalcomania with preconceived intention. And, in analogy to the lasciviousness of the infectious cell, the photograph allowed this sickness to be mass-produced as a Platonic, non-contagious version of itself for pedagogical purposes. As such, the medical camera became a scopic butterfly net that was mated with language to form the empirical possibility of the clinical text.

The subjects of malady, collected as rigorously and meticulously as they were, became an object of prevailing aesthetic convention—a spectacle. Volumes that presented it can even

evoke the terms 'picturesque', 'sublime', and 'vista' in the gaping scope of their vision. One such example is George Henry Fox's 1886 work on dermatology, *Photographic Illustrations of Skin Diseases*, which featured the photographs of Edward Bierstadt. *Skin Diseases* takes us on a stroll through a pathological botany of skin conditions. Its author described the book as 'the first atlas in which the recent and improved photographic processes have been employed in the portrayal of the diseases of the skin'.[6] *Trichophytosis capitis*—a genus of fungi, tinea, or ringworm occurring in the region of the head—was photographically baptised on its pages as a flat scene of information. The term 'atlas' signifies that the body was regarded as a *terra incognita*. Fox's chart-to-know, see-to-believe, amounted to a grand tour of allergic blisters and volcanic boils. In this quantitative light, *Skin Diseases* was a unique identifier: the photographed dermatitis could be held up against the patient to anticipate recognition—clinical *déjà vu* could be confirmed.

Examining the surfaces of clinical photography, one finds an object without texture and a subject without subjectivity. On its best day, it would easily up the ante on the Roland Barthes of *Camera Lucida*: 'As spectator … I wanted to explore [photography] not as question (a theme) but as a wound.' As a solitary gaze, ruthlessly *pricked* by the violent effect of the image, Barthes was to conclude, from the point of view of a *punctured* subjectivity, that, 'Death is the eidos of that photograph.' The immemorial legacy of photography and death somehow collapses before the medical photograph, which, in essence, is a pictorial form designed to represent pathology. Barthes's insight—'He is dead and he is going to die.'[7]—is uncannily applicable, but before the whole oeuvre of forensics, this maxim is spun.

Medicine comes up with the opposite: I wanted to explore the wound as a photograph; a wound outside of the nostalgic screen through which Barthes reads photography. The science of the personal he instigates disarms itself of the possibility to state fact in an heuristic manner. Medicine, on the other hand, cannot conceive of anything but the professionally impersonal. To medicine, the anxiety of the sitter is unimportant and anxiety on the part of the observer is simply not considered. The disease must come first. In order to know the truth of the pathological fact, the doctor must abstract the patient. So it is not surprising that, in any attempt to coax comforting detail from the Bierstadt photograph, as Barthes may have done, we cannot see the beads of sweat dripping down his forehead or feel the quickening of the pulse as is experienced under scrutiny. The pipe and all other contextual accoutrements must be taken from Marcel.* Asked to leave his chequered chair, his social Saturday, he is wheeled down the corridor to be enveloped by a lucid void, the 'detailed blank'[8] of the documentary backdrop. This hypothetical whiteness signifies an eternal asepsis that is the stage for clinical observation. Our subject is desubjectified to become the great, lonely object of disease.

Naturally, the requirements of medical photography engender a situation which is quite unworkable; a most ridiculous cult of repression, surrealism would have thought; an impossible regime for representation to live under. Therefore, it was inevitable in the historical scheme of things that Barthes's 'spectator' and medicine's 'observer' were bound to collide and expose the unconscious of nosology's documentary genre. This was a disruptive move, because, however willingly Barthes's terminology offers itself to the medical figures of 'wound' and 'puncture', as well as to the whole lexical cast of morbidity, there is no place in traditionally conceived science for his brand of subjectivism.

III

To be sick is to have been made false, to be false, not in the sense of a false bank note or a false friend, but in the sense of a 'false fold' [i.e., wrinkle: faux pli] or a false rhyme.
—Georges Canguilhem[9]

It is interesting to note that much medical photography of the nineteenth century has been exposed as nosological fraud, but fraud if only for a paradox of intention. Clinical photographers in the firing line of accusation from later critics, not least the surrealists, created oeuvres that were also infected by their own imaginations. They did not observe the Janetian oath regarding denial. They forgot: pathology cannot be confused with photography.

For science, there cannot be a photographic pathology. Fox: 'it is desirable to have a series as uniform as possible so that changes in the pathological area are not confused with changes in the photographic treatment'.[10]

But what then is the difference between a Man Ray and an Edward Bierstadt? Who makes the sicker picture? Their similarity lies in the transposed understanding of pathogenic anatomy held by surrealist photography. In short, surrealism magnified the condition of error prohibited by Fox, prohibited and warned against by Janet. Enough to send shrieks down the shelves of a medical library, surrealist photographic production, in Rosalind Krauss's terms, dispenses with naked-eye reportage for a phantasmagoria of *effects*: overexposure, blurring, solarisation, the use of excessive shadow, rotation of the subject in the frame—all modalities of disguise, not clarity. The very thought that pathos and charm could exude from the medical photograph is the desirable margin of *error* that surrealism sought to exploit in its photographic production.

If the ward becomes a poem, its false rhyme will eventually refer back to the ward. Disease too was read by medical photography as an optical assault on form, which, like the

surrealist camera, transforms anatomy, 'redrafting the map of what we would have thought the most familiar of terrains'.[11] The transfigurative properties of disease have the capacity to etch away at surface and erode subjectivity until, in Canguilhem's sense, the realm of artifice is achieved. It is for this movement that we may regard surrealist photography as an hallucination of medicine and disease as a surrealist transformation of the real.

1. Pierre Janet, *Principles of Psychotherapy*, trans. H.M. and E.R. Guthrie (New York: Macmillan, 1924), 16. To further contextualise the relationship between Janet and the surrealists, it is significant to note that Janet coined the terms 'automatism' and 'l'amour fou' in the course of his medical practice.

2. For instance, Anna Balakian, *André Breton: Magus of Surrealism* (New York: Oxford University Press, 1971); and Hal Foster, *Compulsive Beauty* (Cambridge MA: MIT Press, 1993).

3. In this instance, Breton refers to his posting at the Val-de-Grâce military hospital in 1917. André Breton, 'Introduction to the Discourse on the Paucity of Reality', trans. Richard Seiburth and Jennifer Gordon, *October*, no. 69, Summer 1994: 140.

4. André Breton, quoted in *Atelier Man Ray: Berenice Abbot, Jacques-André Boiffard, Bill Brandt, Lee Miller* (Paris: Centre Georges Pompidou, 1982), 20.

5. Quoted in Albert Londe, *La Photographie Moderne* (Paris: Gaultier-Villars, 1888), 8.

6. George Henry Fox, *Photographic Illustrations of Skin Diseases*, second edition (New York: E.B. Treat, 1886), np.

7. Roland Barthes, *Camera Lucida* (New York: Hill and Wang, 1990), 21, 15, and 95 respectively. Barthes uses the term 'punctum' to designate a wholly subjective intensity of affect that is derived from a particular point in a photograph.

8. '… a (photographic) document was a study sheet. Its beauty *was* secondary; use *did* come first … in absolute terms we could say that it was a detailed blank.' Molly Nesbit, *Atget's Seven Albums* (New Haven and London: Yale University Press, 1992), 16.

9. Georges Canguilhem, *The Normal and the Pathological*, trans. Carolyn S. Fawsett with Robert S. Cohen (New York: Zone Books, 1991), 278.

10. George Henry Fox, *Photographic Illustrations of Skin Diseases*.

11. Rosalind Krauss, 'Corpus Delecti', *October*, no. 33, Summer 1985: 33. I mean to utilise Krauss's argument with particular reference to her description of the fundamental action of surrealist photography being an assault on and transformation of figurative form as it was established by the documentary canons of modernist photography.

* This alludes to two photos of backs of heads reproduced in Intra's original article: Edward Bierstadt's *Trichophytosis capitis,* showing a scalp bearing a lesion, and Man Ray's *Tonsure* (1921), showing a star shape shaved out of Marcel Duchamp's hair.

Ava Seymour: From Rubber with Love

Midwest, no. 10, 1996.

In the tradition of exquisitely mannered pictures that combine a profound moral vision with a ruthless mastery of technique—pictures that shake up the populace and inspire the aesthete to break into song—comes Ava Seymour's new series of collages, *Rubber Love*. Seymour's complicated allegories are humanistic in their deep concern for social justice and the balance of power, scrupulous in their articulation of the domestic realm, and are as downright beautiful as a voluptuous nurse with a loose key to the medicine cabinet. All this and strenuously polite to boot.

Made in New York and Auckland between 1994 and 1996, *Rubber Love* offers us a rare opportunity to sit down and contemplate contemporary society—its ills, its woes—from the point of view of a dapper statesman tut-tutting over his evening newspaper. Such a dapper gentleman we find in *Christmas Suit* (1995), a fellow who can scarcely see out from behind an extraordinary eighteen-piece latex garment, doubtless custom made by some suburban Madame X or other to his specifications. From his point of view, of course, the war in the Gulf is nothing but a faint murmur from the television down the hall, and the next Documenta couldn't be more of a distant concern—not that our friend is ignorant of what it means to be a prisoner of war, of art, or even of love, for that matter. Patriotically trussed-up in an army-surplus gas mask, he stands to attention when ordered to, and he knows a good painting when he sees one. One would miss the point entirely to say that he isn't, in some way, intrinsically involved in all of these affairs of art and state. Indeed, men like these, and their wives, have a lot to say, about the lack of manners in contemporary society for instance, or the vulgar reductive principles of certain modernist architects, and the scandalous events that occur on the streets outside their houses. Outside their houses!

There's a knock on the door. It opens. A hushed discussion takes place … 'Do you take all major credit cards?' An affirmative response naturally, because anything is possible, everything is purchasable. Upon first glance at Seymour's *Rubber Tea Party* (1994), one is tempted to recognise the guests as young, bad mannered, and as queer as fuck. But unless I'm seeing things, the subjects of this and Seymour's other works seem to be well past child-rearing age, either straight or abstinent, and exceedingly humble and generous; cases in point being the *Rubber Butler* and the *Rubber Nun* (both 1995). These men and women celebrate their special occasion with a spoilt little pedigree called something like Fluffy. They hug, shake hands, and bake cookies. Never ejaculate. At least these are the people who I'm assuming that we see here: blue-collared weekend rubberists whose amateur and risqué

home snaps appear in the mail-in sections of European fetish magazines, side by side with advertisements donated by those Mercedes Benz owners who control 'the industry'.

Yes, these are those mail-order latexologists alright. Only the satirical muscle of Seymour's scalpel has annexed them from their cheesy trailer homes and thrown them into the aristocratic dungeons of the *Vogues* and *House and Gardens* of the 1960s in a spirited reversal of fortune, which might also be considered a fairly blunt attack on what's sheepishly known as 'class'. Imagine coming home after work and finding the Latex Secret Police sitting in your favourite armchair, sipping on your expensive sherry; patting your poodle, for God's sake!

Collaged surgeries upon class, gender, and sexuality are, of course, synonymous with the practice of the historical avant-garde. But it would also be fair to admit that, during the intervening period, collage has also become a staple of the kindergarten art class and business as usual for the advertising industry. School children are invited to reinvent the world from its printed refuse as an identity-affirming exercise, while artists often take for granted that collage, appropriation, and related practices are identity-questioning, critical methodologies. In the meantime, jeans manufacturers present elaborate campaigns that take fragmentation to new heights. Suffice it to say, the potential meanings of collage as a practice have been scrambled since its invention in the modern period.

The Weimar-period collagist and painter Hannah Höch, another artist who delighted in splicing pieces of ladies and pieces of gentlemen together, once had a girlfriend by the name of Til Brugman. In 1934, Brugman wrote a short story about the indifference that is generated when sex is transformed into a matter of public concern and understood as a therapeutic exercise, a piece that could almost be read as a fable of recent art history. Her story 'Department Store of Love' was a thinly veiled parody of Magnus Hirschfeld's Berlin Institute of Sexuality, a veritable counselling supermarket and free-for-all for people of 'all' sexual persuasions. According to Brugman's queer wit, Hirschfeld's institutional gesture towards sexual freedom produced so many apprenticed deviants that the military and the legal authorities were left with no option but to shut it down in the interests of preserving the status quo.

While Seymour's pictures may be categorically deviant in some respects, the virtual lounge rooms and bathrooms of *Rubber Love* differ in attitude from identity-politics-based work, that of Catherine Opie or Robert Mapplethorpe for example. They do not identify a subject, which in turn means that they do not force us through that terrible ordeal of 'examining our own sexuality', one of the most truly horrid conceits of the whole 'pornography debate'. Collage, the way Seymour practises it, cannot 'out' people as there

are no 'people' involved. Her works can only be understood as a satirical exposé of an elaborately fictitious underground. The collaged artifice of Seymour's pictures happily evades the wave of publicly accountable sex and sexuality that has left a trail of pictorial burnout, accompanied by uneasy accusations of exploitation directed at the museum, the media, and the artists themselves. *Rubber Love*, a facetious take on family values, retreats back into the home, where certain practices can be conducted with a maximum of discretion.

Rubber Love positively makes fun of empiricist sexology as well as the hardcore notion that explicit sex is socially redemptive. It visions the fate of De Sade in the age of computer games, an era where the dungeon is part of every teenage boy's play space, and takes Sacher-Masoch to the post-comicbook era, where 'role playing' has been masochistically reduced to the role of the dice in deciding who is doing the dishes tonight. What we see here is an act of sexuality—that of the rubber fetishist—that I simply lack the technical parlance to describe. But, in the end, what is truly extraordinary about these pictures is how the sheer force of pattern and decoration absorbs and annuls the otherwise transgressive potential of the imagery. What 'hurts' is the ornamental excess of the design scheme. It castigates with the impression that somebody has much too much time on their hands, enough idle moments at least to mix'n'match Louis XIV dressers with 1960s vanity units, ending up, as we do, with venues such as the one in *Orange Bathroom* (1995).

Ornament is a crime, and these works truly make the punishment fit the crime. If Adolf Loos developed his thesis for the elimination of unnecessary detail in order to spare the cleaner those extra hours of vanity polishing, thus making for a fairer economy, then Seymour's subjects—who wash, sit patiently, pose silently, bow, hug, and adore each other, allowing for the occasional burst of energy that the whip requires—call for a return to a truly useless, private, idle, and decorative sexuality. Their bodies and their homes are covered with suffocating surfaces of latex, wallpaper, and shag pile. But the protagonists within these florid cells seem as happy and relaxed as guests at a Tupperware party, as socialised and normalised as *The Brady Bunch*. They share an overwhelming sense of community, and, dare I say it, a terribly down-home sense of love.

Derrick Cherrie: Basic Instinct

Monica, April 1996.

Exhibition review: *Derrick Cherrie: Game Load*, Auckland Art Gallery, 12 February–24 March 1996.

Wystan Curnow believes—he says so in *Artforum*—that Derrick Cherrie, along with Ruth Watson, Julian Dashper, et al., is one of New Zealand's most 'incisive' artists. Well, 'sharp', 'clear', and 'effective' (OED)—and, may I add, 'irrepressible'—Cherrie is at it again with *Game Load*, a project for the Auckland Art Gallery's New Gallery.

Game Load is one hulking piece of work. Comprising its incisive regimen is everything one has come to expect from latter-day installation art: video monitors; soft sculpture; sound; wire fencing; gaffer tape on the floor; accoutrements of domestic utility, which are actually undercover sadomasochistic agents (such as the ever-sinister bath plug or the chrome handle with fascistic aspirations); etc. And like many other Fort Knox–style emplacements, which spend a considerable portion of their budgets on hurricane fencing—Christopher Wool's or Cady Noland's come to mind instantly—*Game Load* offers, in a vaguely sinister way, an orientation course of the intellectual variety, claiming influences such as the children's playground, the prison, the cage, or the benign pastel decor of the high-security psychiatric hospital.

Following these 'architectural' influences and his other announced investigations—sexuality, the body, Matthew Barney, etc.—Cherrie constructs a 'play environment' where artistic fancy brushes up against 'repressed' fantasy. 'Repression exists', *Game Load* insists, 'or there would be no need for such an elaborate protest against it.' The work glows with the internal promise of amateur psychoanalysis (libidinal freeloading) combined with a disturbing recent interest in sport. And with the audacity of a smiling Alcatraz tour guide, *Game Load* whisks us through such atrocities from above. Worse, the installation assumes that it can speak to the terrified subject, caught in the midst of this Armageddon of security lights and padlocks, with a cheerful therapeutic message; that the artist, through his macho wielding of simulated catharsis, may offer some relief to our poor incarcerated psyches, which have been so kept since their pre-Oedipal debuts in that originary haunted house, the cot.

'The individual is powerless to affect the impact of the social structure on their life and their psyche', the New Gallery didactic informs us. This is another way of saying that the '*adult* interests' (my emphasis) played out in Cherrie's environment terrify ordinary citizens on the Symbolic level. To alleviate disquiet in the grand manner of sport-as-recreation, all the veils of repression are lifted.

Fronting this cause with a particularly nasty prominence are the installation's two videos, which feature a lone male—whom we assume to be Cherrie himself—performing two 'acts'. Act A involves the artist taping cigarettes onto his fingers and then lighting them—an unextraordinary manoeuvre, which is compelling nonetheless. Act B has Cherrie, or, more precisely, Cherrie's bare bottom, grinning in front of the camera as the artist sensibly begins to attach—again with tape—a baseball to his anal region. We're unsure of our ability to actually interpret this action, but the ball seems to serve the same practical function as a cork in a dyke; a rudimentary butt plug of Mapplethorpean proportions (even though it is not actually inserted and is content to simply bob around the cheeks). The audience, all the time politely transfixed by this action, will gradually notice the graceful wielding of a baseball bat in the corner of the frame, offering accompanying readings of sodomy and death by bludgeoning. Unfortunately, neither of these possibilities are acted upon, but, when one has had enough TV, one is encouraged to penetrate the centre of the installation to witness the lion in the cage—that very baseball bat as it sits, freed from video captivity, growling at the viewer with an American accent.

Perversity—and I use this word with an exceptional sarcasm—is one of Cherrie's great themes. But I have never been convinced that there is anything untoward, let alone distasteful, about his sculpture. Indeed, his is a model of rectitude and simulation—which is why critics have considered Cherrie such a 'good example' of postmodernism. Sure, the artist has offered us testicle stretchers, restraining devices of various sorts, impotent conjugal beds, etc., but it seems to me that, the more he attempts to multiply his trope of choice, the more neutered and normalised his aspirations are revealed to be. Cherrie treats the readymade cast of perversity like a sex shop, a place where one can receive instant but strikingly facile satisfaction. The result of this, of course, is that his art exhibits an academic perversity, if such a thing can be construed. Subsequently, his sex drifts about dully in an abstract environment of stridently dysfunctional puns that offer neither arousal nor point of view. This, undoubtedly, is the most fascinating condition that can be gleaned from Cherrie's enterprise—that he has imprisoned perversion to the extent that he has. Cherrie *quotes* perversity rather than practises it (in either sculptural or clinical terms), a tactic in radical opposition to an artist such as Robert Gober, who uses the emancipatory power of the perverse to augment the cause of gay politics, resulting in what, brilliantly, amounts to a queer reading of ceiling, floor, bathtub, whatever. Gober's art comes up with sculptural solutions that may be categorised as deviant, if one is earnest enough to read them against modernism's straighter orientations. Cherrie has no such demonstrative agenda, but, echoing the innovative solutions of others, he can only produce a grotesque profusion of sex toys.

While Milan Mrkusich's *Journey* paintings in the next gallery are sensationally interactive, in the best sense of that word, Cherrie's perversity, like his other favoured penchant—games—is a rented strategy that offers only a hermetic meanness. It is not the artist's fault that the insanely prominent 'Do Not Touch' signs themselves are as conceptually subtle as his hurricane, but, added by gallery officials, they are a grimly appropriate metacommentary on the resigned inactivity of the whole affair. For 'Do Not Touch' is also the installation's *modus operandi*, and it is a very frigid motto for such an overtly physical piece of work.

However, Cherrie needn't be reproached with the 'doing it' versus 'not doing it' argument, which in itself is one of the more ghastly conceits of sexual politics. Actually, we didn't care at all that the steps of Dalí's *The Lugubrious Game* were no such place, just as no one labours under the assumption that there *is* a gymnasium where one can go for a *Game Load* workout to destress after a hard week. The kind of ethnographic bravado that boasts authenticity above all is easily deflated, for where the body has been is not in the least bit as fascinating as where the mind can go. The whole work has the feeling of a trade-fair éxpose, where one stands struck dumb with awe in front of the new Kubota tractor. Where's the key? Sorry Sir, it's only a display model.

As I said, sport's evil, but it's especially ridiculous when somebody who has obviously never stepped into the ring themselves tries to untangle its elaborate sublimations. However, *Game Load* persists with its 'sporting cure' for grownups, who can have a good giggle at what art has become, get up-to-date on architecture and the body, and learn something about transgression (sic) and how there is more to American baseball than meets the eye (nudge, nudge). And when this ride is completed, they can be further entertained by what amounts to the biggest 'adult fantasy' of them all—that contemporary art exists.

TWA 800: A Dada Manifesto

Monica, October–November 1996.

In television footage of the crash, pieces of aeroplane bob on the green meniscus of the sea, forming a random-pattern aesthetic that glistens on an awesome scale; an unknown language that drifts, basking in the gaze of world-wide broadcast. The TWA 800 crash collides the sciences of aerodynamics, terrorism, and broadcast. Everything is blown into pieces—but what beautiful pieces they are.

In the service of scapegoating and hard news, the wreckage fell to the various agencies of decryption: laboratories, air-transport authorities, the US Navy, and the FBI were speedily deployed to transform this nonsensical mass into the kind of information required by families of victims and the public at large.

The pieces of the once-whole TWA 800 achieved the magical stasis of potential evidence. This material is uncannily suspended as a relic, becoming collective property that the arcane sciences of the FBI ration out to the media, which in turn rations out its morsels with great care. When something is 'held as evidence', it is trapped by specular, forensic powers, which will make the most of what they temporarily possess.

There's nothing left of the TWA 800 flight but dada. It is the decryption agencies' task to turn dada into a government report. The most significant line is the issue of blame, and now that the world has geared itself up to hear the 'terrorist' theory confirmed, the crash retreats from the headlines with its 'tale' between its legs. An embarrassing pause in coverage indicates that the someone writing the crash monograph has lost the plot.

But how can anyone apportion responsibility for an explosion? Explosions are not responsible things. The FBI are nervous that a 'motive' has not been identified. The death of 230 people is somehow absolved in the light of politics: 'Hey, that's war. We understand war.'

The West copes best when there is somebody to blame. But perhaps the West itself is to blame. Even if it wasn't terrorism, the downing of TWA 800 represents a breaking point of our faith in technology; a protest against the strain exerted on 747s that work too hard and are patently quite stressed. One could expand the definition of terrorism to include the margin of error airlines face as part of their programme; chance itself is terroristic. All the optimism and fright of travel is canned into the short spaces and tight schedules of the intercontinental jet. We sit comfortably belted in our seats, covering great distances at high speeds, protected from air pressure and freezing temperatures. Obviously there are risks.

But let's not forget which nations were involved. The event would never have elicited as much 'international' hysteria if it were not for Paris/New York. Ideas such as 'Paris'

and 'New York' increase the quality of disturbance in terms of ripple and effect. This was no Uruguay-to-Capetown. So let's place the blame for the TWA 800 disaster at the feet of the historical and commercial impulses that spectacularise and fetishise tourism and the significance of one particular zone of the earth above another. The idea of world centres is the real culprit and should be put on trial.

One answer to terrorism would be the old dada trick: to destroy, by whatever means necessary, art, architecture, history, and every other symbol of national identity and pride. One should also flatten snowy mountains and pollute beaches, so everywhere in the world becomes a nondescript backwater, thus forfeiting terrorist desire. Who would bomb a shearing shed or a sewage pond?

Another answer: make everywhere the centre of the world. There would be no 'best place' to bomb, as the 'developed' countries would have put billions into obscure, poor nations in order to divert the terrorist's interest. Explosions are site specific, so why not carefully conceal the whole idea of site?

The bomb is merely a motif. Any sucker can make a phone call that will cause the evacuation of hundreds of people. The terrorist bomb creates a new opportunity for the Pacific Bell user to be taken seriously, thus it expands civil liberties. Bombs are broadcast media. The way things explode is analogous to the way television is transmitted, and vice versa. If you are prepared to bomb something, then your message is likely to be on TV within hours. It could be argued that the terrorist bomb, especially in recent weeks, has become a television genre.

Take the pipe bomb. The ordinary citizen can walk into a hardware store and purchase the ingredients necessary to kill a person, disrupt the Olympic Games, and get on television the world over. It has taken years and billions for NBC to get that far. It was just as easy for Marcel Duchamp, who bought *In Advance of the Broken Arm* from his local hardware store, and even easier for the person who left a suspicious parcel on an American Airlines flight recently, causing the plane to return to LAX. The parcel turned out to be tins of cat food. If the avant-garde is dead, how do we explain terrorism and the ingenuousness of this instinct for broadcast?

Ann Shelton: Drive-By Shootings

Pavement, no. 10, 1996.

Book preview: Ann Shelton, *Redeye* (Auckland: Rim Books, 1997).

In the world today, the most interesting photography has betrayed theory and converted to social life. Which is why Ann Shelton's flash-lit wake-up calls, soon to be published as the book *Redeye*, illuminate an incandescent new age of Auckland social existence and propagandise its ripe credibility.

Shelton's new book is part fashion, part accident, and part sheer embarrassment. Her idiosyncratic version of the photographic portrait hones in on the people of a nonsensical culture of 'experimentalism', an excessive yet mannered avant-garde of gender bending, faux glam, and self mutilation that chokes on foundation whilst desperately trying to swallow art theory.

Redeye downloads sixty-four images gleaned from a cast of thousands collected over the past two years. What Shelton modestly terms a 'social diary' is really a charismatic exposé of the hideous truths and self-conscious mythologies of unemployed psychopaths who frequent Verona cafe and actually believe in drag. Shelton's is an eye-in-the-pie snapshot voyeurism. In short, she's outed everyone who'd probably have preferred to remain invisible. In Shelton's drive-by shootings, we don't get the authorised 'celebs'. Instead, we get the feigned theatre of cruelty paraded at the Hell for Leather parties and the André Breton lookalike competitions regularly held at Teststrip gallery on Karangahape Road.

Of course, it all amounts to the same thing: that glamour is a regime perpetrated by photography. And it's only glamour that sustains those tenured aesthetes of sadism. It's almost as though Shelton has realised that we need photography as much as we need drugs and alcohol.

Up until recently, the term 'documentary photography' has been uttered in critical anguish. Shelton's work, perhaps more by circumstance than by choice, makes us rethink this unnecessary cultural cringe. Shelton insists on a premise at the very heart of photography: people are good to look at. What's more, she provides us with work that entertains and titillates as much as scandalises.

Shelton poses new meaning for the words 'celebrity' and 'beauty'. Her dark, brittle, transitory accounts of Auckland are undoubtedly beautiful. They envision a population that we know is condemned to obscurity, not to mention old age, premature death, and a whole host of other attendant mediocrities. But, in the meantime, there's the instant space of now.

Documentary photography should be reminded of the superficial thrill of 'now', beyond the interstices of politics and event, and it is the obscene, shifting beauty of the present that is captured by Shelton's pictures. She perceives the alluring marketability of the raw moment and the bizarre familiarity of the stranger. In *Redeye*, the idea of the celebrity meets the idea of the nobody. Character explodes into art. Rather than make you remember and feel concern, Shelton's photography makes you forget you cared in the first place. Instead, simply enjoy the densely blinding results of the optical and social pleasures that she has put before us.

Charles Gaines

Art and Text, no. 59, 1997.

Exhibition review: Richard Heller Gallery, Los Angeles, 3–31 May 1997.

Just as there is a war against drugs, there is a war against airplane disasters. But who or what can be blamed for a plane blowing up? As opposed to the street-crime 'epidemic' ravaging what are mainly lower-class American neighbourhoods, the air crash, as a highly publicised new-something-to-worry-about, flourishes only in the minds of those who can afford to separate themselves from the earth. Often, as the latest information on the TWA Flight 800 crash suggests, there is literally no one to accuse. Malfunction or obsolescence, as opposed to sabotage, are not so much matters for a police force to deal with (ever tried pistol-whipping a faulty fuel tank?) as a task for the engineers of chance, statisticians, those generally anonymous Merlin types who reassure the public with remarkable formulas, such as 'there is a one-in-130,000 chance that your plane will go down'.

Figures such as these may quell a constant state of panic amongst air travellers, but they're also a deeply ridiculous challenge to indeterminacy, because accidents—which, by definition, are unforeseen—remain accidents. Not so for Charles Gaines, who, in his installation *Missing Figures and Disaster Machines: Airplane Crash Clock* at Richard Heller Gallery, plays up the inevitability of misadventure by suggesting that technological ill fate is something that happens by the clock.

With demented Legoland enthusiasm, Gaines has constructed a five-foot-wide, thirteen-foot-long scale model of a fictitious city (which most closely resembles New York), and, with the use of concealed mechanical devices, programmed a model airplane flying overhead on an aluminium pole to plummet into the city's heart and disappear under its streets—only to resurrect itself at regular intervals. These crashes are controlled by an institution-style timepiece on the work's facade: every 7.5 minutes, Gaines's jet, like Tinguely's auto-destructive sculpture, completes its grim little sermon for the benefit of the audience. The whole piece has the pedagogical rhythm of an industrial test, but it is also a gigantic piece of kitsch, like an oversized Elvis telephone or a pathological cuckoo clock.

Gaines's 'disaster machine' is built mostly of wood. It is possessed of a meticulous but crafty charm, a strange effect distancing it somewhat from the inorganic campiness of Andy Warhol's car-crash paintings, for example. For Warhol, disaster, not unlike glamour, is pervasive—so what? For Gaines, disaster is an orchestrated kinetic display that can transfix the eye.

But what is the artist's stake in the matter? It is tempting to assume that Gaines's intentions cover their tracks. He could be presenting a critique of the spectacles of misfortune, capitalising on an aesthetic of the morbid, or even inventing a sarcastic device to debunk the homogeneity of statistical thought—all of which are predictable-enough intellectual strategies. In the end, though, there's no evidence to disprove that this isn't a knee-bendingly sincere piece of social-concern art—a sort of monument in the manner of Maya Lin's *Vietnam Veterans Memorial* with a bit of *Con Air* thrown in. Charles Gaines isn't a terrorist. He's only paranoid because he cares.

Chris Kraus: A Fusion of Gossip and Theory

Artnet.com, 1997.

Book review: Chris Kraus, *I Love Dick* (Los Angeles: Semiotext(e), 1997).

Chris Kraus's first novel, *I Love Dick*, reads like *Madame Bovary* as if Emma had written it. Kraus spins out the Emma syndrome of dissatisfied feminine boredom through a chronicle of the 1980s art world. Her book is a damningly intelligent form of 'confessional' literature, part love letter and part public document.

Kraus, a Los Angeles–based filmmaker and author, is known for her underground films, including the 1987 pseudo-documentary *How to Shoot a Crime* and the 1996 feature *Gravity and Grace*. Kraus has also edited a series of books for Semiotext(e), which has published writers such as Kathy Acker and Lynne Tillman.

I Love Dick is composed of the *billets doux* written by Kraus and husband, Columbia philosopher Sylvère Lotringer, to their special friend, Dick. As a kind of artworld *roman à clef*, the novel fuses gossip and 'theory'. The profanely and lustfully personal coalesces with intellectual ambition and conceit. Kraus's novel—written in the first person, as any good diary is—reads at times as strategically and dispassionately reductive, not unlike the works of Joseph Kosuth, who the author lampoons in one chapter as perhaps the exemplary white male of his generation. *I Love Dick* is also a genuinely dangerous book. You feel acute pleasure at the misfortune of others when you read it. And you are very pleased at the luxurious distance that is afforded the reader.

Chris Kraus's observations and arguments about art, life, love, and politics are read through her own experiences, as well as the lives of other 'cultural producers', many of whom could well feel a little nervous about becoming subjects of this author's hardcore revelations. Many of Kraus's insights are raw, embarrassing, and virtually obscene. Indeed, the novel's alleged subject has been recently revealed by *New York* magazine to be the cultural critic Dick Hebdige, with whom Kraus falls in love and subjects to a harassing love-letter campaign for months on end.

Kraus has certainly invaded privacy—particularly her own. What she has pillaged from the padded cell of 'the personal' is transformed into an exceptional literature by virtue of the author's erudition and consciousness of literary form. Kraus's spectacularly exploitative project is rich in thought and style, not to mention scandal.

Giovanni Intra: Your book is called I Love Dick. *Could you tell us about this . . . Dick?*

Chris Kraus: Well, you know, this Dick is real. He is a real person. And I really fell in love with him. I didn't set out to write a book. And I wanted him to love me too, so I started writing letters. 200 of them. And then he didn't answer. And correspondence is entirely compulsive; the addressee is a blank screen. And I wanted to tell him everything. And once I started talking, I couldn't stop.

Yes, but who is this . . .

Dick? Dick is every Dick, Dick is Uber Dick, Dick is a transitional object.

So Dick was the alibi for the novel, kind of waiting in the wings?

Dick is an important cultural critic.

Love commanded you to write?

Oh, Giovanni . . . 'Love has led me to a point where I now live badly 'cause I'm dying of desire. I therefore can't feel sorry for myself.' (Anonymous, fourteenth-century French Provençal). Because, when you fall in love with someone, the greatest rush is that you can be so many more sides of yourself with them than with anyone else in the world. That person makes it possible to most fully be yourself. And then, of course, there was the element of failure. I was thirty-nine years old, I'd been married to someone else who was famous in the art world, I'd been working as a filmmaker and editor for fifteen years, I'd just finished writing and directing a feature, yet no one took me seriously. I was a corporate wife of the avant-garde. So, when I felt this—romance—happening, I decided to take advantage of it. I decided to become a lab rat in my own experiment. There'd been so many Dicks in my life prior to [my husband] Sylvère [Lotringer]—mean horse-faced junkie cowboys.

Mean horse-faced junkie cowboys?

Yeah. The mystique of simplicity and silence. And this had really fucked me up, just like a lot of other women, so I figured, if I'm going to do it now, I'd better study it. Revisit it at the third remove. It was very Kierkegaard.

When did the love letters change into a novel? You started writing, it became more compulsive, and then it must have clicked into a book project. You started to address an audience . . .

Well, I realised that I had a problem. And my problem was, as an artist, I had not been heard. And I didn't want to believe that the problem was my fault. I thought it was cultural. You know, like Deleuze says, life is not personal. Because, if success is culturally determined, then so is failure. And it seemed to me that a lot of women who were working in a vein similar to mine had also experienced this 'failure'. So, what drove me on was trying to figure out why there was no position in the culture for female outsiders. You know, singular men are geniuses. Singular women are just 'quirky'. Of course, I really have Dick to thank for this, because he gave me someone to write to.

There's a literary fashion now for confessional literature. On the one hand, your book is confessional; on the other, it's a book about the intellectual context of America in the past twenty-five years. What's the difference?

Well, I want to say there isn't any. And that's why this book is a strategic confession. I'm very drawn to the use of the first person. When I started the Native Agents series of books for Semiotext(e) seven years ago, it was to publish the kind of writing that I liked— and that writing was entirely in the first person. And yet, it was not an introspective, psychoanalytic 'I'. It was an 'I' that was totally alive, because it was shifting. There's a tradition of American poetry that champions and celebrates this—the New York School, the Poetry Project and all its successors. These people are true geniuses because they're living constantly with ideas. They're fluent in a huge literary tradition, and yet they're often denigrated by academe and the institutionalised avant-garde because these ideas are experienced immediately and personally.

So, you think, like the 1970s feminists thought, that the personal is political?

The personal pursued for its own sake is no good. The 'I' is only useful to the point that it gets outside itself, gets larger. In writing this, I kept looking for other people's tracks that I was writing in. No one ever does anything for the first time. I discovered that the New Zealand novelist Katherine Mansfield had been there too. She fell in love with Dick and wrote a story about it.

Most of the successful art-world figures who you describe in I Love Dick *are pretty fucked up. The whole show is revealed as being pretty dissatisfied . . .*

Yes!

So you'd have to reconsider the whole notion of privilege then, wouldn't you?

Well, once you call yourself the biggest asshole, you give yourself a lot of freedom.

So you put yourself in the abject position?

Life had put me in the abject position, so I thought I might as well take advantage of it.

So it's a kind of freedom.

If no one cares what you have to say, then you can say anything.

So, in actual fact, you were in the most privileged position.

I think so. Yeah! (laughter)

I heard a rumour that Dick was threatening to sue you for invasion of privacy.

Yes. He's changed his mind and I'm glad. But it seemed very apt and pertinent to the book. Wasn't the question of 'privacy' the entire point? Exploding this 'right of privacy' that serves patriarchy so well. The artist Hannah Wilke received an injunction on the eve of her first major retrospective from the artist Claes Oldenburg's lawyers. Hannah had lived with Claes for seven years, and one piece of hers features Polaroid snapshots of people from that period of her life. No one fought for her at that time, and she didn't win. Oldenburg managed to erase that part of her. And, I thought, the issue of privacy is to female art what obscenity was to male art of the 1960s. And, I thought, on this small scale, I have to win.

I Live in Hollywood

Log Illustrated, no. 1, Winter 1997.

These texts accompanied four street-view photos of Los Angeles.

I live in Hollywood. And then I don't. I would rather not go there (home). I stay in my studio and pick my teeth and go insane. I now own a 'backpack'. That's good-enough reason for New Zealand Immigration to never let me back in the country.

•

Colonial Drug on Vermont half a block up from Hollywood Blvd. Who could ask for a better store? Your reporter swears that, behind this formidable signage, there is a gated community of Tylenol, Neoprin, and Advil, not to mention LA's best selection of sticking plasters, sunblock, and aids for the disabled. The summer is abominable—one needs painkillers regularly. Another blistering fact: Colonial Drug is an all-girl pharmacy! Your photojournalist swooned on his first of many visits to Colonial Drug upon discovering that the store was run by five immaculate white-coated Latinas, each with the same haircut, each with the same disciplinarian control over the inventory. Aside from LAX, this is the best tourist attraction the city has to offer. I am often found there in the evenings, transfixed, muttering in Spanish about leg braces and incontinence blankets. (Useful website: www.missingkids.com)

•

Sugar is the best and the most dangerous dope. Addicted to Snickers bars and Nescafé iced coffee, as I am, it is hard to resist the confectionorama of Better Drugs on Colorado Blvd., in Glendale. The temptations for self abuse are incredible, and the shit is fine. As one elderly Californian warned me on the bus: 'Watch out for those drug addicts, man. When they're jonesing, it's like their whole body's a toothache.' I know what he's talking about. I would drive my car through a brick wall to score Snickers any day.

•

This very beautiful Misty ('light'n'sassy') billboard suggests a tobacco-company-funded collaboration between King Loser and Tracey Moffatt. This particular one is in the MacArthur Park/Westlake district between Koreatown and Downtown LA, but really they're everywhere. Below the happy woman's smile, you will find x-number of Snickers heads and x-number of LAPD bullyboys and x-number of black, late-model BMWs with white guys from UCLA with bright-red and bright-green hair sucking lollipops and pacifiers who 'just happened to be driving through the area, Officer'. You see, Misty cigarettes and chewing gum fuck up people's lives and intestines.

Pimps for Chance

Monica, Summer 1997.

Conference review: *Chance: Three Days in the Desert*, Whiskey Pete's Casino, Primm NV, 8–10 November 1996.

To be trapped in a twenty-five–cent brothel in the middle of the Nevada desert might sound like no fun at all. As if to inspire repentance, the venue for *Chance*, a philosophical rave conceived and produced by Chris Kraus and sponsored by ArtCenter College of Design, Pasadena, and the French Cultural Services, was a most frightening den of iniquity, worthy of mention in the Old Testament. The word 'Disneyland', muttered anxiously by several stunned guests in a vain attempt to speak for Whiskey Pete's Casino, hardly explained the large number of myopic addicts who were busily feeding the 'loosest slots anywhere'. This real-life white trash, slumped over profoundly anti-ergonomic one-armed bandits as if they were orthopaedic devices, were arrogantly derided by many of the international conference guests, myself included, until, that is, I mistook guest star Jean Baudrillard and his wife, Marine Dupuis, for two of them. Jean, in denim jacket, and Marine, a blonde in sunglasses, were immediately recognisable as French middle-class tourists, which is, in fact, what they were. This rigged paradox was poetic and Baudrillard at Whiskey Pete's was like Johnny Cash at San Quentin: an ecstasy of song and dance presented in honour of bad luck.

So it was that disability, obesity, philosophy, and mysticism were made to dine on $4.99 buffet meals with powdered pancakes for breakfast, endlessly retracing their steps over alcohol-sodden carpets emblazoned with the face of our stubbled forefather, Whiskey Pete. But aside from providing an excuse for the number of reprehensible and illegal behaviours that this décor practically enforced, *Chance* presented the work of over fifty writers, artists, and performers, and was an occasion splintered by opinion. My own hackles were raised early in the piece by Marcella Greening's tediously pedagogical lecture about chaosophy, a subject which was later redeemed from math-lesson status by Wall Street stockbroker Douglas Hepworth's account of economic theory, financial collapse, madness, crowds, and the Dutch tulip trade. Hepworth's entertaining paper made out bankers to be cheats and investors to be vulgar gamblers; all the funnier as he was their sole representative.

There was a humanist/mystical crowd present, who, not only being inclined towards divination (and narrative repetitions of the past), took the conference for a holistic site where a lot of people 'come together' (something like a healing community). Notable cosmics were Shepard Powell, a practitioner of the I Ching, and Diane di Prima, the great beat-generation poet and prose writer, who unfortunately did little else than read from her

earlier books and suggest in discussion that perhaps there was something anti-humanistic about theory in general and about Baudrillard in particular.

Morphing the produce of capitalist greed and autobiographical anecdote was Allucquére Roseanne (Sandy) Stone, the ex-male song-and-dance act. What Stone didn't get by plonking herself on Baudrillard's lap in front of 400 people and serenading him with her adaptation of Cole Porter, 'I Get a Kick from Jean B', was that academe was a theatrical medium in the first place. Stone's primary investigations—identity and gender in the age of virtual reality—are obviously compelling, but anyone who gives an audience plastic hooters and requires them to hoot upon command can do nothing but accept their title as the Richard Simmons of postmodernism. In retrospect, the cringe epidemic Stone engendered was rather interesting and her two most ludicrous claims—'we are all children of Baudrillard' and 'theory is God'—will not be forgotten for some time.

Paul Miller, a.k.a. DJ Spooky, had the right answer to this deification of the word. His theorisation of God: total noise. If God can simply be thought of as Eurotrash, then Spooky's black noise committed a Baudrillardian act of reversal upon the audience: it was philosophy without words, a paradox that Baudrillard himself couldn't accomplish. I still do not know exactly why Spooky's mixing was so amazing, but its matter-of-factness and uncanny intelligence connoted a blasphemous indifference to the rising theological babble of anti-élitism. It produced meaning completely by surprise.

Spooky, the mixing artist who produces new noises, and Towel, a guitar band from San Francisco, performed tandem roles. Towel, terrorist aesthetes who belt out their shit wearing balaclavas and ski masks, were happily incomprehensible, as, for that matter, was Baudrillard's own paper, a fact that connected his theory much more closely to these canons of insensible obfuscating noise, as opposed to the democratic elucidations one usually gets served up at a 'conference'. What Towel, Spooky, and Baudrillard produced collectively was a condition of bewilderment-as-entertainment, a noise, which may have suggested to some the need for subsequent descrambling. These were spastic, gymnastic feats for an audience to manage; they discouraged the patronising threats of participation and interactivity, whilst refusing to succumb to the 'forces of the universe'.

Baudrillard's three presentations amounted to a baroque flurry of aphorism and abnegation. He argued that the drives for individuality, autonomy, liberation, and destiny are suicidal traps that have produced nothing but ornamental forms of self hatred. His main paper featured brilliant pronouncements on the universality of harassment ('homeopathic torture'), as well as the impossibility of subversion ('artificial adversity'), and his reading, which proceeded Oguri and Renzoku's remarkable butoh performance, understood the

Japanese discipline as a disfigurative theatre of cruelty. As Sylvère Lotringer puts it, Baudrillard likes to take punts on the future because the past and the present, let alone the medium of theory itself, are quite simply too boring. These reversals are themselves perverse and might well be tedious to maintain as a theoretical contract, however Baudrillard displayed a cinematic taste for gambling, disfiguration, and shock that rivalled Ballard: 'Isn't it our endless work, in the absence of God', he asked, 'to reconvert all accident into attraction and seduction?'

Here, Baudrillard struck the most malignant, universal, and diabolical aspect of chance: bad luck. And there was quite a lot of it discussed. Liz Larner's reading/installation (part of the art show *Hotel California*, curated by Sarah Gavlak and Pam Strugar) told the sorry tale of a casino cocktail waitress who, when her silicon breasts up and burst one evening, saw no option but to jump to her death from a hotel window. Shirley Tse, an artist from Hong Kong, spoke beautifully on the pollution and plasticisation of Asia. And chance's great sell out, as laid down by Jeremy Gilbert-Rolfe: 'Only the possibility of winning a very large amount of money [in a lottery] ameliorates an otherwise wholly determined capitalist condition.' In the final analysis, luck, chance, and their rosy derivatives were engulfed by a pessimistic tide of technological misadventure, corporeal disaster, and fractal hallucination. It would have been difficult to have thought up a more pleasing conclusion or to have asked for more interesting contributors.

The much-anticipated Chance Band, a mötley crüe consisting of members of the Red Krayola, Mike Kelley, Amy Stoll, and a gold-sequin-clad Jean Baudrillard (singing his own number, 'Motel Suicide'), made the final jump between thought and its disintegration, and if, as Baudrillard suggested, 'Stephen Hawking and his broken body constitute the ideal model for superscience', it might be concluded that randomness and white noise constitute the ideal model for future philosophy.

For Paranoid Critics

PreMillennial: Signs of the Soon Coming Storm (Sydney: Darren Knight Gallery, 1997).

Exhibition-catalogue essay: *PreMillennial: Signs of the Soon Coming Storm,* Contemporary Art Centre of South Australia, Adelaide, June 1997; Australian Centre for Contemporary Art, Melbourne, 11 July–17 August 1997; Darren Knight Gallery, 27 September–25 October 1997; Dunedin Public Art Gallery, 31 January–19 April 1998; McDougall Art Annex, Christchurch, 27 April–31 May 1998; City Gallery Wellington, 17 October–13 December 1998; Auckland Art Gallery, 27 February–16 May 1999.

> *This book is a fascinating account of a unique patient population: struggling young artists who have come to the artistic center of America but, at some point, feel defeated by the overwhelming competitiveness of the subculture. Gerald Alper, a psychotherapist specializing in this heretofore unstudied group, draws upon his own artistic background to form an empathetic bond with these troubled, talented individuals. He provides unusual insight into the relationship of the artist to his own creativity, his teacher, his imagined public, and his therapist.*
>
> —Gerald Alper MS, *Portrait of the Artist as a Young Patient: Psychodynamic Studies of the Creative Personality*, dust-jacket blurb[1]

Conceptualism—roll that word around in your mouth as if it were a piece of chewing gum, then spit it out upon the pavement. Do the same with the words *appropriation* and *postmodernism*, and feel the pleasure you take from doing this. Before you, on the concrete, there are three—perhaps more—pink, masticated blobs, sunken caricatures of what you most hated. You take a sigh of relief, perhaps spit again on the grave of your victims, and walk away.

But it's not as easy as that—is it? For you find that the sorry corpse under your feet has, in fact, taken the supernatural liberty of sticking to your foot, indeed it almost threatens to pin your shoe to the ground. No problem—chewed-over rubber is no match for *your* boot. So you prise your steel cap off the kerb, grind it in a vicious and circular movement, and contemptuously go on your way. But look! What is happening? The awful golem has now decided to take the form of an endless string to which you are now attached, puppet like. You let out a few strong and justifiably harsh curses and attempt, with all your might, to pulverise this tenacious zombie once and for all and to truly separate yourself from it—and you sincerely mean *it,* for it bears no resemblance whatsoever to any human you ever saw. You would like to progress, to get on your way, onto better, less boring, and more edifying things, thank you very much.

You succeed! Your foe is vanquished. Yesterday's gum, now well behind you, will probably attach itself to the cloven hoof of some other unlucky devil. What do you care—

it's not your problem anymore! What you have left behind will never enter your thoughts again—let it be cremated by the sun or be scraped up by the cruel pick of a street cleaner. May these cast-off abstractions never be inspiration to anyone—or, if they are, to hell with them.

You stroll off—a happy spring in your gait. What could be better? It's early summer, you're in New York, you're walking to your opening. You are in the art magazines and you're in the money. Vainly, your glossy eyes turn to the skyline and then to the sky. You whisk through West Chelsea, sure that every dealer is peering curiously out their window at you—you well-dressed and distinguished sod!—and that every artist is muttering sarcastic incantations in your honour. But who the hell cares?—you're invincible.

Is your name Julian Schnabel? Jeff Koons? Rebecca Horn? Dale Frank? You are none of the above, but you're of the same league: a supremely self-confident being, one who has done so very much more than the required leg work—and doesn't everybody know it!

Blown up?—of course you are—and why not?

You're bounding away happily when something arrests your pace. It's nothing much, but it slows you down a little. Something on the pavement begs to differ with your jackboot, and, when you look down—your first glance below crotch level in some thirty-five minutes—you see an object that is very horrible indeed. Partly, this thing is horrible because it is so familiar, uncanny even—but you were not here today, yesterday, or even the day before, were you? This is not your usual route. What is it that dares to interrupt your march? Is this some native of the pavement? An adhesive dejecta from a McDonald's restaurant perhaps. No, you stupid punk. It's that little something that you thought you had quashed—it's those pellet-sized globules of gum that you had so ceremoniously jettisoned from your septic mouth. It's the whole of art history, sucker!

Your brow boils, pus streams from your ears. You quote Artaud at this thing in order to loosen its grip. OK then, Norman Mailer!

Nothing works.

Noticing the ground for the first time in your life, you observe that there are not one, not three, not five of these things—but thousands. There must be millions of pink, trodden-on schools, movements, and artists who are now glaring revengefully up at you from their unhygienic public purgatories. You can see their faces now and you know them well, because you—young God—were responsible for casting them from the canon, making insulting renditions of their profiles, forcing their bodies through that meat grinder otherwise known as 1990s irony. How great it was to hurl your spleen at those piteous wrecks who had once gotten in your way! How confident you had felt after securing that fail-safe contract with

the Dark One! But now look at you!—they've caught up with you again!—they're about to smother you!—and not with kisses but with fists, stupid.

And they have. You're on the pavement, W. 20th Street. Horizontal! No one cares. Reunited not only with your old foes but with the corrupted residues of saliva that you used as a lubricant of expulsion, crusty as they are by now. You pretend not to acknowledge your former disputes with this newly auspicious crowd. Why, you plead, would anyone despise such a nice, cult-loving, self-helping, tax-paying, movie-watching, photorealist soul as yourself; one who has sought only to expose the truth? Your pieces were not insults—they were acts of love! 'Acts of love!', you repeat. You have been misread! No answer. The forces of Good are knocking some sense into you. Eating your notebooks. Pressing their dirty fingers into your mobile telephone. Calling your editor, your gallerist (speaking in your voice, of course), and making jokes at the expense of the only two people who you bow to in the world. Suddenly, you don't have a career anymore. In the meantime, they have cancelled the lease on your Rancho Santa Fe apartment and offered your library to Whitecliffe art school, your black-clothes collection to the Salvation Army, and your unsold paintings to the Museum of Folk Art. Your trust fund has just been spent by a charity that you despise more than most charities.

One by one, each of your victims takes their revenge: Walter de Maria pelts your earlobes with one-thousand brass rods! Daniel Buren peels stripe-width strips of skin from your naked body! The Nutty Professor, played by Eddie Murphy, lowers the full weight of his body onto your right arm! Colin McCahon tattoos unspeakable passages from *Revelation* on your forehead! Lynda Benglis throws you into a vat of boiling foam rubber! And Donald Judd drops you into a steel cube and then welds it up personally! As a self-fulfilling prophecy, my friend, you are beginning to remind me of the most abused Kienholz tableau.

But art crushes everyone eventually; you always thought that. If it were not for its antagonistic spirit, art would have become boring to you long ago. It's pleasant, after all, to be crushed—crushed, that is, by your own imagination. So you might as well have your say, right? Before you go.

So you spit back your summa at the invisible but ever-present enemy in one final, neo-expressionistic rant:

- Don't believe anything Mark Van de Walle says—paranoia eats critics for breakfast.[2]
- Paranoia is a new Olympic sport, an 'extremist sport' like bungee jumping, suicide, and drug addiction, to abuse a Paul Virilio citation.[3]
- Paintings are the maggots; paranoia is the flies; artists are the rotten meat.

1. New York: Plenum Press, 1992.

2. 'A Short History of the Coming Apocalypse', in *Echoes: Contemporary Art at the Age of Endless Conclusions*, ed. Francesco Bonami (New York: Monacelli Press, 1996), 212–24.

3. A 'Dr Touzeau' cited in Paul Virilio, *The Art of the Motor*, trans. Julie Rose (Minneapolis: University of Minnesota Press, 1996), 92.

Gavin Hipkins: Photogenic

Signs of the Times: Sampling New Directions in New Zealand Art
(Wellington: City Gallery Wellington, 1997).

Exhibition-catalogue essay: *Signs of the Times: Sampling New Directions in New Zealand Art*,
City Gallery Wellington, 11 October–14 December 1997.

Although it designates an object that generates its own light source, or one that is produced or precipitated by light, the term 'photogenic' was famously used by W.H. Fox Talbot in 1839 to describe his earliest photographic experiments 'by which natural objects may be made to delineate themselves without the aid of an artist's pencil'. 158 years later, photography is a field comparable in scale to nature itself. Perhaps it's even more significant than the human species. This isn't merely to invoke the idea of technology as a second or third nature, eclipsing an original nature. It is simply to say that, like biological life, photography is now so vast that it absorbs light and proliferates on its own accord: photogenesis. In the present tense of the medium, there is virtually no object which is not photogenic.

There was once such a thing as a tourist photographer who could retrieve images of nature. Now there are only tourists within photography. There's no point anymore in being a photographer, at least in the sense of a photographer who attempts to distinguish themself by producing a certain 'type' or 'style' of photograph. That's hopeless because the more photographs there are in existence—and there are millions added every day—the less chance there is for any individual image to detach itself from the photographic mass. The specialist photographer today is like someone trying to chop down a forest of trees with a blunt axe: they'll eventually die of exhaustion.

Gavin Hipkins is someone unfortunate enough to be struck dumb by photography—not by *a* photography, but by photography itself and all of its malicious scale. Since the inception of his project, Hipkins has concurrently practised what are assumed to be antithetical subgenres of photography—documentary, pictorialist, postmodernist, even regionalist. He has done so with an occult wonder for what the medium can and has produced.

Hipkins's *The Track* (1995–7) is a multipart photographic work that resembles a slot-car or athletic track. It was inspired by his visits to the Berlin 1936 and Munich 1972 Olympic Games stadiums. Being constitutionally spectatorial, stadiums are intrinsically photographic. Catwalks, portrait studios, viewfinders, and backdrops are all akin to the stadium; the stadium being a bowl for vision to happen within, an architecturally elaborate though essentially blank field for the bizarre and pointless narcissism of sport to take place upon—so audiences can watch, from a distance of 1,000 yards, the ultrafast spasms of an athlete's muscle.

International sports competitions such as the Olympics, being completely spurious temporal diplomacies, are first and foremost exercises in political fraud and pictorial transmission—the same thing. The athletes themselves are afterthoughts to such events. Subtract the athletes and the crowds—what is left? The track and the cameras. In recent years, stadiums have been built exclusively for cameras, a fact that is demonstrated by television-broadcast sports events, which often have no one in the stands. The sex of sport is actually the copulation of the camera.

Hipkins has previously likened photography to a plague, suggesting that it is virulent and indiscriminate in its spread, possibly fatal in its inflection. Indeed, it is easier to conceive of photography creating an environmental crisis for human life than to imagine anything seriously threatening the ecosystem of photography. The photographic apparatus is definitely increasing in scale. Hipkins's *The Track* points to the fact that photography, a medium out of control, has not only the potential to make the earth into an archival document but to put its inhabitants out of commission altogether. Sooner or later, all the snapshots will join up and there will be no world left. Photography will delineate itself without photographers.

This already happened in 1977, inasmuch as the earth, a giant photo-booth, ejected the unmanned Voyager satellites into deep space carrying 116 images—100 of them photographs. This group show of the earth was offered to alien races who might intercept the satellites in the future as a kind of sampler of our civilisation. We were, in fact, sending photography into space, not civilisation—there once was a difference. 'Peoples of all creeds and colours', architecture, landscape, sunsets, crafts, arts, and sciences—for the purposes of this mission, all had been reduced to the status of photography. Luckily, photographs don't suffocate, because, if Voyager is discovered after the earth has ceased to exist (Voyager is expected to last one-billion years), that would be all that remained to tell our tale. The whole planet would have been nothing but a photo opportunity.

Pat Scull

1997.

In 1997, Giovanni Intra was commissioned to ghostwrite a fake CV and three fake reviews concerning the fictional artist Pat Scull. They were presented as part of a Danius Kesminas show, framed as a Kesminas/Scull two-person show, in a Melbourne project space. Intra wrote his reviews in the guise of known art critics (Lane Relyea, Jerry Saltz, and David Pagel), as if for actual magazines (*High Performance*, *Time Out NY*, and *Coagula*). The CV and reviews were mocked up by Michael Stevenson, another member of Slave Pianos. Intra later namechecked Scull in his 2001 Slave Pianos essay, 'Slave Artists of the Piano Cult: An Introduction'. The reviews were reproduced in Michael Stevenson's monograph, *Michael Stevenson: An Introduction* (Cologne: Walther König, 2013).

Michael Stevenson explains: 'The name Pat Scull was offered to Giovanni as a gender-neutral identity that he could fill out, and he put more than a little of his own biography into the character, including his first Hollywood residential address. It is my understanding that Pat was somehow a member of Robert and Edith Scull's extended family, and it was here that he first gained his interest in art, celebrity, and the market. For some reason I always think of Dash Snow when I think of Pat. Perhaps he was to the nineties what Dash was to the noughties.'

Pat Scull

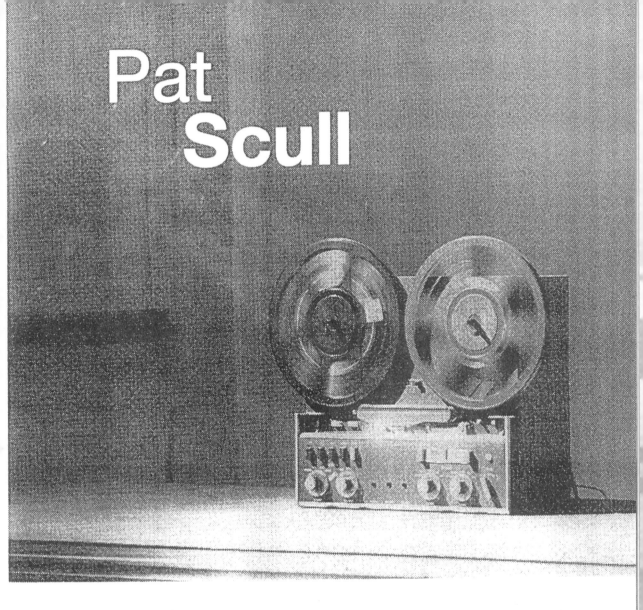

For people who are so smart they don't even watch T.V.

by Lane Relyer

Growing up in Disneyland, California (well, Anaheim), Pat Scull — a young John Lennon fan and inveterate Yoko Ono groupie long before Ono's ascension to art-rock diva status — came to art by studying pop music. While still an undergraduate fine art major at Art Center College of Design in Pasadena, CA, Scull began designing sets for rock concerts and making videos for

C30, C60, C90, Go *(detail)*

local bands; eventually he joined an all-male group called "The Next Queens."

Skull's video and sound work takes us on a curious journey, via pop (he also composes and writes his own songs), into the furthest regions of the male artistic psyche. One of his projects, *Numeric Quitodian (1996)*, is part-homage to John Lennon and part-homage to Carl Andre, and part manic self-parody. It takes its title from the opening line of Lennon's 'Happiness is a Warm Gun', with a slight modification from first to third person. In this video, a recording of Scull repeatedly singing this lyric is sped up, mimicking the quality of his own blurry, distorted image, as, bare-chested, he dances frenetically around the room. Then the music slows and Scull slides down the wall — almost disappearing from the frame — as if momentarily overcome by self-doubt before regaining control as sound and image return to their former, unnaturally accelerated level. Scull's humorous take on male angst sets the tone for his later work and allies him with singers such as P.J. Harvey and artists from Lawrence Weiner to T. Kelley Mason who have, over the past 20 years, gained recognition for their combinations of conceptual scrutiny and popular wit.

When I look at Scull's installations closely, I am reminded of what the Argentine novelist Ernesto Sabato has called "those places where the skin of the self is extremely thin and delicately and abnormally sensitive." I am forced to admit that the critic who made a connection between Scull and P.J. Harvey was not as off the mark as I had originally thought. There's a view of flayed skin to which they're both drawn. Scull uses the video camera as confessor but his confessions feed into the otherwise impersonal genres of post-post (!) conceptualism. His dazzling inarticulateness is philosophy, or as Andy Warhol said about art, "You don't know *what* it is."

At a conference on video, television and art in the mid 70's, John Baldessari asserted that "TV is like a pencil." For Scull, video and sound are sketch books, pencils, not to mention eyebrow pencils and softball bats. Scull co-opts television's ability to program him by using video to set different programs for contemporary art's future paths. His productions remain far from monotonous artiness, because Scull retains popular culture's awkwardness, banality, static, and endearing ineptitudes, its jaw-clenching my-spinal-cord-is-a-chalkboard-and-fingernails-are-running-down-it-uncanniness — necessary impurities until now only seen on the unslick channels of cable-access talk shows, certain ads, and bits of MTV. Scull questions what anyone means by art as opposed to something previously recorded — from life, TV, or a radio station of their own creation, WLEX, Sonic Youth, The Slits, X, etcetera — is the soundtrack to his thinking, blaring from a speaker in a white, shag-carpeted corner of the gallery. Understanding that aesthetics have as much to do with perfume or jeans commercials as with painting, Scull moves on, knowing it is impossible to breathe much less imagine in the absence of now.

What does it mean to copy things onto cassette, on video, to loop conceptualism in order to mainline it? The artist Scull imitates says, "What is the point of making work for people who are so smart they don't even watch TV? Its just useless and depressing." In the Bow Ow Ow song C30, C60, C90, Go, which partly gave Scull's most recent show its title, Anabelle Lwin sings, "My cassette's like a bazooka." Scull transmits detonation, shattering art (and tired notions of what constitutes it), his cassettes and videotapes already recording something to replace it. ∎

Lane Releyer is an author, Associate Dean and Professor of Film and Television Studies at UCLA School of Theater Film, and Television.

Sam Francis

GAGOSIAN

[Sam] Francis, at the time of his death in [19]94, had not only become one of [A]merica's major artists, he stood as a [k]ind of metaphorical icon for the [A]merican West: It's expansiveness, it's [op]eness, indeed the very possibility of a [m]ore pristine America The works in this [ex]hibition are a rare group of large [p]aintings on canvas that remained in [F]rancis' own possession until his death-[m]any have never, until now, been seen [on] public display. Drawn mainly from [t]he *Fresh Air* and *Grid* series, they reflect [h]is interest in and mastery of scale, color, [c]omposition, and emotional intensity.

There is a sophisticated tension [b]etween bravado expression and a ten-[d]er, though not timid, restraint Indeed, [a]s the works in the show progress [c]hronologically--from the mid-sixties to [t]he early 1980s--they appear to grow in intensity. The point is implied that matu-rity--*spiritual* maturity--demands an aug-mented capacity to juggle and reconcile increasing degrees of complexity, a mat-ter that is, at least in past, a by-product of time.

In a 1968 canvas (all here are Untitled) Francis' characteristically iri-descent hues of streaked, stained and dripping paint trace the outer edges of their rectangular paper armature. The literal center of this work stands as an ironic absent yet bold rectangular vacu-um that acts as a window which opens into a space that knows no bounds, while is itself a bafflingly fertile void.

Likewise, a 1971 painting presents a

Sam Francis, Untitled, acrylic and oil on canvas, 96 x 120", 1973.

similarly patterned image of striated paint, only this time the quadratic integrity of the image--it's "squareness"--has been transformed into an oblong ring that is reminiscent of the ring of dancers in Matisse's mythologically charged *Joie de Vivre*. If the previously noted paintings hugs and covers the can-vas' edges, this one begins to concen-trate and encroach toward it's middle, containing the center and giving just a hint of closure. If the prior work draws a clear distinction between world and art, between seer and seen, this one begins to free the periphery, permitting it to wander off into an eternity that both the viewer and the world outside of the work share.

In a 1978 work a bold, deep blue pat-terning of brush strokes clearly divides the canvas into a fence-like grid. While this is a far more self-referential work than the others that have been discussed in that the rhythm of its imagery fully resolves itself of its own accord into a satisfying sense of wholeness and com-pletion, one cannot help but peek through the paint into the emptiness of the white surface beyond. And wonder...and wonder. *Andy Brummer*

Martin Creed & Sam Samore

THOMAS NORDANSTAD

The sound of slowly dripping water fills the empty front space--suddenly it is interrupted by a whooshing sound-then that gargling robot noise you get when you phone a fax number by mis-take. Then its back to plink, plink plink. No wonder the gallerist hides in an office as far away as possible from this water torture. Martin Creed has milked-up the gallery's leaking water closet, the photocopier (the whoosh-ing bit) and the fax: relaying the ambi-ent, everyday sounds of backroom gallery life into the space itself. If I hang around long enough maybe I'll catch a collector taking a dump--gersplosh-solid gold hits the pan. Creed is an odd artist; he once sent to me through the post a scrunched up sheet of A4, and recently had a subway token silver-plated

The back room is quiet, and hung with five blown-up photos. Sam Samore goes around photographing complete strangers--two men walking a woman holding a cigarette, three people together. They're simply going about their lives, but in Samore's grainy, cropped snaps they became anonymous actors in a story that we can only guess at. Looking at these rather beautiful photographs make you feel okay about eavesdropping and staring at strangers. We do it to each other all the time; though not many of us would hide a microphone in some ones bathroom. *Adrian Searle*

Pat Scull

FRIEDRICH PETZEL

There's something important going on in sound/installation/performance right now, and Pat Scull is right in the middle of it. A number of younger artists (Andrea Bulloch, Liz Larner, Alex Bag) are pushing their media beyond beyond ironic historicity on the one hand, and romantic self-absorbtion on the other. In effect, they're bridging the gap between Beck's made-up personae (so conscious of the art world's rhetorical flushes), and Joseph Kosuth's hard-won investigations of spatial and conceptual resonance. They combine fact and fiction, proof and history with a style which could be named the conceptual snapshot: an eru-dite mixture of knowledge which incor-porates an almost lethal dosage of libidi-nally intoxicated pure style.

Like Beck and Kosuth, Scull 'directs' his discourse through the passages of philosophy and mannerism, an unusual combination but one which has seduced many visitors to SoHo's Friedrich Petzel Gallery this week Scull is a veritable con-trol freak, he directs his audio/visual nerve to disarm specific association. Although much of his work is made in Sunny California (he is a graduate of the University of California, Irvine, and presently lives near Downtown LA), his works appear to have been conceived on an aeroplane somewhere between Paris and New York; their dark, brooding qual-ities do not correspond to the bright sim-plicity of much Southern Californian art. Scull's wrap-around installations seem familiar also; they give off the same sense of teeth-gritting, real-time thought as do early Naumans; they have the same hyperbolic sense of pleasure as do the most catchy pop tunes.

In the best work here, a young man looks pensively at the floor of an anony-mous Hotel room--the kind an assasin might stay in just before shooting the president. An unused bed is reflected in a window, while an American flag billows outside in the breeze. The interior and exterior of each installation seems as oddly cut off from each other as the piece's protagonist seems no longer him-self. In another work, an Asian man (Awakawa? Nam June Paik? John Woo?), wearing an apron and a backward base-ball cap, pours chilli pepper into a shak-er. Is he at home? In an academic library?

Is this a parody of the serious, pedagogi-cal claims for conceptual art's legacy recently postulated by Benjamin H.D. Buchloh in the brief pamphlet accompa-nying the over-hyped 'The Kids are NOT all White' show which premiered the new generation of Whitney Program graduates (Scull seems to be the *most* talked about to graduate)? If so, Scull is demonstrating an extreme mastery over the power structures which he is sup-posed to kneel before. If so, he is creat-ing complicated, allegorical fables based on his own talent for self-promotion and self-diminution as well--one hundred steps in front of last year's now-sorry and drug-addicted art-star, Sean Landers. That many critics and artists are divided on these questions is what makes Scull's 'Sounding Off/Critical' Kunst a highly unusual but encouraging New York debut. Its extremely entertaining to boot. That's practically unique in para-conceptual work, one would have to admit.

Of course a lot of people will look at these rigorous and complicated investiga-tions and wonder, what's the big deal? But Scull seems prepared to lose that part of his audience. Content to deliver quietly powerful work which is highly ambiguous in content, Scull provides a new form of artistic thinking for those of us who remain in the gallery, and retain our belief in the gallery
Jerry Saltz

Critics' Choice

1. **Jasper Johns**
 MoMA
2. **Nan Goldin**
 Whitney
3. **Sam Francis**
 Gagosian
4. **Sue Williams**
 303
5. **Yasumasa Morimura**
 Luhring Augustine

REVIEW

For Virginia Woolf, a moment was best understood by dissecting the particular elements that made it up, so that the truth of it, the whole of it might be composed. Just as Woolf sought out the small details of a scene — a lamp being lit or the hoot of an owl — to convey the singularity of an instant so, too, Pat Scull dwells on the minutiae of the particular settings his figures inhabit. In one of the three sound/video environments presented in his Blum & Poe solo, *C30, C60, C90, Go*, figures blend into an ecology of aural and visual (technological) meshings. The work confuses us with its richness.

DAVID PAGEL

On the one hand, Scull seems to be a straight out revivalist Marxist, an artist who seeks to impregnate a wider audience with the spores of his or her own socially redemptive art production. On the other, he's an arch-conceptualist who presents his dense practice to a minute audience who appreciate the product so much that they refuse to let it out of their sight. In short, the reason that Scull's desire to be some kind of Popular conceptualist seems contradictory probably has something to do with our own envy that this category is even attainable by virtue of this utopian projection. This uneasy vertigo and political ambition is what might be dubbed the Scull-effect.

The Scull-effect is laid out over an installation of interior scenes. Standing in the gallery, hands on hips, Scull's confident environments cross the border between micro- and macro-spatiality. We return the work's empty gaze, our eyes finally lost in layer upon layer of cool dark reflecting surfaces and the glare of numerous video projectors. In another installation, a man with a baseball cap stands at a shiny white counter filling a container with an unknown liquid. His watch reads Sunday, 3.52 pm. Though Scull tempts us by presenting works whose poses presuppose a formidable

knowledge of post-conceptual art, the structures defy our very attempts to know them, deflecting our gaze and our partial knowledges into a maze of shimmering surfaces, each delivering another fragment of a history — which and what history remains ambiguous — that brings us closer to the whole. Ultimately, we never learn how to put together all the visual information piled into these installations.

Two installations present sublime landscapes: in one, Scull replaces actual dirt and grass with an aural (digital) symphony anticipating the break of day; in the other, he naturalizes media to the point where it becomes reminiscent of natural phenomenon. It is as if Scull was turning and spinning the technological clock — or preempting technology to return, via the wilful machining of paradox, to an organic, grass-roots consciousness. In each case, Scull's images are never quite still. Whether the swirl of the video screen or the ocean of banal details endlessly repeated from the audio speakers, he delivers the viewer into a contemplative space which is anything but restful.

Scull's installations, like Vermeer's paintings or Woolf's novels, render the moment as something ineffable, and always in motion. He uses each detail to pull us to another place in the tableaux. His moments are so open-ended that they trouble the line between still photography's frozen image and cinema's moving pictures. While Scull may present us with an aural image, it is one which moves in and out of dimensions, perpetually resisting the viewer's desire for narrative closure. Narrative infinity: this is not merely a critical pose or a rhetorical device, instead it creates an alternative way of seeing—one that priveliges the purely visual pleasure of looking and discovering as defining traits of experience.

Blum & Poe
2042 Broadway
Santa Monica.

NEW YORK LETTER BOM

continued from page ?

Manhattan File magazine frantica called yours truly, looking for Matthew matte, but after politely declining a sitt with Ray Newton at the Gramercy P. Hotel and having Gary Leonard settle a shot of Marks' Chateau Marmont su (after darting out of the room) i December, an image of Marks has yet turn up in the heretofore bottomle *Coagula* photo morgue.

Our research department has fou that so far only two shots of MM ha made it to print: *Newsweek*'s *Hot* boomers piece last summer a Jonathan Napack's recent Chelsea Soho piece in *New York* Magazine.

Think that anyone might check the Bennington College yearbooks?

Natterin' Jonathan Napack is su pissed at one of his major sources, La Gagosian's court jester Ealan Wingate

When Napa Napa requested an in view with Gaga's risky star, Dirty Dam Hirst, Wispy Wingate suddenly got fro "I'll have to get back to you." he rep edly told Nape, who then called y scribe to say that he had heard t Wingate did jail time awhile back, repe edly as a noble jester gesture--taking rap for a family business' alleged to dumping.

Now that he's buckin' the Cogan fa bronco, *Art & Auction* magazine Ed Bruce Wolmer is fessin' up to alot.

Loose Bruce admitted to working Lyndon Johnson at the 1964 Democra National convention in Atlantic C before turning hippie. "I just ran into Carroll," Wolm the Wolf allegedly tol thin friend, "we used to score toget constantly..."

– Janet Prest

Final

BLUM & POE

b. Anaheim, Orange County, CA, 1968

Address:
1840 N. Berendo St, #104
Los Angeles, CA 90028

Dealer Representation
Blum & Poe, Los Angeles.
Friedrich Petzel Gallery, New York.

Education:
Whitney Independent Study Program, 1996.
Masters in Fine Art, University of California, Irvine, 1994-5.
Bachelor of Fine Arts, ArtCenter College of Design, Pasadena, 1987-90.

Awards:
Winner, Orange County Fair, Installation Grand Prix, 1995.

Solo Exhibitions:
C30, C60, C90, Go, Blum & Poe, Santa Monica, 1997.
Sounding Off/Critical Kunst, Friedrich Petzel Gallery, NYC, 1996.
Numeric Quitodian, Wright Gallery, CalState LA, 1996.

Selected Group Exhibitions:
Truce, Site Santa Fe, Santa Fe, New Mexico, curated by Francesco Bonami, 1997. (cat.)
Re-animation: corporeal mutations and available space, curated by Mary Kelley, Chris Wilder and Jennifer Pastor for UCLA's Wight Gallery, LA, 1997.
Scene of the Crime, UCLA/ Armand Hammer Museum of Art, Los Angeles, curated by Ralph Rugoff, 1997. (cat.)
Hotel Kalifornia, (one night show) curated by Lisa Anne Auerbach & Sarah Gavlak, Mondrian Hotel, West Hollywood, 1997.
Traditional/Nontraditional, Pat Hearn Gallery, NYC, 1996.
Silverstein Gallery (with Javier Tellez), New York, 1996.
The Kids are NOT All White: the 1996 Whitney Independent Study Program, (3 day show) curated by Benjamin H.D. Buchloh and Boston Whitley, Les Mills Foyer, Whitney Museum of American Art, NYC, 1996. cat. (cont.>)

BLUM & POE

Playpen & Corpus Delirium, Kunsthalle Zurich, Zurich, curated by Mendez Burgi & Bice Curiger, 1996. (cat.)

Unsounded: Echo, Music, Logarythm, White Columns, New York, curated by Mayo Thompson, 1996.

Maureen Paley/Interim Art, London, 1996.

The Legacy: conceptualism, perfomance, critical thought, curated by Brian Jacobsen and Amelia Jones, Brian Jacobsen Memorial Gallery, University of California, Irvine, 1995.

California, A Duchampian California: a 30 year Commemoration of Duchamp's Presence in California, Pasadena Art Museum, 1995. (cat.)

Making it Work: Art for Everybody? Community Coffee Division, CalState LA, 1995.

Grandest Pricks, Onyx Café, Los Angeles, CA, 1994.

Selected Bibliography:

Bonami, Fransesco, Echoes: Contemporary Art In An Age Of Endless Conclusions, London: The Monacelli Press, 1996, p. 154-5.

Decter, Joshua, *Improbable Noises (Theory for the Deaf): Haino, Scull, Morley, Thompson,* New York, Feb 25, 1997, pp 67-68.

Greene, David A., The Village Voice, November 26 - December 3, 1996, p. 93.

Greenstein, M.A., *Pat Scull,* Art Issues, Summer, 1996, p. 37.

Kandel, Susan, *Land Ahoi,* Los Angeles Times, November 17, 1995 p. F13.

Knight, Christopher, *Look Out World, Here They Come!* Los Angeles Times, March 30, 1997, pp. 63-4.

Pagel, David, *Review,* Coagula Art Journal, Issue No. 27, mid-spring 1997, p. 54.

Pokorny, Syndey, *Pat Scull: Freidrich Petzel (review),* The New York Times, Nov 15, 1997, sec.C. p. 32.

Relyer, Lane, *Pat Scull. For people who are so smart they don't even watch TV.* High Performance, Spring 1997, #75, pp. 56-57.

Saltz, Jerry, *Pat Scull: Friedrich Petzel Gallery,* Time Out New York, November 28 - December 5, 1996. p. 46.

Schwabsky, Barry, *Unsounded? — or just not sounding right?* Exhibition Catalogue, 1997.

Ward, Fraser, In the mix: Pat Scull and Delirium Aestheseology, New York: Friedrich Petzel Gallery, 1997.

Lane Relyer, 'Pat Scull: For People Who Are So Smart They Don't Even Watch TV', *High Performance*, Spring 1997.

Growing up in Disneyland, California (well, Anaheim), Pat Scull—a young John Lennon fan and inveterate Yoko Ono groupie long before Ono's ascension to art-rock diva status—came to art by studying pop music. While still an undergraduate fine art major at Art Center College of Design in Pasadena, CA, Scull began designing sets for rock concerts and making videos for local bands; eventually he joined an all-male group called 'The Next Queens'.

Skull's video and sound work takes us on a curious journey, via pop (he also composes and writes his own songs), into the furtherest regions of the male artistic psyche. One of his projects, *Numeric Quitodian* (1996), is part-homage to John Lennon and part-homage to Carl Andre, and part manic self-parody. It takes its title from the opening line of Lennon's 'Happiness is a Warm Gun', with a slight modification from first to third person. In this video, a recording of Scull repeatedly singing this lyric is sped up, mimicking the quality of his own blurry, distorted image, as, bare-chested, he dances frenetically around the room. Then the music slows and Scull slides down the wall—almost disappearing from the frame—as if momentarily overcome by self-doubt before regaining control as sound and image return to their former, unnaturally accelerated level. Scull's humorous take on male angst sets the tone for his later work and allies him with singers such as P.J. Harvey and artists from Lawrence Weiner to T. Kelley Mason who have, over the past 20 years, gained recognition for their combinations of conceptual scrutiny and popular wit.

When I look at Scull's installations closely, I am reminded of what the Argentine novelist Ernesto Sabato has called 'those places where the skin of the self is extremely thin and delicately and abnormally sensitive'. I am forced to admit that the critic who made a connection between Scull and P.J. Harvey was not as off the mark as I had originally thought. There's a view of flayed skin to which they're both drawn. Scull uses the video camera as confessor but his confessions feed into the otherwise impersonal genres of post-post (!) conceptualism. His dazzling inarticulateness is philosophy, or as Andy Warhol said about art, 'You don't know *what* it is.'

At a conference on video, television and art in the mid 70's, John Baldessari asserted that 'TV is like a pencil'. For Scull, video and sound are sketch books, pencils, not to mention eyebrow pencils and softball bats. Scull co-opts television's ability to program him by using video to set different programs for contemporary art's future paths. His productions remain far from monotonous artiness, because Scull retains popular culture's awkwardness, banality, static, and endearing ineptitudes, its jaw-clenching my-spinal-cord-is-a-chalkboard-and-fingernails-are-running-down-it-uncanniness—necessary impurities until now only seen on the unslick channels of cable-access talk shows, certain ads, and bits of MTV. Scull questions what anyone means by art as opposed to something previously recorded—from life, TV, or a radio station of their own creation, WLEX, Sonic Youth, The Slits, X, etcetera—is the soundtrack to his thinking, blaring from a speaker in a white, shag-carpeted corner of the gallery. Understanding that aesthetics have as much to do with perfume or jeans commercials as with painting,

Scull moves on, knowing it is impossible to breathe much less imagine in the absence of now.

What does it mean to copy things onto cassette, on video, to loop conceptualism in order to mainline it? The artist Scull imitates says, 'What is the point of making work for people who are so smart they don't even watch TV? Its just useless and depressing.' In the Bow Ow Ow song C30, C60, C90, Go, which partly gave Scull's most recent show its title, Anabelle Lwin sings, 'My cassette's like a bazooka.' Scull transmits detonation, shattering art (and tired notions of what constitutes it), his cassettes and videotapes already recording something to replace it.

Lane Releyer is an author, Associate Dean and Professor of Film and Television Studies at UCLA School of Theater Film, and Television.

Jerry Saltz, 'Pat Scull, Friedrich Petzel', *Time Out NY*, 28 November–5 December 1996.

There's something important going on in sound/installation/performance right now, and Pat Scull is right in the middle of it. A number of younger artists (Andrea Bulloch, Liz Larner, Alex Bag) are pushing their media beyond beyond ironic historicity on the one hand, and romantic self-absorbtion on the other. In effect, they're bridging the gap between Beck's made-up personae (so conscious of the art world's rhetorical flushes), and Joseph Kosuth's hard-won investigations of spatial and conceptual resonance. They combine fact and fiction, proof and history with a style which could be named the conceptual snapshot: an erudite mixture of knowledge which incorporates an almost lethal dosage of libidinally intoxicated pure style.

Like Beck and Kosuth, Scull 'directs' his discourse through the passages of philosophy and mannerism, an unusual combination but one which has seduced many visitors to SoHo's Friedrich Petzel Gallery this week. Scull is a veritable control freak, he directs his audio/visual nerve to disarm specific association. Although much of his work is made in Sunny California (he is a graduate of the University of California, Irvine, and presently lives near Downtown LA), his works appear to have been conceived on an aeroplane somewhere between Paris and New York; their dark, brooding qualities do not correspond to the bright simplicity of much Southern Californian art. Scull's wrap-around installations seem familiar also; they give off the same sense of teeth-gritting, real-time thought as do early Naumans; they have the same hyperbolic sense of pleasure as do the most catchy pop tunes.

In the best work here, a young man looks pensively at the floor of an anonymous Hotel room—the kind an assasin might stay in just before shooting the president. An unused bed is reflected in a window, while an American flag billows outside in the breeze. The interior and exterior of each installation seems as oddly cut off from each other as the piece's protagonist seems no longer himself. In another work, an Asian man (Awakawa? Nam June Paik? John Woo?) wearing an apron and a backward baseball cap, pours chilli pepper into a shaker. Is he at home? In an academic library? Is this a parody of the serious pedagogical claims for conceptual art's legacy recently postulated by Benjamin H.D. Buchloh in the brief pamphlet

accompanying the overhyped 'The Kids are NOT all White' show which premiered the new generation of Whitney Program graduates (Scull seems to be the *most* talked about graduate)? If so, Scull is demonstrating an extreme mastery over the power structures which he is supposed to kneel before. If so, he is creating complicated, allegorical fables based on his own talent for self-promotion and self-diminuition as well—one hundred steps in front of last year's now-sorry and drug-addicted art-star, Sean Landers. That many critics and artists are divided on these questions is what makes Scull's 'Sounding Off/Critical' Kunst a highly unusual but encouraging New York debut. Its extremely entertaining to boot. That's practically unique in para-conceptual work, one would have to admit.

Of course a lot of people will look at these rigorous and complicated investigations and wonder, what's the big deal? But Scull seems prepared to lose that part of his audience. Content to deliver quietly powerful work which is highly ambiguous in content, Scull provides a new form of artistic thinking for those of us who remain in the gallery, and retain our belief in the gallery.

David Pagel, 'Review', *Coagula Art Journal*, 1996.

For Virginia Woolf, a moment was best understood by dissecting the particular elements that made it up, so that the truth of of it , the whole of it might be composed. Just as Woolf sought out the small details of a scene—a lamp being lit or the hoot of an owl—to convey the singularity of an instant so, too, Pat Scull dwells on the minutiae of the particular settings his figures inhabit. In one of the three sound/video environments presented in his Blum & Poe solo, *C30, C60, C90, Go,* figures blend into an ecology of aural and visual (technological) meshings. The work confuses us with its richness.

On the one hand, Scull seems to be a straight out revivalist Marxist, an artist who seeks to impregnate a wider audience with the spores of his or her own socially redemptive art production. On the other, he's an arch-conceptualist who presents his dense practice to a minute audience who appreciate the product so much that they refuse to let it out of their sight. In short, the reason that Scull's desire to be some kind of Popular conceptualist seems contradictory probably has something to do with our own envy that this category is even attainable by virtue of this utopia projection. This uneasy vertigo and political ambition is what might be dubbed the Scull-effect.

The Scull-effect is laid out over an installation of interior scenes. Standing in the gallery, hands on hips, Scull's confident environments cross the border between micro- and macro-spatiality. We return to the work's empty gaze, our eyes finally lost in a layer of cool dark reflecting surfaces and the glare of numerous video projectors. In another installation, a man with a baseball cap stands at a shiny white counter filling a container with an unknown liquid. His watch reads Sunday, 3.52pm. Though Scull tempts us by presenting works whose poses presuppose a formidable knowledge of post-conceptual art, the structures defy our very attempts to know them, deflecting our gaze and our partial knowledges into a maze of shimmering surfaces, each delivering another fragment

of a history—which and what history remains ambiguous—that brings us closer to the whole. Ultimately, we never learn how to put together all the visual information piled into these installations.

Two installations present sublime landscapes: in one, 'Scull replaces actual dirt and grass with an aural (digital) symphony anticipating the break of day; in the other, he naturalizes media to the point where it becomes reminiscent of natural phenomena. It is as if Scull was turning and spinning the technological clock—or preempting technology to return, via the wilful machining of paradox, to an organic, grass-roots consciousness. In each case, Scull's images are never quite still. Whether the swirl of the video screen or the ocean of banal details endlessly repeated from the audio speakers, he delivers the viewer into a contemplative space which is anything but restful.

Scull's installations, like Vermeer's paintings or Woolf's novels, render the moment as something ineffable, and always in motion. He uses each detail to pull us to another place in the tableaux. His moments are so open-ended that they trouble the line between still photography's frozen image and cinema's moving pictures. While Scull may present us with an aural image, it is one which moves in and out of dimensions, perpetually resisting the viewer's desire for narrative closure. Narrative infinity: this is not merely a critical pose or a rhetorical device, instead it creates an alternative way of seeing—one that privileges the purely visual pleasure of looking and discovering as defining traits of experience.

True Crime: Forensic Aesthetics on Display

Afterimage, vol. 25, no. 5, March–April 1998.

Exhibitions review: *Scene of the Crime*, Armand Hammer Museum, Los Angeles, 23 July–5 October 1997. *Police Pictures: The Photograph as Evidence*, San Francisco Museum of Modern Art, 17 October 1997–20 January 1998; Grey Art Gallery, New York, 21 May–18 July 1998.

Two prominent Californian art institutions recently organised major exhibitions and catalogues devoted to the subject of crime and its history in representational media. In hosting projects of this nature, both art institutions have, inadvertently or not, become crime scenes. They have showcased a spectacle of transgression and capture, introducing material pertaining to crime, produced by both artists and professional photographers, into exhibition formats in which the unambiguous strictures of legal judgment are rounded off to a more democratic notion of 'discourse', a space where innocence, guilt, and the law can be subjects for discussion, not matters for prosecution. These exhibitions and catalogues, specialising in hardcore morbidity, offer excellent opportunities to bask in the suffering of others.

In some respects, *Scene of the Crime* and *Police Pictures* were shows with complementary agendas. *Scene of the Crime* was commissioned by the Armand Hammer Museum from Ralph Rugoff, a freelance curator and writer, author of *Circus Americanus* (1995), and a frequently published critic on contemporary art.[1] In his exhibition, Rugoff aimed to magnify an interzone where contemporary art in the age of institutional critique—an art fixated with institutional spaces and their interstitial meanings—meets the detective's special brand of scrutiny. What Rugoff names the 'forensic aesthetic' is an art-historical subgenre that was compiled from a mixture of phantasmic romance-world crimes, academic references, and contemporary art works.

The 'forensic aesthetic' argues that crime itself, as well as the methods of its analysis by law-enforcement agencies, has spread, both aesthetically and ideologically, through the discursive media of contemporary art of the past twenty years. The after effects of a criminal second, one could summarise, may speed across a variety of hyperacute situations, panicked discoveries, condensations, and distortions of space and time and sciences of forensic procedure, to end up in the ambivalent receptacle of a broader imagination, what could grossly be termed 'popular culture'. In short, criminals and their actions are quite fascinating. Watching them being caught is also entertaining. Advanced art, in the curator's opinion, cannot help but be transfixed by this extravagant compulsion.

Rugoff's thesis additionally suggests that the putative audience of contemporary art—one that the turnstile-conscious public museum is accountable to and is therefore

obliged to monitor demographically—is, in a comparable way to the stunned discoverer of a dismembered corpse, bewildered and perhaps repulsed by what they see. Contemporary art—there is something suspicious about it! In order to make sense of this art, the viewer might perhaps borrow the ultra-inquisitive gaze of the detective—a hungry, imperious, and objective eye that can never be satisfied with the surface of things and will not sleep until the case is solved.

To make his case, Rugoff assembled a canon of seventy-two para-conceptual art works—a collection that included many fine works—that were linked by virtue of their 'scattered' compositions, devotions to a pop macabre, quasi and genuinely psychotic mannerisms, not to mention any radical, political, or iconographic goals that might be discerned from the above. The exhibition looked like a house of horrors reinstalled in an anthropology museum.

While Rugoff curated a distressed, even abject representational art produced in a fairly wide range of media, SFMOMA's *Police Pictures*, by contrast, was an exhibition devoted to specific moments in the history of photography. (I should admit that I was unable to travel to San Francisco to see the exhibition, so I am basing my analysis exclusively on the catalogue, which reproduces all the photographs in the show.) While *Scene of the Crime* was about the work of the individual artist, a production that may be located nominally, *Police Pictures* presents many unattributed, organisation-manufactured images. Essentially, it is a retrospective of the work of the civil servant and the tabloid photographer. *Police Pictures* is composed most significantly of images respectfully borrowed (or pulled screaming?—it's difficult to say which) from the archives of police and other governmental agencies in both the United States and Europe, and from the wave of tabloids such as the *Daily News* and the *Daily Mirror* that emerged in this country in the 1940s. With several exceptions—notably the inclusion of prints by Eugéne Atget and Weegee (Arthur Fellig)—*Police Pictures* is a handpicked boutique of photographs that aren't going to say who took them.

Without exception, the ninety-four works in *Police Pictures* have distressing themes: lynchings, murders, mugshots. Indeed, it is critical to note that, of the many interpretations the word 'crime' could possibly entertain (white-collar, hate, thought, etc.), the figure of the murdered and forensically scrutinised corpse—or, in the case of *Scene of the Crime*, 'metaphorical' corpses—prevailed hands down in both exhibitions.

But *Police Pictures* is also an exhibition about delight. Repulsion is morphed into finery; these are beautiful photographs situated in a modern art-museum context. In this schema, art and forensic photographs—pumped up by the populist doctrines of 'reality television' and 'real-life crime'—blend into one. They all share the inflection of dramatic narration, and

all, in one sense or other, rely on the willing viewer. All are produced by human beings who are—regardless of the 'professional' category to which they attach themselves—normally reduced to a speechlessness before the corpseograph, a kind of blind stupor. How does one 'curate' such material? Quite separate from any conclusions that may have been made regarding criminal motive or outcome in the photographic scenarios, the 'good' forensic photograph—the one involving the most cruel and unusual form of violence—cannot help but arouse a totally prurient interest in the viewer who witnesses an obscene and machinic representation of anonymity and death, and can then take it or leave it.

Whilst providing an interesting-enough critical and historical framework, *Police Pictures* would never have succeeded without this essential ingredient of total, blank sensation, an effect that is critical to an understanding of what photography has achieved—one might say instituted—throughout this century. The opportunity that both exhibitions offered to reflect upon the medium of photography in general—including the photographic crime of violating accused criminals and corpses—was among their most valuable functions. (In Rugoff's exhibition, many of the works were either photographic themselves or influenced by photographs or methods of surveillance.)

Rugoff's 'forensic aesthetic' begins with the oeuvre of Jackson Pollock. For Rugoff, the artist's performative gesture—'action painting'—is understood as a record of the body that leaves evidence-like traces in the form of painted trails. Pollock's works, according to Rugoff, are 'like' crime scenes in the sense that every paint mark is frozen into an evidence-like stasis. Rugoff writes: 'Like blood splatters ... [the paintings of] "Jack the Dripper" recall a history of aggressive movements and to see them as a bloody spillage ... does not seem unreasonable.'

Scene of the Crime then moves on to reflect upon the transfigurations in the work of art in the (quite literal) wake of Pollock: conceptualism, post-object art, institutional critique. Considered here is the dematerialisation/destruction of the art object—for instance the phenomenal 'scatter art' of Barry Le Va; the development of artworks as events, performances, and happenings; and the emergence of the work of art that exists solely as a photographic record, proof of an action that once took place. Chris Burden's *Shoot* (1971) and Bruce Conner's *Prints* (1974), for example, are works that describe malicious actions as well as the techniques of evidence collection that preceded and followed them.

Ed Ruscha's *The Los Angeles County Museum on Fire* (1965–8) was a significant work in this exhibition. Not only was it featured on the cover of the exhibition catalogue, it was also the first work one saw upon entering the gallery. In this painting, the then-brand-new LACMA—which the art-loving public had only just begun to enjoy (the museum opened

in 1965)—is glowing ablaze through the handiwork of an unknown arsonist. Painted in the style of a theatrical backdrop, it is both a funny and a serious painting. By some, it has been read as a comic sketch of the racial paranoia engendered by the Watts riots—which also occurred in 1965. In this regard, it can be thought of as a painted caricature of a possibility: the threat that civil disruption would stop nowhere, not even at a veritable storehouse for national treasures. Today, it seems like a fairly realistic, if facetious, portrait of the kind of business-as-usual paranoia that many cultural institutions and their employees face on a daily basis: the theft of their collection, funding cuts, redundancy, vandalism, archival concerns pertaining to works of art, and being superseded by other, newer institutions.

Scene of the Crime was initiated and sponsored by the Fellows of Contemporary Art, a 'non-profit, independent corporation' that has funded or partially-funded twenty-four major exhibitions in California since 1976. In keeping with the Fellows' policy, all works in this exhibition were by Californian artists. A restriction or a limitation? As Rugoff states in his catalogue introduction, there was no shortage of local work to enrich his thesis. Indeed, there were some incredible works in this show. Richard Hawkins, Bob Flanagan and Sheree Rose, Vija Celmins, Bruce Nauman, Anthony Hernandez, John Baldessari, Mike Kelley, Sharon Lockhart, Richard Misrach, Nayland Blake, Paul McCarthy, Sam Durant, and Monica Majoli were all represented here, many with complicated, memorable pieces.

Of course, it has been in the interests of various mass-media outfits to characterise cities like Los Angeles as places where there is nothing but crime, 'crime' often acting as a convenient substitute for the phrase 'racial tension'. There is no question that Californian artists have responded to this circumlocution, not to mention protested against it, in their works. The Californian focus of *Scene of the Crime*, however, did point to other regionally specific crimes. In this regard, it is relevant to consider the venue for the exhibition itself—UCLA's premier contemporary-art museum—especially given that the legacy of site critique had informed many of the exhibited works so significantly, and that it was Rugoff's aim to consider art production in a sociological context. Now that affirmative action has been surgically removed from the University of California system by Proposition 209, it is noteworthy that Rugoff included, to the point of accusation, mostly white, male artists in his exhibition. The artists making up *Scene of the Crime* represent a complete inversion of the statistics on crime and the demographics of prison populations published by a state that asserts that the majority of 'criminals' are black or Latino, and many of them young, as opposed to middle aged.

As we have seen, Rugoff proposes a 'forensic' model of aesthetics, and, if we are to take his use of this word literally—forensic meaning most basically 'pertaining to the law'—then

we have something like 'aesthetics pertaining to the law'. Through the copious toppled furniture, blood-spatter patterns, fake crimes, and intoxicated stabs at the masters, a weird interdiction was voiced by the curator. The audience, in effect, is asked to be cops, scanning for clues, searching for answers. 'In contrast to the real-life criminalist', Rugoff writes,

> we are not asked as viewers to reach a definitive finding … instead, our search for meaning engages us in a goalless activity … tracing the links between our emotional responses and the ideas that arise alongside them …

To have it suggested, no matter how metaphorically, that we adopt the gaze of a policeman or detective while looking at works of art seems a singularly absurd proposition, and one that should be categorically dismissed on political grounds: artworks are not clues to the 'sickness of society' or pieces of evidence to be used in a court case. One can fantasise about the perspicacity of an ideal detective—but to unify the artist, the viewer, and the 'scene of the crime' in the hopes of illuminating the artwork itself? To insist upon indeterminacy and experimental readings of artworks is one thing, to assess one's 'emotional responses' in terms of an FBI guidebook is quite another.

A different way of looking at 'crime scenes' would have been to study the ways in which law-enforcement agencies are themselves trapped in literary and artistic myths (how did life on the beat change after *Dirty Harry*?), or perhaps to study evidence fabrication and 'police style' as cultural production, rather than art interpretation as a kind of forensic investigation.

Being about shock, delight, science, and history, *Police Pictures* was also an exhibition inexplicably tied to the concept of anonymity. With its inventory of agency-attributed photographs and their long-departed subjects, viewers are constantly staring nobodies in the face. This is somewhat paradoxical, as the original intention of so many of these photographs was to publicly identify criminals—a forensic photograph that fails to prove anything is completely useless to a court of law. In his 1992 essay, 'On Forensic Photography' (reprinted in *Circus Americanus*), Rugoff observed that a forensic photograph that he viewed at the LA County Coroner's office is 'the property of a public agency [and] is essentially a private image … my looking at it is an intrusion, a rupture of its limited intentions'.[2] But this rupture only occurs inasmuch as there are living relations, unsolved crimes, and inflammatory possibilities that might result in retrials or libel suits. After a period of time has passed, such images cease to be relevant in the judicial sense. They then become ripe for other uses.

As outlined in its catalogue, *Police Pictures* is structured chronologically in a timeline that follows the photograph and the photographic apparatus throughout their long affair with the police and criminals. The exhibition is evidently not as historically located as Rugoff's, presenting images from scattered moments across time, with unexplained gaps accounting for the years separating photographs. *Police Pictures* begins with the handprint that was used to solve the 'Affaire de Thiais', a Parisian double murder. Nhem Ein's portraits of Cambodian prisoners, which are now housed in the Tuol Sleng Genocide Museum, conclude its survey of 'the picture as evidence'. In between is, say, the celebrated dead gangster, John Dillinger—a burlesque corpse that erupts from the front page of the *Daily News*, well dressed, well fed, and well baptised under the pornographic impropriety of the flashbulb.

Almost all of the images in *Police Pictures* are 'historical' enough to be immune to accusations of impropriety—i.e., their subjects are dead—and have attained a new status as elegant specimens of noir; a fact that would make them easy to confuse with works of fiction, as if every one of them was a film still. The most recent photographs, specifically the 1976–9 Ein series that shows people about to be killed—alleged traitors biding their time at Tuol Sleng, a Khmer Rouge death camp—are extraordinary testimonies that are bizarrely placed in this context, an exhibition that cannot account for them. They are not 'police' pictures. In fact, the faces here seem to be tortured by the presence of the camera in their faces. These and many other images in this show are images about which I know nothing, but that clog up the fantasy of aesthetic perusal in very definite ways. Of course, this is not to deny the images their compelling quality as inadvertently attractive photographs.

It's very easy to forget that there were once living people involved. The overwhelming condition of anonymity created by the disciplines of police and tabloid photojournalism is what makes these pictures good to look at. This, in itself, is a completely scandalous outcome considering the events involved. The nobody is everywhere here, a very specific nobody who is the product of communication technology pure and simple. What, one wonders, does SFMOMA want us to think, standing before an image captioned 'Crime de la Rue Bouchardon', a photograph of the atrophied corpse of a French woman lying flat on her back (murdered or suicided) in her home? The photograph is undated (presumably taken around the turn of the century), the photographer unknown, and the image is from the Archives Historiques et Musée de la Préfecture de Police, Paris.

Many significant photographs are taken by organisations—by photography itself as a kind of corporation. And this has also been a genius of forensic photography: to establish within image production a condition in which the perpetrator or cadaver is identified, but

the imagemaker himself is not. If photography was unable to consecrate this manner of objectivity, there would be no such thing as forensic photography in the first place. The paparazzi, for another example, are rarely identified as individuals—the paparazzi are a mass organisation of anonymous photographers, not so dissimilar to police photographers. They may operate on different sides of the law, but they share the same side of photography.

This condition of anonymity also permits almost anyone to do almost anything with photographic prints, which is where the museum comes in. By presenting a lurid inventory of 'real life' crime detached from its own institutional and historical contexts, *Police Pictures* translated the original use value of the document, 'spectacularising' the document and returning it to the public who commissioned it in the first place. Documentary photographs work all by themselves. They have revealed themselves to be endlessly fascinating and endlessly exploitable objects, open to any number of uses and abuses—a 'dead men don't talk' situation.

Police Pictures is a project admittedly indebted to 'The Body and the Archive', an important essay by Allan Sekula, first published in the journal *October* in 1986.[3] Sekula provides a Foucauldian account of the photographic impulse as it arose to become a police informant, one capable of both cataloguing the body of the criminal and reducing it to a universally recognisable currency. The categorically dubious triumph of the 'mug shot' is attributed by Sekula to the grim inventions of one Alphonse Bertillon, the French physiognomist who brought us the aforementioned hand (or fingerprint) test, and, following that, the police-photo archive. It seems that Sekula is responsible for introducing Bertillon's work to the field of visual art; that is, to offer art historians and artists a study in technological oppression. But even Sekula's influential essay, which rings with a sharp fascination for photographic history and shares an analytical wonder for the paradoxical works of nineteenth-century science, does not anticipate the current moment, one in which the forensic photograph is presented as a sensational currency—extracted, once and for all, from the context of law. It's as if somebody along the line forgot that Foucault—and Sekula—had a political ambition that was slightly different from that of the police.

For exhibition programmes at contemporary museums, the corpse must be the last straw. These two exhibitions clustered morbidity into a tight spasm, for our pleasure, naturally. While *Scene of the Crime* used the context of forensics to illuminate contemporary art, *Police Pictures* presented another kind of work, one that has been evicted from its original context as a legal document and has become art by default.

But the machinations of art are relatively easy to talk about when compared to the questions—What is crime? Where is the criminal?—that these exhibitions raise but never

address. Are these shows involved, in some way, with criminal intent? Perhaps they are related to the case of situationist Guy Debord, who refused to attend the retrospective of situationism at the Centre Georges Pompidou in Paris in 1989 on the grounds that it was, for him, obscene that a museum would consider to display such an anti-institutional practice. The shocking introductory sentences to Sandra Phillips's essay in the *Police Pictures* catalogue—'We need criminals because they are not us. Crimes are acts, committed not by "normal" people but by those who we define as outside of the norm.'—clearly declare that, for Phillips, it is possible to present 150 years of forensic photography without unnecessary interference from the criminal, and, that, in her position of curator of photography, she finds it appropriate to delineate pathology as something extrinsic to the museum and its visitors. But, as opposed to locating crime in a place away from the art museum, I think it is more pertinent to wonder whether the conflation of aesthetics and crime is little more than a privileged and fanciful idea entertained by these respective museums. The police, after all, have little need for art.

1. Ralph Rugoff, *Circus Americanus* (London and New York: Verso, 1995). This collection of short essays includes 'On Forensic Photography' and 'Pathological Beauty: The Mutter Museum', pieces that relate to Rugoff's subsequent work in *Scene of the Crime.*

2. Ibid., 184.

3. Allan Sekula, 'The Body and the Archive', *October*, no. 39, Winter 1986: 3–64.

Jason Rogenes: Alien Industry

Art and Text, no. 60, 1998.

In his 1966 essay, 'Entropy and the New Monuments', Robert Smithson offered a paean to artists who introduced artificial temporalities and foreign materials into the field of art practice by studying the cultural and industrial refuse of their particular moment, from B-movies to landfill: the advanced artist, he proclaimed, must think at the speed of trash. One could say that, thirty years later, Los Angeles–based Jason Rogenes's work is similarly afflicted by the inorganic and the cinematic, except for the fact that Rogenes uses actual trash to build what might be thought of as an afterimage of the cinema.

Rogenes's sculptural project orbits between the world of science-fiction film and that of industrial waste: he uses discarded Styrofoam packaging—precisely the kind designed to safely house electronic products during interstore transit—to build large-scale temporary installations that most closely resemble spacecraft, at least the spacecraft envisioned by the cinema of previous decades. Rogenes has been exhibiting these sculptural fictions since 1995, when he was a graduate student at the University of California at Santa Barbara. His projects, which have since been shown at LA venues such as Post and Woodbury University, were included in an exhibition of new LA artists at Amsterdam's W139 gallery last fall.

Indeed, Rogenes's works are quintessentially Californian, both in their apparent embrace of cinematic 'special effects' and in their obsession (that's the only word for it) with the new science of ufology, a regionalist discourse that fuses academia's purported 'expertise' with occult, new-age strains of out-of-it speculation. However, like the extraordinary Californian sculptor John McCracken, Rogenes ponders how such alien (alienated) landscapes are as much a product of the factory and studio as of the imagination. One need only consult any one of the plethora of Hollywood's 'The Making of' books and TV shows to observe that all of those ultra-credible death stars and battlecruisers that have waged war upon disposable incomes since Stanley Kubrick's *2001* are nothing but fantastic illusions crafted from common materials. This is the unremarkable genius of 'space povera', a sculptural-industrial genre to which McCracken's and Rogenes's oeuvres seem to belong.

One easily empathises with the putative spacecraft designed in the 1970s to look as if they were built in the twenty-fifth century. An unprecedented form of kitsch, utterly trapped in time, these grotesquely mnemonic vehicles are the ancestors of Rogenes's sculptures. Suspended from gallery ceilings, bifurcating and replicating themselves parasite-like across architectural surroundings, Rogenes's works deliver the familiar kick of sci-fi trompe-l'oeil infinity, in all its cosmic pathos. *Project 3.94c* (1997), for example,

was a composite space object some twenty-five feet in length, which appeared to be a floating city or enormous power source engaged in intergalactic travel. Belief is suspended indefinitely—not to mention willingly—in front of works like this, which are predicated upon a surrender to spectacle. *Project 3.94c*'s outer-space theatricality was intensified by the fact that it was tilted upwards, motioning the heavens. This tilt further suggested an actual trajectory through space, making the work less of a blueprint or model than an actual vessel.

Rogenes's installations are network sculptures, built from system components. Constructed onsite from individual Styrofoam sections, they illuminate themselves with fluorescent tubes, which wind through their spatial complexes. The works are plugged into local power sources, with electrical cords going off in all directions. The Styrofoam components, which are formally compatible and interlock by virtue of their mass-produced sameness, are utilised as a kind of accidental Lego, which links together perfectly like plug and socket. Construction, then, observes a logic that is literally built into the Styrofoam object. There is no imperative directing the artist to carve, mould, adorn, or otherwise manipulate his material. Rather, the self-contained virility of the component parts has its way, and the sculpture goes with the flow of market domination and mass reproduction— agendas that, funnily enough, are shared by despotic aliens and late capitalists.

The sculptural interdiction is not to subtract but to duplicate. Each part must match the next in perfect symmetry. Additions will go on indefinitely; the sculptural product growing larger and larger until, presumably, it occupies all available space. Indeed, Rogenes has suggested that, venues permitting, his sculptures will hopefully expand in this manner. What could he do to stop them?

Like Kurt Schwitters's room-sized *Merzbau*, Rogenes's works have a shrine-like quality— one that suggests the strange mise-en-scène of devotion of the contemporary department store. The thrown-away material wraps around the viewer's space but is devoid of the quality of 'junk sculpture' because the Styrofoam remains immaculately, transcendentally clean. Styrofoam is a material virtually without weight; it repels dust and liquids. Uncannily light, it seems to defy gravity, suggesting an applicability to spacecraft construction, so long as one forgets the fact that, like Icarus's wax wings, a Styrofoam craft would spectacularly combust if it neared the sun.

Even though its raw material is scavenged, Rogenes's sculptures appear brand new, even newer than new. This is because they are still fresh with womb-like associations to the electronic products they once protected. The new computer, regarded as a smarter object than most, must be packaged by a material that won't betray the illusion of its artificial

intelligence (computers don't come dressed in swaddling clothes). Unlike the relationship between skull and brain, the hard technology of the computer comes wrapped in a soft, protective layer that it later gets rid of.

Project 5.09e (1997), installed at Post, took the already-paradoxical notion of packaging—products masquerading as themselves—to even more hyperbolic levels. The viewer literally had to walk inside of a large cardboard chamber/cell fabricated by the artist in order to view the strange light-emitting deity it contained. The viewer became the product, or became equivalent to the consumer worshipping the product (it is difficult to tell which), leaving the Styrofoam to bask momentarily in the glory of its new-found divinity.

Fundamentally, Rogenes's works are about transport—that split-second journey between the dumpster and outer space. It's a perfect illusion, one that has long been perpetrated by the infinite number of movies to which Smithson referred, as well as the infinite number of factories that produced them. Rogenes allows the symbiotic relationship between capital and its waste product to keep inverting at light speed. He suggests that we be entertained by the cycle, and his work charts its movement as if it was itself a form of cinema. When the Californian movie theatres empty out in the evenings and the cleaners throw hundreds of thousands of Styrofoam cups into the recycling bins outside, one thinks of Rogenes's sculpture and the canny maxim it offers: here, trash is condemned to eternal life.

Charles Ray

Flash Art, no. 198, January–February 1998.

Exhibition review: *Charles Ray: Unpainted Sculpture*, Regen Projects, Los Angeles, 18 October–29 November 1997.

'Jesus Is Lord'—these words, rendered in a swirly, distinctly Californian surfie script, were legible as a slightly raised bumper sticker on the trunk of Charles Ray's new sculpture, a 1:1-scale fibreglass replica of a late-model automobile. The unfortunate vehicle in question was spectacularly pulverised in a head-on collision that killed its female driver before it was purchased by the artist from a police auction. Over a year later, Ray's blockbuster *Unpainted Sculpture* (1997) has itself absorbed practically every detail of that impact. Piece by piece, the totalled auto was pulled apart, cast in moulds, and reconstructed as a model version of itself. The result is an extremely decorative work of art painted tastefully in matt grey. The absolute disaster has been granted an afterlife in the baroque splendour of Ray's oeuvre.

Look at Ray's sculpture—the only piece in his solo exhibition—and you might see a car, but there does come a point where this and other similitudes come apart. The work is an optical illusion of the first order, mainly because it is a highly traditional piece of fabricated sculpture that seems to masquerade as some kind of 'response' to recent events in the media. In other words, forget Lady Diana's Mercedes and think of Rodin's *Balzac* in his heavy, flowing gown; dismiss all thoughts of Ballard and remind yourself of Anthony Caro's welded-steel constructions.

Super-realist sculpture of the kind practised by Ray is elaborate, not to mention funny—the painted 'unpainted' sculpture and the car's absent window panes are just two paradoxical gags laid into the work. But the absent body of the accident victim is probably the strangest thing of all. As we peer through folds of fibreglass, which are as delicate as Michelangelo's gown of the Virgin in his *Pietà*, we spare a tearful second for the crash victim who has, perhaps, returned to her maker. But, then again, that's a ridiculous line of thought before such an extremely atheistic work of art.

Span

Span (Auckland and New Plymouth: Artspace and Govett-Brewster Art Gallery, 1998).

Exhibition-catalogue essay: *Span*, Artspace, Auckland, 21 January–28 February 1998; and Govett-Brewster Art Gallery, New Plymouth, 31 March–17 May 1998.

> *. . . space breaks all obligatory continuity.*
>
> —Georges Bataille[1]

'Have trouble staying seated?' An Attention Deficit Disorder (ADD) website offers the gift of pathology to the person who cannot sit still, the one who experiences a nervous fidgeting, the one who finds normal things 'boring'. ADD—'a disorder as diverse as life itself' in which one time span asphyxiates another by way of a clinical interdiction: the psychiatrist tells you how long you should be looking at something. But all the digressions isolated by this hyperactive interlude represent a will to escape, a desire to see the world from a different angle, the choice to exit the theatre or drop the novel—the civil right to reject boring art.

In the new multiplexes, one sits down to be transported, is ushered through moving sequences, while the body itself stays relatively inert, attacked by comfort until it cannot be comfortable, cannot stand, cannot concentrate, needs to piss, or has other troubles remaining in situ. To get out of these dark, carpeted mazes in an emergency—mid-movie—is more difficult than it should be. One fidgets at the expense of total humiliation. As the crowd's gaze regroups, the temptation to divert attention is rounded off into the physiognomy of 'slump', a defeated posture that prohibits fidgeting but doesn't permit attention either.

ADD is only interesting because it posits a scale of inattention without defining attention. What is the perfectly understood work of art? Optimum attention, perfect comprehension, and the entirely coherent art work are unimaginable. Attentions on all sides are divided—split—between objects. This is why conventional narrative situations, such as the classroom or the ninety-minute feature-film format, are so disciplinarian in their defence of chronology. They deal out stingy dosages of so-called information in apportioned, segmented packages of time engineered for the reception of an 'average' viewer, all the time knowing full well that most of what they dish out will go in one ear and out the other.

Span is about these fluctuations in attention, inasmuch as they may be thought to register changes in the ways artworks in general, and videos in particular, are made and experienced. This is an exhibition about moving images, in a period in which it's impossible to delineate such a thing as a 'still image'. In this vital world—where video and film have

proven themselves to be the most greedy in their appropriation of the term 'moving image'—what eventually defines all images is their contextual variation and journey through space.

These video works by Jessica Bronson, Mariko Mori, and Diana Thater create Möbius strips in which loops, cycles, and artificial infinities build time warps; they stretch out across rooms rather than occupying timeslots. Without beginnings or ends, the works are like certain books that encourage the reader to open them at any page.

These videos operate within what we more modestly call 'space', that is 'architecture'—you walk past them, through them, and around them. Anticipating you and your schizy attention span, they don't plan to hold you down for a fixed duration. They tend to bend out and modulate the very idea of the viewer by presenting an art that either hyper-compacts or completely disperses linear narrative, creating a viewing experience that is more like passing through a revolving door.

With these walk-through videos, *Span* shows how those hilariously conceived 'disorders' of looking and thinking have been superseded by a combination of affects—what Jessica Bronson, in theorising 'A Poetics of the Video Effect', has called 'spacing in'.[2] It also shows how elaborate attempts to capture attention are losing battles—space will always win because, as Bataille put it, space is a 'lout'.[3]

Everything, these works assume, is moving, including the audience. Everything—the walls, the backs of the monitors, and the electrical cables—are transmitting or have something to utter. This synthesis of kinetic forces adds up to something more baroque than the structuralist trope of 'exposing the apparatus' of film. Here, computer-generated and filmed images are so decelerated as to become mesmerising or sped up to the pitch of delirium. Both wonder and boredom are produced—effects paradoxically close to those produced in viewing unmediated natural phenomena.

'Have you often wondered why in recent years there seems to be an increase in the number of children and adults with Attention Deficit Disorder, learning disabilities, anxiety, anger, and rage?', the website continues. 'Technology'—and specifically television—carries its fair share of the blame. One writer argues that television, 'by manipulating the way the brain responds to changes in perception, can wreak havoc on the ability to concentrate ... and thinking rarely intervenes'.[4] This is to say that there are certain types of movement that turn knowledge into an insensible blur. Media stand accused of defeating one another's dromospheric nuances and ethical values. Television, it is said, destroyed the novel only to be itself contaminated by the commercials that sponsor its duration but cripple its integrity. Cinema will be outrun by online, electronic transmissions and home-entertainment systems, which promote the campaign of destroying the outdoors once and for all.

'Video' (video art) can't compete in this diabolical contest of media. Being related to, but utterly distinct from, cinema and television, it wanders through biological, mineral, and technological time, transmitting its flat reverberating picture. There's nothing particularly blessed about it when it's lined up against every other culprit in mediated space, no special privileges or compensations. Why is video different to film, or to the other things that stir? The crystal ball in Mariko Mori's *Miko No Inori* (1996), a monitor within a monitor, is the dead centre of the otherwise quick world of the airport in which it was recorded—her calm is out of the ordinary.

Video transmits a kind of movement all its own, an electric movement out of sync with that of the human body, but one which draws that body toward it. It presents sequences from past time that have been horribly dismantled and delicately put back together again, and, in the end, the passage of images appears to be more or less smooth. But even the perception of movement is an optical illusion. The nineteenth-century scientist Étienne-Jules Marey revealed that physiological movement is, in fact, quite the opposite to how it appears to the human eye—or, for that matter, how it may appear to the video camera. Movement is all shakes and shudders—little violences that are subsequently rounded off. Movement and attention span are alike in that they are idealised as continuous, but are actually fractured, rough, and crazy.

Video tape rolls and so do its philosophical tenets and avowed principles—they all fall down and are replaced. Assume that 'video' itself—already burdened with any number of proposed critical destinies—is unable to pay attention to its delegated tasks and has erred, wandered off. Forgetting to listen to the frantic orders of directors, it has become delirious, inattentive, and miscreant, producing its own disorders and bubbles in space and time—for it seems that, in some cases at least, 'video' is exhibiting strange symptoms.

Where did it go?

When video acquires ADD, it does not mean the medium falls apart. It simply adopts new characteristics that weren't there to begin with, creating more foreign languages within the foreign language of video. It is not just the audience that can't sit still—the medium can't sit still. It misbehaves and reverberates with unnatural poise, like Diana Thater's animal actors, who, like ideal viewers, are trained into behaviour but will revert to other activities given half the chance.

Here, perhaps, are some explanations for the appearance of an art that runs continuously, seemingly without beginning or end, capturing the viewer's attention for split seconds and indeterminate durations.

1. Georges Bataille, 'Space', *Encyclopaedia Acephalia*, trans. Iain White, ed. Robert Lebel and Isabelle Waldberg (London: Atlas Press, 1995), 75.

2. '"Spacing out" is a phrase I have often applied to this state of affectivity, yet this terminology commonly implies a complete loss of affectiveness. While a person may appear to be outwardly inattentive, he or she may still remain attentive to an interiorised state. Perhaps, then, "spacing in" more aptly describes this inward shift in attentiveness.' Jessica Bronson, 'A Poetics of the Video Effect' (master's thesis, ArtCenter of Design, Pasadena, 1994): 2.

3. 'Unfortunately [for philosophy] space remains a lout, and it is difficult to enumerate what it engenders.' Georges Bataille, 'Space', 75.

4. Danielle C. Lapp, *(Nearly) Total Recall: A Guide to Better Memory at Any Age* (Stanford: Stanford University Press, 1992), 77.

Salvador Dalí: Oui: The Paranoid-Critical Revolution: Writings 1927–1933

Bookforum, vol. 6, no. 2, Summer 1999.

Book review: Salvador Dalí, *Oui: The Paranoid-Critical Revolution: Writings 1927–1933*, ed. Robert Descharnes, trans. Yvonne Shafir (Boston: Exact Change, 1998).

What is Dalí? Dalí is something horrible for us to laugh at. Not a threat to the canon, or even a serious artist, just an uncomfortable sensation brought on by the terrifying abjection of popularity, the mass-market exploitation of a signature, the disgrace of dilettantism, and Freud. One can only hypothesise that Dalí invented his paranoid-critical method, featured in this newly translated collection of his writings between 1927 and 1933, in order to defend his artistic and critical legacy from the humiliation it is generally subjected to nowadays. In that case, it's easy to comply with his self-proclaimed status as a genius.

Dalí engineered his paranoid criticism while under the spell of his father, his mother, André Breton, Jacques Lacan, Gala Éluard, and a number of others. Who could blame him for the extravagantly defensive method that resulted? Since then, a number of us have also been influenced by these and similar luminaries (with the notable exception of Gala). It may have been a surrealist accident, or indeed a tip off from Lacan, but Dalí's conflation of 'paranoia' and 'criticism' suddenly becomes something to consider for all those obsequiously tunnelling their way into the critical establishment, not to mention artists and scholars parsing one of the most important Robert Smithson conundrums: 'the artist who writes'.

Dalí's P-C method is at once a defensive and a purely generative platform for critical theory, a self-induced anxiety attack resulting in an endless flow of X-rated philosophy seminars. Dalí proposed a new 'anti-artistic' documentary form: when he squeezed his mind in the proper fashion, a torrent of images was produced—pianos, Galas, airplanes—and these would wait their turn to be calcified as objective facts in the ultra-science of surrealism. A documentary, as Dalí defines it repeatedly in these texts, is an anti-literary, anti-artistic drive that manufactures objectivity with a factory-floor mentality, attacking all lyrical and poetic impulses. 'When hands cease to intervene', he wrote, 'the mind begins to know the absence of blurry digital flowerings; inspiration detaches itself from the technical process, henceforth entrusted to the unconscious calculations of the machine.'

Much like Smithson's artist/writer paradox, Dalí's method, laid bare in these texts and elsewhere, notably in his fashion sense and his paintings, demonstrates the trajectory by which artists' pretensions to high intellectualism flourish in idealistic spasms—such fanciful turns of phrase!—and then jettison themselves from the sphere of academic rigour,

landing in another space altogether. This space, quite unlike the unflagging demand for Dalí T-shirts, is always on the verge of a credibility crash, suggesting, once again, that the writings of artists are a fragile genre, even if their art objects are darlings of capitalism.

Dalí's writings are brittle and bad tempered, shot through with contradiction and an atmosphere of desperation, which makes them particularly entertaining. Dalí was a hysterically moral thinker; he chose recreational psychosis as others might choose fundamentalist Christianity or extreme sports. Sometimes his hallucinations align themselves gracefully, as in the essays 'Photography: Pure Creation of the Mind', 'Psycho-Atmospheric-Anamorphic Objects', and 'The Rotting Donkey', in which Dalí discourses on crime, love, exhibitionism, and art nouveau all at once.

His ultra-orthodox psychoanalytic delirium, his ideas of multiple figuration, and his old-fashioned sexual perversion were handcrafted for the 1920s and 1930s, and fragments of those decades drift throughout the bodies of his texts: phantasms of technology and communism, elements of Man Ray, homages to Joan Miró, and so on. Dalí may have been a minor intellectual, but his project has a resounding importance, and his thought has compellingly reappeared in Rem Koolhaas's *Delirious New York*, Rosalind Krauss's writings on surrealism, and John Welchman's work on faciality.

It should also be noted that Haim Finkelstein edited and translated an even more comprehensive collection of Dalí's writings in *The Collected Writings of Salvador Dalí*,[1] and one eagerly awaits an English-language edition of Dalí's book-length paranoid-critical analysis of Millet's *Angelus*.

Oui is a worthwhile collection, but its own reasons for being are not clear—it is without a polemic. As a cabinet of avant-garde curiosities, the volume does rather well in realising Dalí's most acute fear: his own works' transformation into intellectual kitsch. This, of course, has been achieved several times over, and perhaps it's something that the master himself would have celebrated with a glass of wine. But there are other, more exciting applications of Dalí's method, and therefore it remains to be seen what the next wave of the paranoid-critical revolution will be.

1. Cambridge: Cambridge University Press, 1998.

Mike Kelley

Bookforum, vol. 6, no. 4, Winter 1999.

Book review: Isabelle Graw, Anthony Vidler, and John Welchman, *Mike Kelley* (London: Phaidon, 1999).

'For me, critical interaction has always been about sexual interaction.' This proclamation, made by Mike Kelley, appears in the midst of the interview with German critic Isabelle Graw that opens the new Phaidon monograph on the artist. In the interview, Kelley explains his ambivalence toward criticism, stating that in the early days he was 'forced' into writing about his work because critics were saying 'erroneous things [that] were then passed on from article to article'. Unlike Kelley's own landfill of 'erroneous things'—his collections of dejected or unfashionable cultural matter—this critical trash needed to be swept aside, as it were, perhaps even back into his project, as in his hysterically poignant works on 'abuse' and 'recovered memory', which answered the earnest suppositions that his stuffed-animal pieces *must* have been the sublimations of a poor, abused boy.

Obviously, this situation has changed. This monograph, perfectly illustrated and produced in association with the artist, achieves a synchronicity between image and text that builds on *Catholic Tastes*, the catalogue for Kelley's 1993 Whitney Museum retrospective. Largely written by longtime friends and collaborators—Dennis Cooper, Kim Gordon, Timothy Martin, John Miller, Colin Gardner, Howard Singerman, et al.—*Catholic Tastes* fused anecdotal evidence (recovered memories, even) with philosophical speculation to form a psychedelic united front. These essays complemented the artist's own previous writings on other artists as well as art-theoretical issues, while anticipating more recent, provocative, 'unauthorised' texts by Faith Wilding (who, in her 1995 essay 'Monstrous Domesticity', argued that Kelley's stuffed animals were ahistorical appropriations of first-wave feminism), Sande Cohen (who, in her 1998 book, *Passive Nihilism*, sharply critiques the curatorial practices surrounding the artist), and Rosalind Krauss and Yve-Alain Bois (who filter Kelley through a theoretical doctrine based on Georges Bataille's *informe*).

Compared to *Catholic Tastes*, the Phaidon volume has less of a 'club' atmosphere, and this is a strength. Graw pursues some intriguing lines of thought—she questions Kelley about the relationship between colour and sexuality in his work, and instigates discussions about 'crawling', neo-conceptual art, commodification, Kelley's collaborations with Paul McCarthy, performance art, and art education. The major essay, by John Welchman, 'The Mike Kelleys', tracks the artist as a multiple entity, who, if not exactly schizophrenic—as this implies a kind of babbling that Kelley's critical pragmatism contradicts—has engaged 'popular forms', conceptualism, neo-expressionism, and appropriation with a unique and

pertinent focus. 'Kelley is obsessed with the vanishing point of structures', Welchman writes, 'the places before and after logic settles into fashion or doctrine'—and indeed it would be difficult to dream up a more bewildering but accurate haiku for Kelley's work. 'Structures', and Kelley's vertiginous orbit around them, are investigated in passionate detail by Welchman, who, in accordance with Kelley's own method, splices chronological and historical data with unlikely theoretical digressions, such as his take on Kelley's animal motif, describing this profusion of creatures as a 'fantasmatic zoo, a Noah's Ark of refracted, coupling species'. Welchman, who takes pleasure in negotiating the meta-ironic traps and complexities of visual culture, is nonetheless obliged to tell Kelley's mythological story— Detroit, blue-collarism, Destroy All Monsters, Los Angeles, Europe, New York—but his essay is not overtly reverent either, and the section entitled 'The Art of Repression' deftly shadows Kelley's own highly ambivalent relationship to post-Freudian psychology.

Kelley's homages to and disagreements with recent art history are generally more tangible than his take on behavioural psychiatry's arcane stutterings. When addressing the latter field, Kelley's work is appropriately perverse—ideas of the subject and the analyst are consistently satirised. There's no 'subject' at all, in fact, which doesn't seem to concern Anthony Vidler, who, in his essay on Kelley's architectural-trauma epic *Educational Complex* (1995), produces a fine complement to a work literally constructed of gaps and erasures. The rest of the book is dedicated to Kelley's writings and Phaidon's customary 'artist's choice' section, for which Kelley chose extracts from Bataille and Charles Fort. Kelley's own texts, which need to be collected in a separate book, accomplish just about everything his critics achieve—often more. Placing texts by the artist and his critics within the same binding, this volume is a valuable guide for those who wish to learn and unlearn the lore of Mike Kelley.

Viewed in terms of Kelley's notion of the 'transitional object'—fetishes, surrogates, and the like—the criticism collected here can itself be seen as a 'transitional' entity, this book being a strange and inverted fetish of Kelley himself. In this scenario, we don't know who is the father, who is the mother, and which one of them had the alien baby—an ideal outcome indeed.

The Mobile

Originally published in Italian, 'La Struttura Mobile', *Tema Celeste*, no. 72, January–February 1999.

To be truly seen, the whole of consciousness has to be mapped onto an alien surface. Étienne-Jules Marey, the late-nineteenth-century physiologist who transformed conceptions of movement and chronology, faced a then-impossible problem of measuring eddies, flows, fluxes, and circulations in the blood and in the air; movement in human, animal, and purely spatial bodies. His techniques were opposed to vivisection, or what he considered to be the crudities of naked-eye observation. Marey's discovery, made clear by the spectral and arcane language of his chronophotographs, was that movement is a stuttering diction, smoothed off into chronological sequence by the human eye. This was a radical and strange idea, even in the age of instruments, for to reckon that the eye was wrong is also to dimly suggest that the whole of subjectivity, as it was being formulated and scientised at that time through the beautiful veracity of 'talking', could also be an error of judgment. Marey is today famous for unleashing the mechanistically stuttered image into the modern lexicon. He released the trace of a bird's flight through space onto a photo-sensitive ground and created a spastic language of the image, which has never sat still since. This perception attached itself permanently to the oeuvres of futurism and Duchamp, plainly enough; it now has tenure in the contemporary discourses of vision, linguistics, notation, and speed.

Marey perfected optical techniques; he was obsessed with instruments and with technology. Essentially, he created a photographic clone of movement, its prosthetic equivalent. Working in unison with Eadweard Muybridge, Jules Janssen, and Gaston Tissandier, Marey observed the diabolical mandate of photography—it draws everything in the physical world toward it. Philosopher of science, François Dagognet, insists that Marey's iconographic virility has morphed with the consciousness of mass reproduction, and can be situated at the core of the twentieth-century 'culture industry'.[1] Marey's insistence on prosthetic translation, as Dagognet understands, can easily become a grotesque techno-positivism. Marey's suppositions, for example, are politically ambivalent regarding the spaces that vision has been codified into subsequently; for example, the exemplary surveillance of consumers as they try on a new pair of shoes or use the telephone. However, when looking everywhere, I think of Marey and his incredible argument that movement is a foreign language located beyond the comprehension of an unassisted perception.

'Mareyism', as Dagognet calls it, is an advocacy platform for technology, progressive as well as immoral; for what does movement, in itself, generate on ethical terms? Marey participated in a prefuturist blind chirpiness, for which he can't really be attacked, unless

it's for the sheer state-funded optimism, which is seen as reprehensible. Marey was about a particular mania of perception, one articulated through the emerging super-sensitivity of machines. A certain pressure was applied to the image that obliged it to divide infinitely, a standard explanation of today's mediated environment. That many artists today are concerned with motion, sequence, recording, repetition, and cloning does not mean that their work comes from Marey. But, inasmuch as these works have revealed fractured and unprecedented forms of movement, they may be compared to Marey's investigations.

A hallucinogenre that reverberates with spatial inquiry and stuttering reception is video installation, in which no intemporal surface can be achieved, due to a constant recycling of space. In video installation, an effusion of pixellated light and colour photosynthesises architectural surface with traces recorded elsewhere or on the spot. The video projector provides a suffusion of imagery, a mosaic as opposed to an 'object'. It is a graph of continuous motion that can only be focused upon for a limited time until a retinal exhaustion sets in. In other words, it cannot be entirely perceived. To say that one has 'seen' a video installation does not mean that one has witnessed every circulating pixel or knows it by heart. It says that one has experienced, for an undetermined period, a sequence that may have no relation to the actual length of the piece itself, if indeed it has a fixed duration.

Diana Thater's and Jessica Bronson's video installations are designed to loop multiple projections of text, collected footage, and self-recorded images around finite gallery spaces, creating a televisual spectacle. Thater's work began in 1990 with a fork in the road of video art that she herself created. Dividing off from the major video artists Bill Viola and Gary Hill, who were producing heavy and psychologised annexes of darkness, Thater built a language of light and spatial properties, an architecturally sensitive, non-transcendental video on an epic scale. Thater has made a claim for a video of intrinsic qualities, and has built installations that, she argues, function against a psychoanalytic interpretation of cinema and the moving image by unpacking their mechanisms in the clear light of day and in the presence of the viewer and space: nothing is concealed. Likewise, Bronson shows video as a medium that has collected intrinsic qualities: effects generated in camera, peculiar distortions, colours (video green, video blue), sequences, and mobilities.

Bronson has a background in biomedical science, and her earlier works in video, such as *Tank* (1994), fused appropriated 'nature footage' of microscopic underwater creatures and footage recorded in a supermarket with a submarine-movie soundtrack. Bronson thinks of video as a medium that absorbs every field (cinema, science, and so on) and translates them into a curious, flat world that generates poetry. Her inventory of fuzz effects and on-screen distortions are like Thater's animal and nature videos, in that they ultimately

light up this technological space of video. Monitors, cords, projectors, and so on, all create an equivalence of surfaces and textures. Animals are taught to behave like animals and cameras to behave like cameras.

A sculptural object might be thought of as the physical opposite of video installation. The latter is physically expansive, self replicating, weightless, in dialogue with the surrounding architecture—an anti-illusionistic, fractured narrative situation; while the former is inert, illusionistic, singular, and varying in weight. The first throws visual material outward in a scattering, circulating motion; the second pulls optical attention inward and holds it emphatically around a particular material density. But sculpture is always kinetic to some degree, even for the fact of its discursivity.

For Charles Ray and Charles Gaines, disaster moves through space with a tangible and fetishisable momentum. Disaster is an elusive event that accessions a virtual physiognomy for itself. With jest and perversion, their works dedicate craft to the immortalisation of a moment that is otherwise imperceptible. In Gaines's *Disaster Machines: Airplane Crash Clock* (1997) and Ray's *Unpainted Sculpture* (1997), split seconds of impact and aftermath are granted not only a monument but an eternal return, for whatever use value that it's worth. Both these works are mechanically ironic and ventriloquised through mass transportation's native tongue—statistics. The accident, we understand, is inevitable; there is a science of its relative occurrence. Marey's question of organic motion has been usurped; motion and flow are now phenomena of capitalism: jet engines and automobiles.

Ray's 'car' does not move, but it is a cinematic experience nonetheless. The dramatic motion of the crash—this sculpture is a 1:1 cast of a wrecked automobile purchased from a police auction—has been sunk into the leaden space of the still, only to reverberate with the violent energy of impact all the more. This paradoxical relation between movement and stillness, as conceptualised in Marey's chronophotographs, is also an effect of Ray's sculpture, and this partly accounts for the brilliant weirdness of its *Popular Mechanics* phenomenology. Come to think of it, the pathos this sculpture has generated—pity for the victim, etc.—is a religious testimony for prosthetics, which is the exemplary game of Ray's sculpture in general. Ray's art is very convincing, but it might be convincing us of something terrible, that we are plastic after all. I am intrigued by the way people have felt emotions of pity before this fibreglass car. But, on the other hand, the world was in tears over the movie *Titanic*—the destruction of a very expensive model, strategically sunk into a vast ocean of tears.

On the level of manufacture alone, Gaines's dromology has less class than Ray's car, but it has more pedagogical wrath. Gaines's airplane-crash clock, one of the funniest objects

in the history of sculpture, is a soapbox critique of the statistician's tedious lecture about the safest form of transportation: the airplane. Every time a passenger jet goes down, one might hypothetically imagine, a red flashing light goes off on Gaines's sculpture— SCORE! Well, that's about as much sympathy the sculpture exhibits, anyway! It catalogues the eternal plummet of an accursed plastic jet, which, in perpetual encore, nose-dives every 7.5 minutes into a crafty, wooden, generic city made by the master Charles Gaines. In Marey, movement is articulated through sentences and in stages—the more complex the movement of the body, the more beautiful it becomes through that complexity. In Gaines, movement—descent—is flattened and glamourised. The hypothetical deaths of the Lego citizens happen one after the other. It goes by the clock, on time, and for the audience.

From the simplest incomprehensibilites of movement, a graphic language has erupted. Gaines's and Ray's works, although sculptural, are substantiated by the languages of abbreviation and condensation, which is to suggest that they are graphic diagrams of time and space. These works are to the technological disaster what the cartoon is to the human face, a ridiculous visage.

In her 1998 installation *Hades*, Christiana Glidden was present as a distressingly real silicon model of her face and body. This plastic version of the artist was called *Death of a Replicant*, a take on Paul Thek's sculpture *Death of a Hippie*. *Hades* is a map of sorts, which this replicant girl, a mute clone of the artist lying in a glass tomb, presides over. The space surrounding her was full of bits and pieces from her past life, and everything was floating in a mythological pond, stagnating, with special creatures (especially frogs) that had been created by the artist. In *Hades*, the dead replicant and the other objects tell the story of an artist obsessed with Thek and Smithson, who makes a journey through the swamp of post-1960s art in order to find self realisation.

Graphic language is prosthetic and infinite. Deleuze's essay 'He Stuttered' makes an account of how language itself, like the stock market or the airplane, can crash due to an unprecedented accident that sends shocks through the whole of a linguistic constitution.[2] Transposed from speech into writing, stuttering is a change brought about by an alienation. The stutterer's 'problem' with the language creates a new bubble within language, thus expanding the properties of language.

The embarrassment of stuttering slows down time, but the camera, very fast, compensates for the humiliation of slowness. Marey's figures appear to stutter across the span of the photograph. His revelation of movement was that it was fractured and broken, like a poorly prepared wedding speech in which the bride's father loses his possession of language. Two artists who graphically expose thinking, amputating their thoughts and dropping them

into two- and three-dimensional environments, are Frances Stark and Pae White. Stark's quotations, from the lexicon of available language, dart across paper in rote; their narratives allude to the romanticism of literary submersion, mountains, and dark, green landscapes. But, for all their insinuated pleasures, the movement of the textual image on paper is slow and tempestuous, anguished and laborious—traced sentences are stuttered and replicated across the page. Stark's works show how the mind, at least her mind, proceeds through complications, accumulations, and distributions of language; reading then drawing what she reads. These drawings are words, processed. They emit a singular delight. Perhaps they are a graphic equivalent of herself, a Mareyan diagram.

Pae White transposes brilliant graphics across space. She has delicately wrecked the happy distinction between artist and designer, for her intellect is editioned in the forms of catalogues and books, sculptures, drawings, and mobiles—without a trace of the mandatory disciplinarian anxiety. The ease with which this has been achieved is impressive and important. White will design work for an exhibition, then make its catalogue, and then the catalogue will become her art, and the whole exhibition gathers a dimension that most exhibitions do not even hope for.

The mobile, invented by Calder and specialised in by White, is essentially a flat plane vitalised by its suspension in light and space—an arrangement that destroys the unity of particular surfaces by affecting an animation in mid-air. Mobiles—and it's impossible to forget this when we say their name—move. They are at once an artwork and a trajectory. White's mobiles are like her books: they are narrative surfaces that anticipate motion, such as the flicking through of pages and gusts of wind that disarray. In this sense, everything she completes is a moving image and a storytelling machine that self replicates. The pieces travel through digital and three-dimensional space as if there were no distinction, changing all the time. From each flat plane of the mobile—which alternately proffers written language, organic surface (leather, snakeskin), as well as the many languages of colour—a microscopic delirium ensues. This blending of text, space, and chromatic intensity is impossible to follow, but the sensation of movement and blur is radical, though never too much to disrupt the overall symmetry of the arrangement.

This is a discourse about movement, but movement, in itself, does not amount to a discourse or even a point of view. Movement is an idea about life, centred on vitality, and a programmed function of machines that is subjected to scientific examination in many baroque fashions and filtered through the language of *techne*.

1. François Dagognet, *Étienne-Jules Marey: A Passion for the Trace*, trans. Robert Galeta with Jeanine Herman (New York: Zone Books, 1992).

2. Gilles Deleuze, 'He Stuttered', in Gilles Deleuze, *Essays: Critical and Clinical*, trans. Daniel W. Smith and Michael A. Greco (London and New York: Verso, 1999), 107–14.

The Fanatical Scenery of Elizabeth Bryant

Elizabeth Bryant (Los Angeles: Works on Paper, Inc., 1999).

Exhibition-catalogue essay: *Elizabeth Bryant*, Works on Paper, Inc., Los Angeles, 9 September–9 October 1999.

> *A thing is a hole in a thing it is not.*
>
> —Carl Andre's motto[1]

There is a hole in the perimeter fence of Huntington Gardens through which I occasionally crawl. I do so in order to avoid paying the hefty admission, but also because this secret portal affords me access to the garden as the sun sets. I linger on much-too-green emerald lawns after dark or watch the moon reflected in the koi ponds, pleasures unknown to regular people, as mean security guards shut the gates at 4:30pm on the dot.

Call me a thief, I am here to steal the view. But also to up the ante on Huntington's gracious 'gift' to the public: you may borrow my view (my assets). Such landscaped gardens—temperamentally public places—are based on the idea that the gesture of philanthropy is as good and as grand as Nature herself. Fantasy perspectives (the Japanese garden, the Australian garden, the desert garden) are sealed deliriums of peace within the equivalently psychotic urban suburbs beyond the fence.

Walking into the gardens, away from the rest of the city, you are apart from the city, but still carrying it with you, meaning that its impressions are reverberating under your eyelids, flashing back. But this 'nature' is so wired that it may as well be Alhambra, California. You think you're seeing a corpse flower, but you're just watching an English TV sitcom. The language of flowers is a language of wires. Such acidic bouquets, though, are usually enough to repress any ungenerous thoughts members of the public might otherwise have for the late Mr Huntington, who you imagine thinking:

> I purchase the grounds and germinate the foliage, after a fashion. In so doing I take out a lease (in my name) on the many mythologies of nature. The Garden of Eden will now be associated with me. A bed of roses, from now on, is nothing but a machine to produce a prosaic variety of delight to be followed quite shortly by beneficent thoughts about Huntingtonism. My garden is living lithium, a philanthropic narcotic, the plot where the opium for the masses is grown.

Falling Asleep at the Real

> *In psychosis ... reality itself initially contains a hole that the world of fantasy will*
> *subsequently fill.*
>
> —Jacques Lacan[2]

You have noticed that my argument is full of holes. But a lot of art is full of holes, not least the photoworks of Elizabeth Bryant, works that take as their theme the idea of nature and its organisation (the history of the garden as opposed to a study of nature itself, the formation and deformation of sentiment, and the paradox of the view).

To make her recent works, Bryant has seconded contemporary 'kitsch' photographic landscapes and subjected them to a process of incision-as-decoration, a collage in reverse that feeds on the pictorial like an ant feeds on honey. With a scalpel, Bryant will subtract (cut out) the silhouettes of many small ordered flowerbeds, constructed bodies of water, or pathways from fields of paper upon which such extreme landscapes flourish. Typically, one classification of landscape architecture—chosen from the history of the formal garden in the East or the West—is laid in reverse (as a window) upon a new and unlikely landscape, a typical-enough colonial incursion. This disjunction, however, is quite strategic; it produces pictorial raptures and ideological oxymoronics. In *Kashmir Pleasure Gardens/Alpine Waters* (1998), a diagram of a sixteenth-century irrigation system forms a sentinel-like absence in the middle of a fine, generic ogglescape that seems to hail from the 1970s, but that also cannot be placed, as it doesn't refer to anywhere in particular. The 'new' diagram of a garden design eats a hole in the 'old' landscape, producing a splintered, layered, kaleidoscopic image, which may be compared to Smithson's idea of displacement and the non-site, in that it is a '"logical picture" [that] differs from a natural or realistic picture in that it rarely looks like the thing it stands for ... [It is] the Non-Site (an indoor earthwork)'.[3]

Holes in the Unreal

> *I did not know whether to take the streets of Leipzig through which I traveled as only*
> *theater props, perhaps in the fashion in which Prince Potemkin is said to have put*
> *them up for Empress Catherine II of Russia during her travels through the desolate*
> *country, so as to give the impression of a flourishing countryside.*
>
> —Daniel Paul Schreber[4]

The intense photographic grounds that Bryant employs are quite amazing. But which comes first, the postcard or the view? Mountains miraculated themselves before they became greeting cards, but can we be sure of this—where did the mountain learn how to look like it does? Smithson—who wondered if art, as it approached gardening, was 'degenerating' (not such an unhappy fate in his eyes)—spoke of the photographic itself as a blotter paper for landscape and the sentiment surrounding its depiction. He wrote, 'The gardens of history are being replaced by the sites of time.' In other words, the living garden is sucked in by the coffin of the printed page: 'Memory traces of tranquil gardens as "ideal nature"—jejune Edens that suggest an ideal of banal "quality"—persist in popular magazines like *House Beautiful* and *Better Homes and Gardens*.'[5] Malevolently or miraculously, the paper landscapes found and used by Bryant buckle and bulge with the apparition of acidic lake, mountain, and tree, but such significations are utterly delusional, much like Prince Potemkin's flat and exotic gardens or Smithson's idea of the vanishing and reappearing garden. After Smithson, Bryant's works might be called non-scenes (pure nonsense) because we really don't know what we're looking at or where 'it' came from, as it came from nowhere and is the depiction of nothing.

The posters hail from what we will dub the Lurid-Landscape School of the late-twentieth century, a ghost-written genre in which both human sentiment and natural environment have met with a decidedly anorexic fate. The utter thinness (and emptiness) of these pictures is so excruciating, one might gain the impression they are, in fact, real vistas sliced into micron-thin portions, like servings of pastrami or microscope slides: forensic, generic pleasurescapes; tokens of a now-destroyed arcadia. Everyone can take a hit to their home (which doesn't have a view), leaving the carcass in the field to rot. And, as if to exaggerate this Armageddon of the picturesque, the colours are overdone—overkilled—engendering a whole new chemistry of delight; what Jeremy Gilbert-Rolfe, in relation to the video screen and the painted surface, has called a 'thin brightness'.[6]

In their original state, these posters of posters are a fascinating and excoriated sublime—art for hospital corridors, or, in their kinetic guise, an attention-plucking video that is projected during the panic-stricken moments of an airplane's take off. This is the garden as a synthetic mall. From Arcadia to the arcade: mallflowers. Images that call everything into stillness, they are all about anxiety. But, if such wallpapers on paper have a narcotising effect—and they do—Bryant's incisions wake them up. In this sense, Bryant's works operate like Fontana's slash paintings or Matta-Clark's opticalised, tunnelled-out architecture: the opening up of a protective or duplicitous surface is an occasion for light to come flooding in through a break in the sealed membrane. New sensations of pattern and juxtaposition are created. Bryant's works are simultaneously regressive and progressive.

The lurid landscapes are reified for their degraded spiritual fetishism, while the horizontal satisfaction of the garden schemes are flipped into the so-called (and very thin) air. Cutting a hole into something that is nothing.

Hung-Up Gardens

Heian Shrine Stroll Garden/Azure Vista (1999), the major work in this exhibition at Works on Paper, Inc., combines ideas of the view, the hole in the view, and movement (the mobile).

Bryant is preoccupied with the idea of place. But isn't 'place' a vague notion, even vaguer than non-site? The 'borrowed view', a term on loan from the lexicon of the Japanese gardener, has been a guiding principle of specificity. The 'borrowed view' refers to the space extrinsic to a garden: the view outside of its walls, its non-site; what it isn't, but what can be seen from within it. The amount of space allotted to a Japanese garden can be so small that it is often necessary for the distant view to be considered part of a garden's assets. The design of the garden and its perimeter walls—which are together understood as a microcosm of a greater nature, one perfected by the disciplined gardener—are organised around the best of available views, all the better if there are mountains or groves of trees in the distance. The garden as an optical machine creates a frame for what lies outside of its walls. Visitors must follow a set course, a chronology of 'vista points' that are precisely located in order to make the most of the surrounding landscape. One wanders through the garden on a network of paths that choreograph the elements: plant, pond, and stone. It is the site and the non-site rolled into one.

The holes in *Heian Shrine Stroll Garden/Azure Vista* are taken from constructed ponds around which the Heian Stroll Garden is laid out, and Bryant has expanded upon the scheme significantly. Creating a hanging, billowing landscape for the plot of the gallery, the artist has excised the bodies of water from the Japanese garden, cut their profiles into this generic lakeshore landscape, and suspended these phantom ponds in front of the picture plane as a mobile. The mobile, invented by Calder, is a 'trajectory', a narrative of movement.[7] A picture plane drawn and quartered, the mobile is made to contend with three-dimensional space, becoming a pictorial geometry to walk around and experience. The art gallery as stroll garden.

Mobile

The land belongs to no one.

—Jenny Holzer

The land might well belong to no one, but the view can be very expensive. Either that or virtually worthless. Capitalists, image gardeners, are always trying to give away things they never owned, like Huntington and his garden. It's much like the idea of the national park: the division of a great space into 'scenery' and 'non-scenery', or language into 'sense' and 'non-sense'. In a country as vast as this, a simple stroll through the garden is not good enough. It has morphed into the full-bore optical assault known as the road trip, and, following that, the screen. Huntington—who, for his part

> greatly expanded the existing railway lines, creating an extensive inter-urban system that provided the transportation necessary to encourage population growth. As a result of the railway linkages and the development of the property adjacent to the lines, the population of the region tripled between 1900 and 1910.[8]

—was a lover of 'the west'. He loved seeing it from a vehicle moving at speed. Now the west is a body covered in optical spots, divided by roads.

There is a final and unlikely reference laid into Bryant's project. During the postwar economic boom, Standard Oil Company conceived of its own blatant (but charming) versions of borrowed view. Their scheme is more accurately called 'Pay for View', as the idea was to draw a map of great natural wonders in the Western United States that were (conveniently) situated near Standard gas stations ('See Your West' was the tagline). As they themselves wrote:

> Many other natural-color Scenic Art Prints will be distributed at two-week intervals in this vicinity. These are part of a series of sixty pictures selected from 7,000 beautiful views, which we are giving away at the map under this print. Distribution zones are arranged so that you may get several pictures in a normal day's driving. On longer trips you can get an even larger collection.

The road-trip fanatic, Standard Oil accurately predicted, would fill their empty album with rather striking renditions—photographic souvenirs—of the local scenery, images that could only be obtained by visiting the gas station nearby the scene in question. Go to the gas station, fill up the car, get a free 'art print' of the surrounding landscape.

The car thus takes its own 'stroll' through the desert, the coast, the mountains, selecting its own 'vista points' in accordance with its appetite for petrol. In *The Migration of Paradise 2* (1997–9), Bryant has made television tables of these souvenir 'art prints',

continuing her practice of cutting absences into their skins. The series poses the question as to whether these 1950s drivers took in national parks, lakes, and deserts, or if they were simply embarking on a national tour of gas stations (which, in itself, would be quite an arid thrill). But that's hardly their final point. Suffice it to say that these enlightened pit stops, like Japanese gardens and non-sites, are possessed of the most wonderful 'borrowed views', views that the cash-spending traveller could take home and enjoy as a thin slice of life. And, as Bryant takes pleasure in reminding us, the conceptual interest on this debt is steadily compounding as time goes on.

1. Cited in Robert Smithson, 'A Thing Is a Hole in a Thing It Is Not', in *Robert Smithson: The Collected Writings*, ed. Jack Flam (Berkeley and LA: University of California Press, 1996), 95.

2. *Seminars of Jacques Lacan: The Psychoses 1955–1956*, ed. Jacques-Alain Miller, trans. Russell Grigg (New York: Norton, 1997), 45.

3. Robert Smithson, 'A Provisional Theory of Non-Sites', in *Robert Smithson: The Collected Writings*, 364.

4. Daniel Paul Schreber, *Memoirs of My Nervous Illness* (1903), trans. Ida Macalpine and Richard A. Hunter (Cambridge MA: Harvard University Press, 1988), 224.

5. Robert Smithson, 'A Sedimentation of the Mind: Earth Projects', in *Robert Smithson: The Collected Writings*, 105.

6. 'Cabbages, Raspberries, and Video's Thin Brightness', *Art and Design*, vol. 11, no. 5–6, 1996: 14–23.

7. Giovanni Intra, 'La Struttura Mobile', *Tema Celeste*, no. 72, January–February 1999: 50–5.

8. www.huntington.org. No longer online.

Mike Kelley and Paul McCarthy: Repressionism Is Dead
Art and Text, no. 68, 2000.

Think of it as psychoanalytic boot camp: superior-to-inferior interdictions, sludge, oatmeal, and lard, all pushed about by men and women dressed in military fatigues, ordering each other around in an epic *M*A*S*H*-style installation. The subordinates—naked, giggly she-males and what are obviously uniformed graduate students, some thirteen of them—move from tent to tent, shower stall to mess hall, taking part in short and humiliating skits that seem to have been suggested by these stark, floodlit environs.

The rear admirals, as it were, are none other than Mike Kelley and Paul McCarthy, two salivating, perverted commanders acting out a post-Disney version of Pasolini's *Salo*. This is their own art work about repression, *Sod and Sodie Sock* (1998), and it reeks of hard labour, strict discipline, comedy, and shame. In the catalogue published by the Vienna Secession, which hosted this installation, images of the aforementioned activities are interspersed with art works by figures such as Pollock (whose paintings appear next to stills from splatter films), David Smith (whose *Cubi* sculptures are visually likened to torture benches), and Brâncuşi (whose *Endless Column* becomes more phallic than I had ever imagined it to be). In between are sandwiched stills from your favourite war movies—*Apocalypse Now*, *Escape from Colditz*, and other generic fare—as well as 'untitled' porno screen grabs featuring male marines having their wicked way with other male marines, plus scenes of heterosexual shower-room voyeurism. Oh, and a few aliens wandering around for good measure.

Sod and Sodie Sock is consistent with what I think of as Kelley's transsexualism, by which I do not mean 'drag', in the standard sense of male-to-female impersonation or vice versa (although this is a subject the artist has long been interested in), but the literal elongation of contemporary cultural myth, the dragging and dirtying of concepts. Of course, there is the genetic splicing of 'freak culture', West Coast conceptualism, and blue-collarism usually present in Kelley's work, which amounts to the classic repression scenario with a twist, but there are also the more obscure and tangled distortions that have been made of other ideological dictatorships: psychoanalysis, psychiatry, pedagogy. Kelley's work is often thought about in relation to the conceptual reappraisal of freak culture, by which we are expected to imagine 1960s counterculture in its pure and unfettered form (unlimited sex for everyone and fuck the police). But then, is not psychoanalysis, with its history of freaks on both sides of the couch, an even more literal manifestation of this idea? Kelley's work, the way I read it, not only invites us to think that psychoanalysis is freak culture, but that so too is curatorial practice, art criticism, and graduate school.

Psychoanalysis in drag? It is not so much a question of psychoanalysing any particular freak culture, which has proven to be a depressing ambition, but freaking out psychoanalysis and other administrative mass movements by way of an anamorphically enunciated polemic. Take 'repression', one of the most classical conceptions of twentieth-century thought. Kelley makes work about repression, but the terms of his 'about' are very distorted; one of his most important schisms being the idea of insincerity, or at least the laughable spectres of confession and 'good faith'. His stuffed-animal sculptures were understood as confessions of his own child abuse, so he made a series about fake recovered memories, a perversion of the idea of sincerity. *Sod and Sodie Sock* might be read as a work about what is 'repressed' by the trumpeting force of military aesthetics, but all of those ingredients— homosexuality, fetishism, voyeurism—are already and forever entirely manifest, and Kelley and McCarthy provide the documentary evidence to prove it. The sincerely frozen atmosphere of repression and counter-repression that characterises the work of, say, Pierre Molinier, does not have a referent here, as Kelley takes theatricality much further than does the latter. Instinctual desires, as they arise, are satisfied to the point of redundancy, not timelessly necrotic eroticism. The luxury of *Sod and Sodie Sock* is that desire is extinguished and everyone is sitting around twiddling their thumbs. The Koonsian Major General, Cindy 'Sherman' T. Potter, has his way with the cadets and is bloated with post-coital uselessness. The repressed has returned so many times that you get sick of the sight of it.

'I have increasingly dealt with biographical materials', Kelley said in a recent interview with Isabelle Graw. 'But much of it is blatant lies.' Marginalisation and repression, inasmuch as they have been related to the analysis of culture, are Protestant, juridical ideas, based on the triumph of the underdog and ideological puritanism. They are mathematical formulas of equivalence by which 'repressed' cultural matter eventually returns to the surface, as if it were as easy as sticking an *Easy Rider* poster on the wall and announcing the return of '1960s style' (this is done all the time). To call an image 'repressed' when it is, in fact, everywhere is a perfectly deluded conception. 'Culture is not fair!', as the child would say, and, in this sense, the concept of 'pseudo' is a joyful one for Kelley: pseudo-man (half a man), pseudo-artist (craftsman/woman), pseudo-human (alien). Kelley practises a kind of pseudography inasmuch as all of his transsexualisations should be regarded with sincere suspicion. Try taking *Sod and Sodie Sock* seriously—you will go insane. As a work of pseudography and perverted cultural analysis, however, it makes perfect sense.

At the end of the *Sod and Sodie Sock* catalogue, Kelley and McCarthy have made a collage narrative using photocopied, uncited pages of various psychoanalytic texts, military jokes, and other glossolalia. 'The Social Function of Sexual Repression', which it appears to be

titled, is an example of textual drag in which alien paragraphs blend into one another. Photocopied edges of books, scrawled notations, and inappropriate quotations ('his mother died when he was very young'; 'Brâncuși ... pursued the monolith to the ultimate extreme') are Reichian, Greenbergian, Kelleyan, whatever. These unidentified, 'repressed' authors all contribute to making this dandyistic nonsense the best catalogue essay I have read in a long time. 1960s counterculture was one thing, but, if you want something really far out, try post-Freudian critique.

Spandau Parks

Art and Text, no. 68, 2000.

Exhibition review: Los Angeles Contemporary Exhibitions, 18 September–13 November 1999.

Spandau Parks is a painter with no ideas. Perhaps he has one idea, and this is to work on a painting for twenty-five years, but I'm not sure this qualifies as an idea, more like something that one receives a gold watch for. Notwithstanding, Parks's exhibition at Los Angeles Contemporary Exhibitions (LACE) was not even a painting exhibition; it was a photography show. For some reason, these twenty-five-year-old paintings-in-progress were held back in the studio (waiting to be shown in another twenty-five years, perhaps?), and, in their place, as if to advertise their arrival, were three mural-size, contemporary-looking photographs of the paintings, slickly mounted and spectacularly ugly.

What do we know about Parks? Well, almost nothing. He went to art school with Paul McCarthy (in conversation with artists and so on, this seems to be the principal calling card for the show). 'Spandau wears a baseball cap', a LACE employee informed me. He shows at Hauser and Wirth, Zürich, the press release shares. Well, that's something, but it's intriguingly nothing, too.

Parks's photographs have been described as indescribable. What an annoying conceit. In this exhibition, there were three of these things: towering, ultra-shiny, polychromatic, glistening fields of photographic surface that reek of acrid chemicals and high-end Kinkos-style office reprographics. Apparently, the twenty-five-year-old paintings-in-progress had a four-by-five camera aimed at small sections of them, and the harvested details (we know neither where in the paintings the images come from nor how much of the paintings they show) became the subject of the murals. The murals are nice enough to look at, as you might imagine a surface that has had this much paint applied to it would appear. There are chunky, tapering bodies of solid paint, covered by translucent glazes of electric, flashing colour; more daubs smother them as curly, anthropomorphic skeins jut out from the obese surfaces with an inquiring motion, like buds in springtime. Occasionally, some fantastic bubble appears as a half-sucked candy bar; other ripples of paint are, for a split-second, labial folds. If you can recall details of Rosenquist paintings that feature luridly inedible spaghetti and tomato sauce, you would be getting warm; perhaps also imagine Cindy Sherman's irradiated mould-and-waste photographs; or, better still, an over-cheesed lasagne blown up to three-hundred-times life size.

Of course, I'm missing the point. The exhibition is about a highly misunderstood idea, 'process'—the main evidence of this being the time involved. 'Becoming-sculptural,

becoming-performative' is one excuse the press release gives for Parks's eternal deferral. Please don't wear out Deleuze in this way. 'Twenty-five years' is, at once, a completely fascinating and uselessly vague term to describe the time art takes, and thus what process might be. The gravity or bravado of time is what might make these photographs/paintings appealing, but the process of rephotographing detemporalises them, giving them the appearance of every other painter's slops bucket. Allow me to state, however, that spending one's lifetime on a work of art is one of the most beautiful ideas imaginable, if there's a reason for it.

Perhaps the works' most interesting effect is to set off a rabid anxiety in writers like myself who are simply ill-equipped to handle such a radically directionless project, one that seemingly aims itself at the heart of the discourse of painting and then ambivalently negates it. When an artist does not state his or her intentions, we might take them to be intentionless, and, if Parks were truly an intentionless artist—and this I somehow doubt— then his would have been a fantastic project.

Dave Muller: Free Software

Art and Text, no. 69, 2000.

Art works + audience + music + beer. Does this = social sculpture? If so, then the whole principle has haemorrhaged: every gallery opening, every artist or art entrepreneur from Joseph Beuys to Charles Saatchi—anyone with a drink in his hand!—could be thought of as some kind of activist or political agent. But that would be perverse, as the historical impetus behind the dematerialisation of art was said to have been at least partially an allergic reaction to the institution and the marketplace, as nebulous as those things have always been. Where can the line be drawn today, when it comes to the articulation of a political practice? The Los Angeles–based artist Dave Muller comes into focus as someone who has looked at ironies dished up by the last two decades—the question of artistic communities, public art, the schooling of artists, and the 'commodification of dissent', to use Thomas Frank's phrase—and has formed a response to these circumstances without negating the radical impulses and precedents that were set by critical forms of 1960s and 1970s art. It is in the space after Kaprow, Fluxus, and Cage, after 'the 1980s', after the last five years of goodie-providing neo-social sculpture (Rirkrit Tiravanija, Jorge Pardo, and so on) that he has staked his claim. This is the space in which I think his work takes hold: a specific and often contrary adaptation of these previous models; in other words, a fusion of politics, territory, and business acumen.

Muller is one of the best marketeers of the LA moment, and, by this, I do not mean he is some kind of slapstick demographer or has anything in particular to do with the grotesque art of public relations (marketing, after all, was one of Duchamp's great specialties: the inflation and speculation of the concept, how the idea plays out in space, all factors that contributed to the success of international conceptualism, not to mention today's deliriously speculative market for contemporary art). However, it cannot be denied that Muller's extended practice is fascinatingly tied up with the idea of promotion and its consequences as a form of social sculpture.

'Marketing' is perhaps a distasteful metaphor for Muller's project, which is overwhelmingly positive in nature, but there are two ways in which this oracle might be brought to bear upon his work. As writers on the artist have noted, his output appears to be divided in half. On the one hand, there is art production *per se*, in the form of small, crisp watercolours on paper depicting other artists' gallery invitations, event flyers, and printed material; on the other, there is organisational/promotional work for the artist's celebrated 'nomadic artist-run project space', Three-Day Weekend.

TDW is an event and a commentary on events, a diagram of the social space of art, even a work-producing machine. The TDWs—exhibitions held together by art, music, and short expanses of time—do not necessarily announce themselves either as works or as protests against any fantasised 'establishment'. They have proceeded quietly since Muller's time at CalArts, when he used his studio to present other people's art instead of making his own in it. Seven years later, in 1999, a TDW was presented at Gagosian's Beverly Hills gallery as part of a group exhibition about LA curated by Terry Myers. In the interim, these events have taken place in veritable broom closets and respectable galleries alike. Featuring artists from many different cities (perhaps fifteen in one showing, and far too many to mention in total), TDWs—and there have been more than thirty of them since February 1994 alone— have been held in Tokyo, New York, Chicago, San Francisco, and a number of European locations. The nerve centre of the project, however, remains the artist's former studio in the Echo Park district of Los Angeles, 1818 Glendale Boulevard, where I drunkenly experienced Muller, Mike Kelley, Jim Shaw, et al. (a.k.a. The Gobbler) performing before Patrick Painter and a large studio audience.

TDW, which Muller describes as an 'artist's project', succeeds in that it is not nostalgic, pedigree-driven, or ambitiously self conscious; it claims for itself the ingredient of fun. 'I see myself as an organiser rather than a curator', Muller said in a recent interview with Hans Ulrich Obrist. The historical models TDW resonates with—Harald Szeemann's 'Museum of Obsessions', living museums by Spoerri and others, 'relational' sculptures by artists including Franz West, not to mention the international tradition of artist-run spaces, especially strong in London, the Netherlands, Australia, and New Zealand—are present in the back of one's mind, but they don't clog up the spontaneity of Muller's gesture. Muller works to extend 'the perimeter of the territory of the work by constructing a space bordering on architecture and welcoming an audience' (to quote Achille Bonito Oliva on Kaprow), and, in so doing, creates a novel sense of effusiveness around discrete works of art.

Connections between Muller's works on paper and the TDWs are not frequently stressed. Why not? Muller's enterprise should be understood en masse, not in parts. The overall project—the point, if you will—is the conversation between seemingly disparate activities and their chaotic fusion in one large body of work that encompasses the social situation. Not documentaries, strictly speaking, the exhibition-flyer paintings call up moments in time and the characters populating them. Muller collects and archives the thousands of flyers that come his way and sometimes makes a watercolour portrait of one of them. These riff on the date paintings of On Kawara, which likewise offer a meditation on time or a means to negotiate its passing, even decorate it. Sometimes, they're quite pretentious, i.e., these

artists are my friends. The original flyers, published by commercial galleries (including Muller's own LA gallery, Blum and Poe) or other experimental venues, are advertisements before they become paintings, and, in one sense, remain so after the fact; some sort of art-historical 'product drops'.

One of the effects of 'the 1980s'—i.e., big money, ecstatic language, and an over-enthusiastic demand for 'art'—was the dehistoricisation of art to the extent that 1960s models of practice, style, and life reappear today as a kind of salon art, as in the Factory-style parties currently held by dot-com millionaires that are choreographed in advance. The very idea of 'the market' produces anxiety for many contemporary artists: sell too much, one is critically invalidated; too little, bitter and poor. Major museums are accountable in strange new ways. 'Self promotion' and 'selling yourself' are classes offered by many art schools; and starting one's own exhibition venue, as Muller has done, is considered a venerable tradition of alternative practice. This is an environment of contradiction. A time-based event like TDW does not always offer a product as such, or even take an 'anti' or 'pro' stance (and Muller is, perhaps, too strategically quiet on such questions), but it acknowledges that there is a capitalism of the event, and, even though time is fleeting, it must be milked. As we glean from *Out of Actions*, Paul Schimmel's 1998 LAMOCA exhibition, time is the money of the performative situation.

That Muller's project has blossomed within today's 'healthy' American economy leads one to wonder. Indeed, why would one idealise the fact of art when there's money to be made? I think it is because Muller's work fosters the vitality of the idea, whether it takes the form of a live event, a social conviction, a picture, or the residual chatter that hangs in the air of a TDW. To concentrate on the event and its flotsam and jetsam in such a non-fetishistic manner means that much of the content of those moments slips through Muller's fingers— and this is, in fact, desirable. Muller doesn't set out to own what he chooses to show at a TDW. People see things and other people get shown, and there is a promotional engine involved here, of course, but many things about TDW are completely non-documentable, unrecoverable. This is an argument for practice as experience. It is a matter of producing an event via art that may replicate itself in a positive fashion: the act of marketing the unsellable. Muller is an artist who creates events that have both use and value. His example and his ideas are always available for future application.

Daniel Malone: Triple Negative

Art and Text, no. 70, 2000.

In New Zealand and Australia, segments of the population are afflicted by what is referred to as cultural cringe. Although this syndrome appears in many countries, these nations boast their own regionally specific varieties, as with tropical diseases. A complex that has not yet yielded a master list of diagnostic criteria, cringe is nonetheless a burgeoning field of study, and, indeed, practice. It might be described as an experimental or phantasmic identification with a different culture that haunts the antipodean, who is, by definition, isolated. (There would be European variations on this, for instance, the 'primitivism' of Picasso and Braque.) The ungraceful face of influence, cringe is an important theme in New Zealand art, if an inadvertent one. And it is a double-edged sensation: embarrassment at the state of one's culture, plus a megalomaniacal overestimation of it, which, in certain cases, grafts the horror of entropy onto the benevolent notion of identity, making a real mess of recent progress in this area. Paul Hogan of *Crocodile Dundee* fame is the patron saint of cringe, not for downplaying himself—as his identity is already paradoxical—but for the opposite reason: a hyperbolic intensity of character performed to sickeningly theatrical proportions. Cringe is to identity what wealth is to debt: the hallucination of prosperity, sophistication, and authenticity ascertained through an ironic hall of mirrors. Not so much the opposite of national pride, it is a perversion of pride.

The profound desire to be someone else, a symptom of cringe, is a common-enough preoccupation in twentieth-century art history—it is manifested in the transsexualisations of Duchamp and, more recently, the staged racial drag of Yasumasa Morimura. The results, as we know, can be both comic and terrifying. Auckland-based conceptualist Daniel Malone, most significantly a practitioner of video and investigator of the performative action, has, over the past ten years, produced a sustained response to this 'given' of New Zealand art. An artist of Cherokee descent who plays the race card as if it were a set of bagpipes, Malone has articulated these questions through the synthetic languages of tagging and spinning—signing a name and then erasing its sequence—and has produced brilliantly reflective gestures that are both antagonistic and celebratory.

Malone might be considered a kind of portraitist, only, in his delirium of cultures, he produces what I think of as a portrait in reverse, a vertiginous face that rapidly dematerialises. This occurs in a work entitled *Kum of Sum Young Gai* (1995), for instance, a collaboration with Denise Kum, a Chinese–New Zealand artist. By way of prosthetic makeup, Kum grafted Asian features—most obviously eyelids—onto Malone's face. These plastic lids allowed

Malone to be a pretend Oriental for a day, and, in this precarious, synthetically Asian state, he wandered the streets of Chinese-ified Auckland, trying to blend in the best he could. It didn't work, of course, and this was the point. As a fake Asian man, Malone was awkward and theatrical, like spelling mistakes on a restaurant menu, each misstep serving to amplify empathy and identification to the point of absurdity.

This performance, you might have gleaned, has something to do with identity politics. However, if much identity-based work is predicated on the assumption that identity is an intrinsically good thing—the validation or affirmation of a presumably marginal existence—Malone's project takes us in the opposite direction. 'It is not an attempt to identify with the other', he says. 'My work is a refusal to identify with notions of self that identify an other as other.' In other words, when Malone pretends to be a person of an ethnicity distinct from his own, he pretends to be pretending to be a person of another ethnicity—a fine oracle of contradiction.

Malone, or 'Mal-one', as his graffiti tag announces, has, appropriately, occupied a marginal position in New Zealand art, mainly working outside of institutions, or within them, covertly. Malone has performed such actions as replacing videotapes in other artists' museum installations; breaking contracts with curators and gallerists; and regularly making impromptu, unrehearsed, unlikely performances in places curators do not gather (for example, in collaboration with Harmony Korine, Mal-one spent one 1996 afternoon in Queens, New York, repeatedly shooting a tree with a Glock pistol for a sound work called *Amerika*). One season, Malone simultaneously grew an Afro and a Fu Manchu moustache; he was hardly recognisable. Then came his feature-length video, *A Street Kid Named Desire* (1995–9), in which an all-Asian cast (excepting its star, Daniel Malone) played out the noir-ish illegal routines of an imaginary triad who languish in small envelopes of Auckland that, for all intents and purposes, appear to be locations from other cities: corporate arcades, generic parking structures, and public restrooms. For an exhibition about fetishism, Malone changed his name to Billy Apple, a New Zealand pop-conceptualist himself once known as Barrie Bates. And, in the performance, *In Advance of a Broken Leg* (1997), the artist smuggled a syringe of 'homebake' heroin into Australia, a country where the drug is readily available, inside the plaster cast he was obliged to wear when he almost broke his leg running away from a security guard who caught him tagging a corporate lobby in Auckland.

For *Art and Text*, Malone has produced a series of images demonstrating the crisscrossing of iconographies that characterise his practice. The project *Me Tū* splinters off from the landmark hip-hop album *E Tū* by the group Upper Hutt Posse. *E Tū* (which, in Māori, can mean 'hold up', as in 'hold up your hand', or 'hold up', as in 'stop') was released in 1988 in an

intense political climate, following the creation of the Waitangi Tribunal to address Māori land claims in 1975 and the much-protested tour by the white South African Springboks rugby team in 1981. That moment was important in terms of affiliation of urban Māori with hip-hop, as a political stance as well as a style. Dedicated to the fight against injustice, *E Tū* was known to the art scene perhaps because the artist Terrence Handscomb and curator George Hubbard were involved with its production.

Me Tū, a homage to *E Tū*, is a typical Malonean meta-critique. In a photographic restaging of the original album cover, Malone stands on a freeway overpass, alone. He is sporting a downbeat homeboy/hip-hop style. The words 'Me Tū' (in Māori, 'me' can variously mean 'as', 'with', 'and', or 'for') sprout from above his head. In his hands are cardboard containers of Just Juice, Upper Hutt Posse's corporate sponsors. Here, Malone reinvents the product drop. In the photograph, he is poised to throw these juice containers, which are actually filled with paint, onto the freeway below, where they will inevitably be run over and thereby form a massive splattered painting—a bombing whose final composition is decided by chance. Bart Simpson–like in its delinquency, but Cagean in its pretences to indeterminacy, Malone's painting system is a three-dimensional allusion to the computer game *Tetris,* in which players arrange cascading digital 'bricks' into the orderly semblance of a brick wall. The 'bricks' in *Me Tū* fall to the ground below, forming an enormous, nameless tag. Not forming words or marking territory in any sensible manner, Malone's painting writes the signature of no one. In *Me Tū*, the artist throws himself away.

Malone's performative gesture, focusing on his body and a litany of signs, does initially pretend to a kind of multicultural masquerade. That, at least, is the positive side of the gesture, the visible outcome, indicating his support for Upper Hutt Posse, their music, and politics. But what is missing is the negative, that which is ejected—and, of course, it is Malone himself who is etched out of the picture. If, by magnification, Malone repudiates the project of interracial, intercultural identification, then he substitutes the synchronicity with a nothingness, an anamorphic tag, a signature that detests its author. Malone's brick game stacks such negations alongside each another: double, triple negatives. There is malice in this, but it is mixed with a certain flippancy. In surpassing what local critic Matthew Hyland, commenting on the fallacies of intercultural identification and historiography, calls a 'toxic empathy', Malone becomes an engine for the overproduction of cringe, and it is a strange force to wield. As a pun, Malone swallows culture whole, perhaps for the sheer delight of poisoning himself, and vandalising the freeway to boot.

Daniel Paul Schreber: Memoirs of My Nervous Illness

Bookforum, vol. 7, no. 2, Summer 2000.

Book review: Daniel Paul Schreber, *Memoirs of My Nervous Illness*, trans. Ida Macalpine and Richard A. Hunter (New York: New York Review Books, 2000).

Every hundred years or so, there is an unlucky person who, for no apparent reason, is singled out by God to be told magnificent and terrible things, things that will forever change the course of history. In 1893, this person happened to be one Daniel Paul Schreber, a presiding judge of the Superior Court in Dresden. Pulverised by God's will for more than nine years, Schreber finally whipped himself into a lexical frenzy, producing an excruciating tract designed to secure his release from the asylum in which he was incarcerated for having claimed to be able to channel God in the first place.

Luckily for Schreber, his defence worked—he was set free. And luckily for us, his rambling release petition was published, as *Memoirs of My Nervous Illness*, in 1903. Those of you who have read *Memoirs* know just how exquisitely entertaining it is to wallow in the psychosis of a nineteenth-century German bourgeois who was married but miserably childless, whose father was a notorious promoter of 'physical culture' and child psychology (in its infantile stages), and who got a lot of (unsolicited) mileage out of being written about by Freud in 1911, long after the celestial voices had subsided.

The standard contemporary line on the unwitting Schreber—whose words have been meticulously tinkered with by a host of thinkers, including Jacques Lacan, Elias Canetti, Deleuze and Guattari, and, most recently, Eric Santner—is that he is central to almost everything. Schreber was instrumental in the development of psychoanalysis, not to mention its post-1968 deconstruction; of fascism, for his obscure proclamations on the Jewish race; of queer theory, for his haughty transsexualism; of McLuhanesque information theory, because Schreber's universe was one of wires and cryptic messages; and of anti-psychiatry, for calling his doctor an 'assistant devil'. Beyond all this, in Santner's view, Schreber cuts to the quick of power itself, revealing fissures in language, history, and politics that point to a generalised 'crisis of symbolic investiture'.

Schreber is appealing because his writing is loose and vague, full of sex and politics—a kind of information pornography. It fulfils the pleasures of his readers whatever their ideological persuasion. *Memoirs of My Nervous Illness*, recently re-released by New York Review Books, has long been out of print. The second English-language version, published by Harvard in 1988, sold out long ago, leaving what Sander Gilman dubbed a 'new generation of outlaw Schreberians' carrying stacks of third-generation photocopies already pawed over by their professors.

What are the *Memoirs*? They are, principally, legal/theological diaries of Schreber's highly conflated physical, sexual, and political experiences, crammed into a book that reverberates with an uncanny, cosmic abundance—but which, comically, is styled as a bizarre, what-I-did-on-my-summer-vacation type of narrative. Schreber's epic tale begins with bouts of insomnia—little ripples of executive stress, really—but, as the pages turn, the reader can feel the psychosis taking over. The pious words of a judge soon become tangled with the interjections of an evil and lascivious God who is bent on, as Schreber put it, 'destroying my reason'. What Schreber means by 'reason' is really his body. God was apparently sexually attracted to Schreber's intense 'soul-voluptuousness', and, because God can do whatever he wants, he decides to turn Schreber, the last man on earth, into a woman for his personal satisfaction. It then becomes Schreber's task to repopulate the then-barren planet. Everyone—the 'fleeting-improvised-men', the ghost orderlies, the ghost doctors, his ghost wife—has a part to play in his transformation into a holy whore, and Schreber's paranoia, his only real defence against this ultimate indignity, plays itself out through crystalline descriptions of celestial warfare and the over-the-top proclamations that hold the book together.

The *Memoirs* read like a cross between Napoleonic battle strategy and *The Starr Report*. The heavens fire a wide variety of rays at Schreber, rays that explode at his feet, insulting his intelligence. Conspiratorial lines connect and divide galaxies and stratospheres beyond our comprehension. Celestial birds rattle off nonsensical phrases before they hit the ground and combust. Male nurses prod him in embarrassing places. God—who, it seems, is not as smart as Schreber himself—plays with his intestines. It's really quite sad.

Beyond the intergalactic lunacy, there's a great intensity to Schreber's writing that has always been difficult to parse, though it has inspired academic work of great beauty. One hopes, however, that future critics avoid further Freudian interpretations of the *Memoirs*, if only because the Freudian path, in this case, is so well-trodden. Deleuzian readings seem misguided as well. Deleuze, if anything, pointed to the transformative qualities of Schreber's prose in the face of an utterly arcane legalistic and psychoanalytic pedagogy. I would venture that, barring the emergence of critical copycats, the newly reissued Schreber text is free in more ways than one—freely available and free from theoretical baggage.

In the 1988 collection *Psychosis and Sexual Identity: Toward a Post-Analytic View of the Schreber Case*, Alphonso Lingis writes his essay in the voice of Schreber, and, although the pose is a bit silly, it is perhaps what the judge might have hoped for from his future interpreters—that they fully embrace his own hallucinatory logic. Given that Schreber is long dead, it's pointless to keep offering him cures—whether psychoanalytic or theoretical.

Schreber is now in paperback, glistening in the mainstream. Let's do him justice and send him to heaven in a Hollywood movie based on the *Memoirs*: screenplay by Bret Easton Ellis, starring Leonardo DiCaprio, directed by Roman Polanski—the ultimate in starfucker entertainment. I think he would love it.

Too Autopoietic to Drive

Drive: Power>Progress>Desire (New Plymouth: Govett-Brewster Art Gallery, 2000).

Exhibition catalogue: *Drive: Power>Progress>Desire*, Govett-Brewster Art Gallery, New Plymouth, 12 February–30 April 2000.

The question of the car—as a nice, singular thing—has been swallowed by its location within the mass: mass production and mass transportation. In contemporary culture, cars are a theme like money is a theme—we have no choice but to address them. It is not a statistical fascination with the grotesque mass ferrying of bodies that sums up this preoccupation in contemporary art. Neither is it completely a question of 'fetish finish'—the unadulterated and overwrought love of the machine and its surfaces. It is a result of the fact that cars are an excruciating, everyday obligation. They're mandatory, and one has to put up with them, to touch them, be cramped within them, be pulverised by them, to glare out of their windows, or to fill them up with fossil fuels, just to be a normal human being. Possibly you detect my slight indifference toward the great automobile. It is worthy of an explanation. My sensible mother refused to allow me to sit my licence when I was fifteen. Later, several members of my family and my best friend were either debilitated or completely finished off in car wrecks, and, to top it off, I ended up living in Los Angeles, a place where these diabolical machines rule one's life, managing to extract every miserable penny from an already starved budget. Cars pollute, destroy, and impoverish; they kill cats. In any case, after an overnight hit and run, followed by my lovely Toyota Tercel being towed away three times (in rapid succession) by the LAPD, I am now carless, which is to say I am a third-class citizen.

Cars and the vehicular, grafted to their numerous spinoffs, have, as *Drive* demonstrates, claimed the attention of many important artists. The vertiginous mass of questions and sensations that is the domain of driving and automation (these questions or sensations might include the psychic complicity of being driven; the theorisation of psychic drives and machines; the stunning and dumb sexuality of the car; technology and questions of vision from the point of view of the driver and the road; vanishing points, velocities, and transports; and the fantastic implications and applications of industrial materials) do not always add up to a study of mechanical machines per se. Instead, the works in *Drive* might be thought of in terms of fetishism and affect: art 'about cars' that has an ambivalent relationship to cars. In many art works, vehicles are dysfunctional and cannot be driven as such; they become questions as opposed to conventional transportation devices. Although there have been any number of 'artists' cars' that actually run—recent examples include Rosemarie Trockel's *Kinderspielplatz* (1999) and Jason Rhoades and Peter Bonde's cars-

as-sculpture installation *Snowball* (1999). These works, both in the 1999 Venice Biennale, tend to function as a graph of experiences and commentaries. In this sense, *Drive* is not a study of cars as much as it is an exhibition about perception and its devices. Previous shows—such as Pontus Hulten's 1968 *The Machine as Seen at the End of the Mechanical Age* at the Museum of Modern Art and Harald Szeemann's 1975 *The Bachelor Machines* at Kunsthalle Bern—were accumulations of Duchampian objects and artworks that activated the fascinating eroticism of machinery and its zoomorphic possibilities. *Drive* is also concerned with the machine, but not in and of itself. The exhibition provides a conceptual frame for art works to be read in terms of many subjects, most contemporaneously following the cybernetics of Norbert Wiener, the wit of Marshall McLuhan, and the development of information technologies—the so-called post-mechanical age.

'There is a growing uneasiness about the degree to which cars have become the real population of our cities …' This insight appears early in McLuhan's chapter on cars, 'Motorcar: The Mechanical Bride', from his book *Understanding Media*.[1] McLuhan's discussion about the triumph of the car over American social space bridges the wide gap between mechanical and pre-mechanical epochs, not to mention the post-mechanical ones that, in 1964, he so brilliantly parodied. Touching upon the car as sex symbol, or 'mechanical horse', and noting the auto's ubiquitous presence in early cinema (often alongside the policeman), he describes the violent developmental sweep of machines in relation to the human mind and body, concluding with the insight: 'The car … has quite refashioned all of the spaces that unite and separate men, and it will continue to do so for a decade more, by which time the electronic successors to the car will be manifest.'[2]

But are cars machines, and, if so, in what sense? Félix Guattari's 1992 book *Chaosmosis: An Ethico-Aesthetic Paradigm* is interesting in this regard, as it articulates a conception of 'machines' that is not erotic or futuristic in a utopian or Duchampian sense.[3] It is, rather, a pragmatic philosophy that takes technological developments into account. Guattari is definitely not a 'disciple' of technology, unlike the raving futurist Marinetti. Indeed, his conception of the machine is striking, as he considers that machines both 'predate and activate technology'. He writes, 'We should … consider the problematic of technology as dependent on machines, and not the inverse.' Within the concept 'machine', there are virtues and dangers that have to be distinguished from one another. After Francisco Varela, Guattari characterises two machines: the 'allopoietic' and the 'autopoietic'. Interestingly, Varela's two machines are both considered to be organic and industrial in nature. Allopoietic machines are ones that need oil and grease and make things other than themselves; autopoietic machines, alternately, produce themselves and fluctuate according to given

conditions. These machines adapt or evolve because, in Varela's conception, they are life forms: autopoietic machines are biological. Guattari, however, takes Varela's autopoiesis and modifies it to include assemblages, which, in turn, could include social systems, technical machines, and psychic drives—in other words, energies such as art works. These autopoietic machines also include music, collectives, and individuals who are moving through the mechanosphere accompanied and propelled by a variety of forces, human and non-human.[4]

Guattari, who considers thought to be a means of transport, presented himself with the following paradox: speed is the epitome of progress—it is inevitable and it must be thought about, however speed makes it impossible to think.[5] The tenured philosopher's fat and grotesque body, not properly exercised, has been sitting down all day. He has a different body shape, not in accord with the angular dimensions insisted upon by the rat race. But the philosopher has to live somewhere—in her car? The chaosmotic model chooses to leave the cave for the freeway, cruising in something that has been manufactured (mass produced) and not simply 'formed' like the cave. Thinking must keep up with the Joneses, not to mention the Jetsons: one must think at light speed. At best, Guattari opines, technology leads to the production of images opening up onto unprecedented plastic universes. In hoping for the best, he wishes to develop a 'paradigm' to glide on, work within, exploit, and to enjoy the tidal wave of technological effects.

Traversing LA, courtesy of its famously inept public-transport system, as I have been doing lately, means living life in the slow lane. The time it takes to reach point A from point B is four times that of the average latter-day sports-car driver, and the motion of surrounding traffic becomes faster by comparison. The first irony of this situation is that, instead of looking through a car window, I spend long hours looking at cars. The second is that the idea of speed is best demonstrated by inertia. Inside a transportation museum or gallery, vehicles are marvelled at for being fast, while they are, in fact, just sitting there. High speeds are impossible to comprehend without the surrogate of inertia, and the relativity of speed is negated when one is moving at the same pace as everything else. Conversely, there is no such thing as complete stillness. In museums of different kinds, the symbols of ultra-fast movement are the resplendent bodies of the vehicles themselves, polished and inert, sacrificing their motion to become a symbolic object. What Paul Virilio called 'the barbarous aesthetic of the mass-produced American car, the provocative excess of its body, of its ornaments'[6] is made clear to audiences at venues such as the Petersen Automotive Museum in LA and the *LA Auto Show*, not to mention the thousands of car sales yards where new and old models of cars are displayed like so many bodies for sale. The corpse of the car

frozen in state (or the embryo of the new model) is always a pretty sight because it activates the thought of motion.

The artwork as an autopoietic machine? A work that perfectly activates this delirium of speed through a display of time killing is Charles Ray's *Unpainted Sculpture* (1997), a one-to-one-scale cast-fibreglass replica of a late-model car. The unfortunate vehicle in question was spectacularly pulverised in a head-on collision that killed its female driver before the artist purchased it at a police auction. Ray's *Unpainted Sculpture*, cast with ultimate precision, absorbed every detail of that impact. Piece by piece, that totalled auto was pulled apart, cast in moulds, and reconstructed as a plastic version of itself. The result is that the disaster of the crash has been preserved, given a decorative afterlife, in Ray's oeuvre.

As critics noted at the time, Ray's *Unpainted Sculpture* was not a car; it was something else altogether. The work is an optical illusion of the first order, a highly traditional piece of sculpture seeming to masquerade as a response to events in broadcast media. It was first shown just after the release of David Cronenberg's film adaptation of J.G. Ballard's novel *Crash* and Princess Diana's fatal car accident. Ray's work appeared to resonate with this accident, even though it had taken over a year to build in the artist's studio. The meteor-sized chunk of car transported into the gallery—also seen in the work of Edward Kienholz, Joseph Beuys, Sylvie Fleury, Dale Frank, and Sarah Lucas, among others—comes either as a showroom model or its opposite, the skeletal wreck.

Having recently driven across the width of the United States, from LA to New York, in the middle of winter, I have been seen by a lot of traffic. I witnessed, also, the insane circuitry of roads. Doug Aitken's photographs of LA show the utter straightness of the urban grid, just as Rem Koolhaas's *Delirious New York* describes the intense architectural intelligence that accumulates, multiplies, and fornicates in the space above ground.[7] The cross-country trip, however, is a completely alien geometry of infinitesimal angles, strange accents, sharply divided states, and policed freeways. We were pulled over in Louisiana and our car was searched for bodies. In Baltimore, we completed a horrifying 360-degree spin on the freeway after hitting black ice. We encountered falling snow and multiple accidents. We passed what the Americans dub 'primitive roads' (i.e., roads that only four-wheel drive vehicles are advised to travel upon), and, needless to say, we consumed some decidedly poisonous food. Driving through this condition of circuits is an exercise in hypnosis, as is the constant battle for the long-distance driver to stay awake. I often thought of Rodney Graham, an artist based in Canada, who made a beautiful work about the hypnotic rhythm of the road. *Halcion Sleep* (1994) is a modest video work that depicts Graham, doped down on the sleeping pill Halcion, lounging, dead asleep and kind-of smiling in his stylish silk

pyjamas, in the back seat of an apparently classy auto that is making its way through the nightscape of Vancouver. Graham is dead to the world, on some kind of mystery tour. The sights of the city are unavailable to his eyes; he is seeing the sights, presumably, that are formed in his sleeping mind, although these are not made available to us. If not a study of falling asleep at the real, then this is a study of the motion of travel and the intoxicating lull of movement itself: that peculiar, narcotic slumber of traffic as it winds through the streets, as if Graham was an exhausted child, with his parents, on the way home from a late-night party.

Like Graham, the LA-based artist Jessica Bronson has used the slouching and spastic movements described by the video apparatus as an allegory of the movement of the car, of coordinates, spaces, and travel. These devices are linked, inasmuch as they both traverse distance, even if the video camera describes a more inhuman occupation of space. Bronson's pieces, which work up a logic of immersion, demonstrate certain phenomenological qualities of the video medium: that colour and shape collide in the body of the camera, that speed can overtake colour. The 'trauma' of the image, in Bronson's case, also becomes a pleasure of the image. *Red Line* (1996) is a study of race-car movement in which the senseless circularity of a Grand Prix racetrack stands in for the circularity of video footage, looped around tighter and tighter coordinate points and time slots. The title, *Red Line*, literally refers to the breakdown of the machine. Video effects of blur, static, 'snow', and noise simulate the accelerating movement of the car and dramatise the imminent catastrophe of an accident. Bronson fuses randomly generated effects (the explosion of static on the screen as the car cam smashes into a wall) with effects developed in the studio (split screen, slow motion) to form a surrogate racetrack that tests the transferred velocity of race car and video apparatus.

It would only seem appropriate that LA-based artists, such as Bronson, would spend inordinate amounts of time thinking about, being inside, and being bothered and fascinated by cars. Indeed, the car and its 'culture' have fascinated many West Coast artists from Edward Kienholz and John McCracken through to Catherine Opie in her recent series *Freeways*. If Kienholz's *Back-Seat Dodge '38* (1964) is the pornographic apotheosis of automobile-related art, then the abstract works of McCracken (spray-painted monochromatic surfaces using auto-painters' techniques and lacquers) are fetishes to the surface, to speed, and to the skin of the car and the painting. As in New Yorker Richard Prince's 'hood' paintings, such ideas are linked and hallucinated into a series of sculptural objects. Back in the 1970s, John Baldessari—represented in *Drive* by *Car Color Series* (1976), a suite of seven C-type prints—was also drawn to the planes of colour that cover cars. McCracken's and Prince's works relate to Baldessari's piece inasmuch as the car, for a split second, becomes a non-representational painting; the parked vehicle becomes the colour chart in a paint store.

The accounts of perambulation and movement in Baldessari's and Bronson's works also find a referent in the work of Mungo Thomson, based in LA. Thomson's *Random Walks* photographs (1998–9), of imaginary road signs made by the artist, apparently track his movements on a stroll through a neighbourhood. The situationist trope of the psychogeographic map, a record of spontaneous sensation and drift as opposed to sensible cartography, is developed by Thomson into a graphic disarticulation of a freeway sign that becomes a cartographic cartoon of motion. His *LA Rubbing* (1998), an editioned frottage work on paper, is more Duchampian in nature, with its fixation on the sexual qualities of the comically phallic gear stick, the rubbing, and the resulting impression. The video work, *Ninety-Five* (1995) documents, in blurred form, another journey—freeway signs on the Interstate 95 from downtown Manhattan to upstate New York.

In 1998, another LA artist, Eric Wesley, built a camper for the back of his pick-up truck and headed north in a straight line to Alaska. Wesley's mobile home was rough but elaborate; the premise of his journey being to head north and 'chase the sun', to traverse the Northwest, to build works, and to test the reliability of his invention against the elements. Living and working in this environment for a month, Wesley needed to ensure that necessities for survival were worked into the design with as much ergonomic panache as possible. The artist divided and built out available space in what he describes as 'design as the result of function',[8] a series of space-related decisions that would enable daily activities to run smoothly. Not only did Wesley equip his vehicle with solar panels, a perfectly functional bathroom, stove, and enough tinned pork and beans to keep him alive in emergencies, but the interior of his 'room' was also animated by small artworks, notes, and maps pinned to the wall of the cabin. Oh, and a shotgun, to defend himself from any over-affectionate bears. Along the way, he built several objects that served practical and aesthetic functions, including a parka that was customised from a sleeping bag, a wooden lute carved from a tree trunk, and a carved model boat with a likeness of the artist standing inside it. And, according to his plan, all purchases, aside from gas, were shoplifted en route.

Wesley exhibited the camper in LA as a sculptural narrative of his journey. The camper itself was the major object on display, but small objects and drawings surrounded it like a series of satellites. Constructed from a wooden frame and covered with a plexiglass-and-aluminium shell, Wesley's experimental, mobile architecture moved between the functional sculpture of Atelier Van Lieshout, a *Mad Max*–style science-fiction vehicle, and an improvised living structure—the type that might be found in California's Slab City, a community of improvised trailer parks in the high desert.

As we see in the work of Wesley and other artists in this exhibition, to drive, ultimately, is to move. *Drive* presents movement (video, film) and inertia (static art objects) as a reflection on movement itself. The exhibition is like a series of relics that promotes thought as well as being an archival record of what has been thought. Hopefully, an exhibition such as this, which presents completely new juxtapositions of works and ideas, will change what has been thought. It might function, after Guattari, as a fantastic kind of autopoietic car in its own right. The exhibition is the vehicle for the concept as paper is the car for the word.

1. Marshall McLuhan, *Understanding Media: The Extensions of Man* (London: Routledge and Kegan Paul, 1964), 218.

2. Ibid., 225.

3. Félix Guattari, *Chaosmosis: An Ethico-Aesthetic Paradigm*, trans. Paul Bains and Julian Pefanis (Bloomington and Indianapolis: Indiana University Press, 1995).

4. For more, see the 'Machinic Heterogenesis' chapter in *Chaosmosis*.

5. Ibid., paraphrased.

6. Paul Virilio, *Open Sky*, trans. Julie Rose (London: Verso, 1997), 97.

7. Rem Koolhaas, *Delirious New York: A Retroactive Manifesto for Manhattan* (New York: Oxford University Press, 1978).

8. Artist's notes published in a press release from China Art Objects Galleries, LA, 1999.

Miguel Calderón: Letter from the Louvre

Art and Text, no. 72, 2001.

Miguel Calderón has quite a family. Here they are in a photograph, dressed in their underwear. They look this way because the artist asked them to. It is not quite as simple as that, though. At first, and as we might expect of any civilised group of people, Calderón's extended family flatly refused their relation's bizarre request, the very thought being conclusive evidence of any suspicions they might have had about his chosen career path. But Calderón persisted. His persistence toughened. It became annoying—a standing joke at family gatherings. It became so offensive that an uncle, at the end of his tether, blurted out something like, 'Miguel, this is not going to happen. If you want this to happen you are going to have to get a letter from the Louvre stating that this foolish notion of yours is indeed art. Nothing else will do!'

And so it was. Based in Mexico City, but with elaborate connections the world over, Miguel Calderón produced a letter from the Louvre. The family members, honourable to their word, agreed to submit to the camera to produce *Family Portrait* (2000). One might reassure them that they look very nice and that the photograph, an edition of one, should end up in a famous collection.

Calderón himself is a form of artistic energy that emerges, then disappears, then re-emerges in a different form. Among other things, he is a gallery artist (with Andrea Rosen in New York), collaborator in an alternative gallery (La Panadería, Mexico City), documentary filmmaker, and member of a punk-rock band called Intestino Grueso, which recently performed in Los Angeles. This splitting between roles tends to dissipate Calderón's project, making it imperceptible to those who prefer artists to display their works in more traditional environments. But it is more to the point that Calderón is an artist in the habit of hijacking operatives, making the best of them, and then folding that impetus into other dimensions. To be an audience of his work is to move very fast around different venues, and structural and geographic poles.

Calderón's take on portraiture, to an interesting extent, encapsulates the world's view of his home base and its third-world classification. As a parody of anthropological filmmaking, and perhaps a jab at the recent devotees of Jean Rouch's 'possession' cinema, Calderón placed an advertisement in a local paper inviting those possessed by the devil to pose for his video camera. Assuming, since times are tough, that the unholy one no longer offers worldly comfort to his devotees, hard cash was thrown in for good measure. Well, the spiritually besieged responded in numbers. The 'possessed'—that is, individuals who, for

a bit of change, would display the precise physiognomy of benign takeover, frothing at the mouth, speaking in tongues, unnatural arching of the spine, etc.—were more than willing to display themselves, letter from the Louvre or not. Judging from the screen grabs from this work in progress, *Inverted Star*, it becomes apparent that the thin line between diabolical acting and diabolical internment has been well and truly depicted. Calderón's two projects reveal, it seems, that it is the camera itself (not to mention the dineros) that is the real agent provocateur behind some of the more unusual developments in early-twenty-first-century human behaviour.

Evan Holloway: When Bad Attitude Becomes Form

Art and Text, no. 72, 2001.

One fine day in Los Angeles's summer of 2000, some city employees, driving around Hollywood in their truck, discovered a hole in the universe. It must have come as quite a shock to them, these parking-meter inspectors, as one of their highly prized coin-guzzling reliquaries had been well-and-truly straitjacketed. What they happened upon was *Meter Boot* (2000), an editioned sculpture by Evan Holloway that should be mass-produced at once. It is the citizen's answer to the much-maligned 'Denver boot', that device which, when attached to your car's wheel, immobilises it until such-and-such a fine is paid. Holloway's new, glorious boot, a fabricated metal cube in two parts that snaps tight over the parking meter's ugly face, completely sabotaging its divine purpose, proved such a problem for the city—such an affront to their motto, 'Keeping LA Moving'—that they simply sawed the meter off at its base and took the offending article back to headquarters for further scrutiny.

The artist Morgan Fisher later mentioned to Holloway that, for him, the *Meter Boot* was concerned with taking a space and making it invisible, cutting a hole in the world. This observation rings true for Holloway's work in general, as the explicit deviance of this piece is present in all of his recent pieces; only this attitude—which is manifested in the form of a device—surfaces in other works in a more cryptic fashion. Holloway's works are devices that, in different ways, create reversals, building a variety of negative spaces and decorating their perimeters with colour and structure. Holloway's work is full of disfigurations and voids, such as can be felt in *Music of Chopin Performed on the Reversed Piano* (2000), a CD recorded by the artist in which piano sonatas by Chopin are played on a piano that has been restrung exactly backwards. This counterclockwise music sounds pretty enough to begin with. But, when one is informed of the operation in progress, there is a certain agony the mind must go through in order to cogitate on the piece. Dwelling on the question for too long could well lead to madness, which is hopefully what happened to the people who discovered the *Meter Boot*.

Elsewhere, this device directs itself at ideas of sculpture and artistic format. At this point, Holloway's work takes a complex, pataphysical turn. A student of Charles Ray's, the artist has an acute awareness of object lore and the phenomenological language of sculpture, but these doctrines—notions of base, figure, modelling, construction, etc., spanning from, roughly, Rodin to Judd, and including the innovations of Robert Morris and process art—are understood and then tweaked in a way that only such a fanatically close and original reading could divulge. Ray's appreciation of Anthony Caro is well known, and,

similarly, Holloway is making objects that display an almost pathological delight in a vast catalogue of so-called 'formal sculptures'—lacquered-fibreglass creations, forgotten post-minimalist extravaganzas adorning corporate lobbies in the suburbs, particularly those of California, particularly those produced between 1960 and 1980 and uncomfortably foreign to the contemporary aesthetic. It is precisely Holloway's traditionalness as a sculptor and his devotion to the idea of sculpture that allow him to rewrite sculptural formalism in order to come up with something approaching the 'negative formalism' or 'deformalism' that exerts its strange intensity within his repertoire. He is a kind of sculptural extremist whose work ventures an idolatrous but aggressive read on the history of art and is crowded with narrative pertaining to it. Pieces can refer to abstract sculpture, for instance, but be literally figurative at the same time. His work is not an essay on 'thingness', 'the status of the object today', or anything else like that; it is more like a guillotine that chops itself up into little pieces.

'Sculpture played backward' is impossible to achieve. This, however, has been attempted by Holloway in earlier works like *Upsidedown White Rauschenberg* (1999), a homage written through the inversion and declassification implicit in its title. *The Model* (2000) includes a drawing on the ground that depicts a hole in the floor. Suspended above the flat horizontal drawing, which alludes to a three-dimensional chasm, is a three-dimensional painting on paper that appears ready to submit itself to the illusionistic void. The sculpture consists of phantasmic volume, its vanishing points attesting to the disappearance of mass, a parody of vertigo. A quasi-figurative assemblage, it approximates Boccioni's *Unique Forms of Continuity in Space* of 1913, insofar as the kinetic dynamism of Italian futurism is alluded to by its flamboyant exoskeleton. *The Model* is also an optical reeling machine comparable to Duchamp's *Rotative Demisphere (Precision Optics)* of 1925, but its flare of colour returns us to California and the investigations into sculpture and colour made by, for example, Liz Larner or John McCracken. It could be a weird riff on surfboard design as well.

These are the kinds of games Holloway's sculptures play with our minds. They are devices that pervert the act of perception. His conglomeration of sculpture's language, however, is not about the appropriation of celebrity art works or 'quoting' *per se*. Rather, it is an investigation into and attack on the nature of format. Format is the groove through which work is produced. It is, in effect, the law that underwrites production, what distinguishes one category of objects from another. Holloway concentrates on format, not only to point out that fabrication is predicated on the assumption that things that are built have a beginning and an end, and that this is all wrong, but to destroy the notion or at least reinscribe its principles. Thus, the paranoia of Holloway's newest work, *Gray Scale* (2000), reveals itself

through a rabid multiplication. Starting from the beginning with a tree branch's central trunk, *Gray Scale*, a Frankensteinian exercise in construction, proceeds outward. Each time Holloway encountered an offshoot from the main trunk, he broke it off and reset it at a right angle. This sequence of angled twigs, which becomes thinner as the sculpture extends into space, constitutes the work's final form. This succession of breaks and joins forms a three-dimensional contour that is familiar but disconcerting (a reversed tree, painted), and, like *Meter Boot*, the sculpture is a prototype for a kind of machinic operation as well as a fully-fledged machine, in Lyotard's sense of 'a device making it possible to reverse operations of force'.

Works like *Gray Scale*, and even *The Model*, are somewhat decorative, in that their structures exceed the simple economy of making a point. Conceptually, they are also embellished. *Gray Scale*, dryly titled as it is, is described by the artist as being an elaborate pun on the dualism between nature and culture, carving out what he calls a 'mental gap' between its discrete components. Handling several agendas at once, *Gray Scale* is funny, but in a confusing way. Holloway's most-absurd organic art works, though, are from his *Projector* series (1999–2000): sullen lumps of wood fashioned into the semblance of video projectors, screen included, happily showing structuralist films of wood grain. Of course, they don't really show anything except the strange cannibalism of an abstract machine that swallows its own volume.

John McCracken: Alienbait

Art and Text, no. 73, 2001.

To recycle an old joke of Ad Reinhardt's, I literally bumped into John McCracken's sculptures at David Zwirner's Soho gallery one day in 1997. This was shortly after *Frieze* had excerpted the artist's journals, which speak of meetings with extraterrestrial life forms, and thirty-two years after his first solo exhibition in 1965 at Nicholas Wilder Gallery in Los Angeles. I hadn't compiled this or any other information on McCracken at that point— I was just walking into a show—so I was meeting mass without clear intellectual expectation. McCracken's sculptures drew in the room and threw it back, weird like a Vermeer painting, and it was one of those incredible art experiences where one doesn't know what one is seeing, tries hard to figure it out, fails, and spends the next few years wondering about it. The sculptures were extremely still, not prevaricating in the slightest. Their deployment of density, colour, illusion, scale—all potentially stern particularities—achieved a surface that was dramatically alive, something between a computer screen and a pool of water.

I left the gallery thinking McCracken was exactly like Andy Warhol—his work is about absolutely everything. Several years later I would amend this to say that McCracken's work is about everything in the universe—everything except Warhol's interested indifference. McCracken's work is marked by an intensely charismatic surface, a glistening readability that is completely transporting. The sculpture has the capacity to morph art-historical and mythological information into a tight package very much its own. The artist deals with epic, cosmic themes, but his work is not heavy; it is possessed of all the hallmarks of serious art, but there is a complete lightness to it, even a sense of humour in places. Consisting of material bodies whose subject is dematerialisation, the sculpture is animated by a sense of contradiction, but, on the other hand, it is as pragmatically conceived as any art could be, and somehow tremendously obvious.

McCracken is often praised for his consistency. His work is formal and its language is constant, the literature states. He is a serious post-minimalist, one who has remained devoted to a programmatic operation.[1] But, if there is an overall consistency to his work, which in a sense there is, radical bifurcations are also apparent; major shifts, for example, in titling and how language in general surrounds the abstractness of the oeuvre. In short, the work has fluctuated a lot. There were paintings, also different experiments with images on the sculpture, textures aside from the ubiquitous smooth ones, diverse construction techniques, a shift to computerised rendering, and even an admission that the perfect material vehicle for the work hasn't been discovered yet. Over a thirty-five-year period,

the work has been in a state of vital refinement. McCracken is a minimalist, concerned with the elemental, but his art teems with strange excess. Although he has largely abjured the monumental sculptural scale of his contemporaries (De Maria, Smithson, even Judd with his large-scale outdoor works), McCracken has produced a fractal continuity that is monumental in sequence, sculptures which en masse are quite literally in a state of expansion, conversing with each other and evolving, as he describes them, in a manner that approximates 'species of beings'.[2]

It is interesting to start from the beginning, in the late 1960s. McCracken was central to that primordial LA art boom that introduced the 'finish fetish' artists—Billy Al Bengston, Larry Bell, and Craig Kauffman among them—into a densely marketed and tightly intellectualised art culture for which the terms 'new sculpture' and 'new art' radiated with promise. The LA-gallery scene at the time was clustered around La Cienega Boulevard and presided over by the Ferus Gallery, whose artists were gaining most of the attention from *Artforum*, which had recently moved from San Francisco to LA. McCracken was born in Berkeley, went to school in Oakland—where, in 1962, he was written up in the *San Francisco Sunday Chronicle* for making junk assemblages on the Emeryville mud flats—but was lured to LA immediately after art school, where the scene was hysterically geared toward establishing a West Coast aesthetic and splintering it across North American space. According to a 1996 text by the enterprising Wilder, who admittedly had a vested interest, the young McCracken 'fit right in' to an aesthetic of 'high-gloss craftsmanship', and both financial and critical markets were appropriately thrilled.[3]

'Finish fetish' is a term the artist has mildly disavowed over the years, though he admits an interest in car painting and industrial finishes, but his inclusion in that particular batch of 'new LA art' was of great benefit to his early career. The art-world gods shined upon McCracken's ultra-reflective works, none more so than John Coplans, *Artforum*'s chief critic, who directed the work within a powerful East Coast/West Coast rubric. Presiding over the gallery at the University of California Irvine, Coplans curated McCracken into his *Five Los Angeles Sculptors* in 1966. This participation was synchronised with coverage in *Artforum*, and, from there—boosted by concurrent solo shows at Wilder's gallery and Robert Elkon in New York—interest ricochetted. By 1967, McCracken had participated in the fifth Guggenheim International, the fifth Paris Biennale, Barbara Rose's *A New Aesthetic* at Washington Gallery of Modern Art, Washington DC, and the two most reified American sculpture shows of the late 1960s: *American Sculpture of the Sixties* at LA County Museum of Art and Philadelphia Museum of Art and *Primary Structures* at the Jewish Museum in New York.

A peculiar contradiction of minimalism is that, on the one hand, it weighs in on the side of seriousness, refinement, affinities to certain art-historical and philosophical conceptions of space (i.e., phenomenology, cubist sculpture), a critical relationship to architecture and installation, and a visibly non-expressive appearance (in allergic response to abstract expressionism). In other respects, it seems to have been an extremely eccentric enterprise. Consider Flavin's titling, Judd's lexical and sculptural paranoia, Stella's historical referencing in the titles of his *Black Paintings*, even the confusion that surrounded a movement trying to patent itself and coming up with several versions along the way: Lawrence Alloway's 'systemic painting', Barbara Rose's 'ABC art', and Kynaston McShine, who, dismayed at the term 'minimalism', came up with his own architectonic trope, 'primary structures'. Each artist and critic, it seems, had their own personal, fetishistic obsession—competitive or otherwise—which endowed minimalism with an underworld of peculiar psychology to match its impressively cool intellectualism. McCracken, for his part, contributes something that is both amazing and obvious, namely an elaborate, quasi-spiritualist narrative that billows out from a hard-edged, apparently reductive aesthetic. In his 1968 artist's statement for *A New Aesthetic*, he promotes the party line by advocating increased cooperation between industry and artists (more sponsorship from factories!), but one ascertains his main, almost-Reichean concern as the promotion of 'environmental energy' and 'interactive violence', not to mention the concept of a 'new reality . . . the gradual realisation of a "oneness" in which everything is organically related'.[4]

By 1964, with works such as *Theta*, McCracken had already hit upon a method of producing objects: plywood forms, geometric, painted and lacquered until perfectly smooth and deep, covered in 'radiant, jewel-like color'[5] (the artist's words), and possessed of a light-repellent and therefore paranoid surface—a glowing field of colour that optically suffocated the works' built interiors. In a sense, these things were totally theatrical; their surfaces expressing an idea of eternal newness (a new future) through an impervious totality of gloss that has a lurid index to pop, as in the puckered lips or glistening spaghetti of a Rosenquist painting (McCracken's installations can look like oversized makeup counters). To deal in gloss is a phenomenologically commanding position certainly, but the idea also leaks into Marxist notions of commodity fetishism, not to mention Freud's notorious '*glanz auf der nase*'—and both conceptions are perversely counterproductive to McCracken's goals. Gloss and reflection, in another sense, can be tentatively detached from the question of commodity and returned to the art historical: the polished bronzes of Brâncuși, chromed works by Anish Kapoor or Thomas Schütte, not to mention the mirrors of Larry Bell, Dan Graham, or Robert Smithson. But, reflective surfaces, in their elemental sense, are simply

those that repel light, surfaces that send light back in the direction of its source, and this in itself doesn't guarantee a 'new reality': reflection is nothing more than a reflex action. If the object does not absorb and cancel out light, as is the case with Kapoor's voids, it just goes somewhere else—into the viewer's eye via the sculpture's planes. McCracken's pigmented sculptures refract, producing images of what is around them, and they are optical instruments in this sense, having a relation to the photographic and the cinematic. But these images are so trapped within the experience of colour that it would be difficult to read the sculptures in relation to narcissism; unlike a mirror, they appear, paradoxically, to be self lit. Parabolic mirrors in Vermeer are frozen, as if to demonstrate their uncanniness, but McCracken's sculptures bring everything back to life through a poetics that calls the materiality of the object (and the world) into question. The stainless-steel works, an extremity of reflection, project, devour, and cut through space like a five-dimensional camera obscura, examining and reversing the rooms they are within, almost to the point of everything's disappearance.

McCracken's works, completely unlike anything else in art or industry, propose what might seem like a dysfunctional binary between industrial material and transcendental thought, but this is blown out by the deployment of colour in the sculpture, which functions as the third element in the binary. The 'candiness' of these colours doesn't spare McCracken a relation to pop, but the intensity of colour's delivery—one could say commercialised colour and its total presentness—deliberately and in a complex fashion shifts the works' terminal register away from the billboard or Formica object, leaving space for the artist's programme of using colour 'structurally—not decoratively'. McCracken tries to make a sculpture out of colour itself: 'I try to use color as if it were a material; I make a sculpture out of, say, "red" or "blue".'[6] In notes from the 1960s, he writes that 'color is the form', and this is another way of saying that his concentrations of elemental colour—generally primary, secondary, and tertiary hues (even fluorescent or metallic ones), as opposed to natural tones like green and brown—work to vaporise any didactic recourse one might have to the quotidian or 'primary' nature of the built object, with its stupid nails and store-ready plywood, and even the mass-produced, commercial object. One can't simply dismiss the fact that the work's production and consumption are specifically dependent on its coordinates within late capitalism, only to say that the fixation on workshop technique and its modish deification—'finish fetish'—are overstated in comparison to the way a work like *Yellow Plank* (1968) might otherwise blow your mind. This looking has a lot to do with visual pleasure and is 'kind of like running your finger over a large pearl that had been covered with a thin film of soap', which is how propulsion expert Dan Fry described his face-to-face encounter with a UFO's 'seamless, glistening hull'.[7]

Even after McCracken's 'finish fetish' debut was gradually absorbed by the artist's other priorities, a standard response to his work has always been on the level of its sheer technical impressiveness, which is by far the most boring way to view it. Despite the abstractness of the sculpture, language, in the form of titles and statements, has been very much a part of the work's refinement. There is persistent equivocation in McCracken's naming of things, which is yet another point from which eccentric subspecies of the project may be ascertained. *Think Pink* and *Spiffy Move*, two perkily titled 'plank' sculptures from 1967, were made alongside works such as *Dark Red Slab* (1967) and *Black Plank* (1968). The generic titling of the latter works is again punctuated by Venice Beach philosophemes like *The Case for Fakery in Beauty* (McCracken has stated that 'beauty is essential in art'), a dainty light-lavender number from 1967. Some McCracken titles literally encompass trajectory and speed, such as *Mach 2* (1992), while more metaphysical, abstract designations, such as *Way* (1988), *Lumina* (1990), and *Guardian* (1990), intensify in the recent work that is directly concerned with astral domains.

The artist's statements and interviews over the years have the capacity to shock. But, after examining these objects over time, it comes as no surprise to learn of McCracken's interest in time travel, UFOs, and related phenomena. The sculptures are otherworldly, or, as McCracken says, 'I'm after a physical object that appears to be nonphysical, hallucinatory or holographic',[8] stating his interests in making sculpture that could have been brought to earth by an alien, or an object that an alien civilisation would be impressed by. The work is an act of seduction, a kind of lure—'alien bait' as one friend calls it—that draws in the human (and alien) eye, lulling it into a state of contemplation. To some degree, this may be gleaned from the work itself, but statements, such as 'Remote Viewing/Psychic Traveling', create an irreversible context for viewing:

> I think of a question. I ask him [an alien], 'Have I ever been abducted?' He answers, 'No, you haven't.' Then I ask, 'Were those figures in my bedroom when I was a kid Grays?' He smiles (with his thin lips), and says, 'Maybe.' I ask him if the Grays have interacted with Earth governments. He says, 'Yes, for some time, as many of you are coming to know.' I begin to ask him if my art work appears to him to be concerned with UFOs and other dimensions. He breaks in before I finish with, 'Yes.'[9]

The smiling, thin-lipped Gray doesn't seem like a bad person. He thinks about art and knows what he likes, and although he appears in a Buck Rogers–style spacecraft, sporting

the baroque clichés of late-twentieth-century interstellar chic, there's no apparent reason to doubt his existence. McCracken's work, in fact, is a good deal more sober than Jeff Koons's, for example. The deadpan paranormality of such accounts is fun—'fun' being a word McCracken often uses to describe time travel—but it also is a precise metaphorical register of what the sculpture achieves in a material sense. These alien dialogues are compelling, but, even without such an index, McCracken would have conceived of an extraordinary use for minimal art, turning primary structures into exploratory vessels of complete expansiveness.

1. See, for example, David Pagel, 'John McLaughlin and John McCracken', *Art Issues*, December 1990– January 1991: 23–7; and Roberta Smith, 'John McCracken', *New York Times*, 13 June 1997.

2. In Ghislain Mollet-Viéville, 'Interview with John McCracken', in *John McCracken* (Paris: Galerie Fromert and Putman, 1991).

3. Wilder's essay 'The Test of Time', which discusses the artist's early career, is included in the catalogue for *Heroic Stance: The Sculpture of John McCracken 1965–1986* (LA and New York: Newport Harbor Art Museum and PS1, 1986).

4. John McCracken, artist's statement in the catalogue for *A New Aesthetic*, curated by Barbara Rose, Washington Gallery of Modern Art, Washington DC, 6 May–25 June 1967.

5. In drawings, McCracken will often make notes surrounding plans for work. A selection of such works are published in the catalogue for the artist's 1995 Kunsthalle Basel retrospective. The exhibition was curated and the catalogue edited by Thomas Kellein.

6. 'Between Two Worlds: Interview with Francis Colpitt', *Art in America*, April 1998: 86–93.

7. Cited in Gordon Cooper, *Leap of Faith: An Astronaut's Journey into the Unknown* (New York: Harper Collins, 2000), 186.

8. Dike Blair, 'Otherworldly: Interview with John McCracken', *Purple Prose*, no. 13, Winter 1998.

9. John McCracken, 'Remote Viewing/Psychic Traveling', *Frieze*, no. 35, June–August 1997: 62.

Landscape in David Korty, Paul Sietsema, and Vincent Ward

The First Auckland Triennial: Bright Paradise: Exotic History and Sublime Artifice
(Auckland: Auckland Art Gallery with Artspace and University of Auckland, 2001).

Exhibition-catalogue essay: *The First Auckland Triennial: Bright Paradise: Exotic History and Sublime Artifice*,
Auckland Art Gallery, Artspace, and Gus Fisher Gallery, 3 March–4 June 2001.

Followers of Vincent Ward's 'artistic' cinema may have buckled over in horror at the release of *What Dreams May Come* (2000), the New Zealander's latest film. Indeed, it has a sense of scandal: the sheer force of its grand budget, its appropriation and computerisation of beloved landscape paintings, Robin Williams. However, the film's mainstream bravado and neoconservative psychology is tempered by the fact that it's a truly strange work of landscape. In this, it might be compared with other contemporary landscapes by Los Angeles–based artists David Korty and Paul Sietsema, whose interests are also filtered through the languages of painting, cinema, and conceptual art.

With *Dreams*, Ward was obliged to balance Hollywood's commercial imperatives with his 'artistic vision'. In this case, the vision is quite literally a vision, a sequence of hallucinated landscapes. In blinding succession, the actors stroll through forests and lakes that appear and transform, mirroring their states of mind. 'Emotions' plod by in a pageant of asinine excess—happy versus sad versus remorseful, etc.—but Ward's landscape itself, a post-death netherworld, is extraordinary. Pretty computerised topographies bend over backwards, overcompensating for the decidedly Christian mood swings of the protagonists, for whom guiltless paradise is a field of flowers or a lake (Monet and Friedrich), while hell is a broken-down house populated by rats. When bad vibes set in, the Boschean dead run amok, and the transition between the two polarised spaces (heaven and hell, loosely) depend on the Williams character's negotiation of good and evil, and guilt.

If Hollywood purgatory is reserved for films that 'bomb', its paradise is the endless flow of capital magically passing through Robin Williams's smile. But when a director is directing such a project, what exactly is being directed? *Dreams* is a psychedelic allegory from a time when money and the science of its anticipation command cinematic space like an emperor. And yet the capitalist sublime it promotes does not reek of money; it is an emotional landscape in which such worldly considerations are irrelevant—in other words, a delusional fantasy that transcends even its own spectral imagery. As Williams dances through a computer-spawned monemation, one imagines a future cinema that has no need of actors, a cinema of pure opticality that extends out from Disney's *Fantasia*. *Dreams* is less a vehicle for its star than for special effects, compelling in their liquidity and

phosphorescence. The intended audience response is 'wow', and a good wow hosts many nuances. Without the wow there would be no film. The wow needs a story to hang on, even though the effects' delirious opticality decorates and asphyxiates the story at the story's expense. Specifics are rounded off in the service of sensation.

Dreams's amped-up visuals may be kind of jarring to the university-educated aesthete, but there's no point judging Ward on such grounds, as the film's look is generated under a regime of consensus and approval. As a work of pure negotiation, the film is a masterpiece that delivers a depressing message to New Zealand's proud but quivering auteur cinema, from which Ward emerged as our preeminent landscape filmmaker. Will Hollywood grant a self-declared 'artist' the opportunity to sanctify his political and poetic ambitions in an epic work of his own direction? Probably not. And, if it does, only in a very contemporary way, attended by fantastic compromise. Ward's career may seem a unique odyssey from independent film to the abstraction and complication of Hollywood business, but this trajectory complexifies the interpretation of his project as a whole, in particular his consistent interest in the representation of landscape.

What Dreams May Come—a hallucination of capital bleeding out of nature—contrasts with Paul Sietsema's *Untitled (Beautiful Place)* (1998). Sietsema's work is a minuscule epic, the production of one person as opposed to a crew. *Beautiful Place* folds out time. Its eight vignettes each depict artificial flowers and gardens meticulously built by the artist for the purpose of filming. The many months involved in its production, the intense labour and concentration, are, in a sense, inverted in the final product, which is extremely short by comparison. There is the sense that we are viewing an accelerated stop-motion sequence of the process of production, strangely flipped into cinematic form, condensed down, and that time itself has been reversed. The piece is the optical version of a dripping tap.

Beautiful Place is not *National Geographic*–style nature cinema akin to stop-motion images of a flower blooming—the kitsch celebration of 'life'. Rather the piece has a gently menacing, industrial character. As the frames turn over one by one, their appearance synchronised with the projector's movement, there is a decidedly unnatural occurrence taking place. Sietsema's optical machine of projector and image, like a small factory, manufactures a foreboding artificial intensity reminiscent of that of the city in Fritz Lang's *Metropolis* or the starkly lit sets of German expressionist films. Physical reality is artificially lit. And, ventriloquised through the projector's body, it inherits a multitude of perceptible jumps, shakes, shudders, and sounds produced by its chugging, mechanical operation. These stuttering images are both monumental and delicate.

The technology employed by Sietsema, 16mm colour film, is both relatively and conspicuously old. His practice thus makes a clear break from the ubiquitous video-projection format. The project is not polemical as much as it is explicitly directed at what the film media can achieve both ideologically and visually. In addition to this, the work acknowledges a conceptual-art tradition involving photographic, spatial, and phenomenological concerns, and so can only tentatively be described as a work of cinema, despite appearances. *Beautiful Place* is not designed, like Ward's film, to further exploit an already exhausted language of emotions—the poetics of flowers: funereal, erotic, etc. It is a serene formal exercise that uses the image of artificial botany to reflect on time and representation. A compelling effect of this work, for someone with romantic inclinations, is that, within its duration (it's a short film that seems very long), the desperate hope to read the film psychologically crystallises and then mineralises. It hardens into an almost-scientific perception of light and surface.

David Korty makes watercolour landscapes of LA. His readings of the atmosphere, the architecture, and the topography of urban space are often taken from the vantage point of the Hollywood Hills, which crest above the flat, gridded street system. Korty began landscape painting in 1998, making almost pointillist studies of generic landmarks such as the Hollywood Home Depot megastore and the LA Olympic Stadium, but soon moved on to complicated studies of the ether, describing what happens to sky and clouds when they react with land and sun at different times of day, notably dusk. Like Ed Ruscha's recent paintings of aerial views of LA, Korty's watercolours participate in the pictorial myth of LA, often including glimpses of Case Study homes on canyonsides, silhouettes of Griffith Park Observatory, and sometimes even a muted Hollywood sign. But Korty's works eschew Ruscha's ironic, cinematic, linguistic approach, while drawing on his graphic immediacy. His pictures' disarming simplicity is disconcerting to some viewers, perhaps because it's such a measured response to the predetermined heaviness of prevalent photo-based conceptual work or the de-rigueur seriousness of non-representational painting.

The sky in LA is unique, as the sky is everywhere. It hosts tons of particulates, both desert dust lifted by the winds and the diabolical weight of smog. These particulates blend with sunlight, making a mess of perspective and distance, producing amazing, inadvertent atmospheres. The tan fuzziness of airborne dust is often mistaken for smog, but real smog is as bright as paint. Its mineral showers appear on the horizon in green, purple, and orange stripes. The industrial equivalent of an aurora borealis, smog corrodes and poisons everything below. When Korty paints these skies and the electric light, hills, and traffic jams, it appears to be chromatic exaggeration. And though his palette, like Ward's, is

intensifying—with his more photographic renderings of concrete freeways and endless stucco apartments giving way to polychromatic clouds of light and explosions of phosphorescent, electrical excess—his approach is essentially realistic: this is what one sees in LA much of the time. These weird green mists consuming buildings in the distance or harsh sunlight hammering down on dusty, bleached buildings are given a surprising representational double. When compared to other recent portraits of the city, like Mike Davis's apocalyptic prose or other post-riot arcana, it becomes apparent that Korty's interpretation of urban space serves primarily optical and painterly agendas, a perception that corresponds with the nineteenth-century 'golden light' of Californian realist painting. But the project is also ideological in that it reminds the Hollywood violence-saturated city of its Arcadian other, the days when Southern California was a 'beautiful place'.

Today, landscape features in artworks that operate out of diverse conceptual, contextual, and technological predicaments, with no common rationale. But what binds Ward, Sietsema, and Korty together, perhaps, is that they regard landscape as a crutch of representation. If the image of nature in contemporary art and culture is supposed to offer some kind of momentary relief from an otherwise technological reality, then these works provide that delight, mixed with the experience of absolute complexity.

Paranoia and Malpractice

Hallucination of Theory: More and Less 3 (Los Angeles: ArtCenter College of Design, 2001).

> *Let God use you. God wants to use you. Lie back and let him use you, use you.*
> —Bret Easton Ellis, *Less than Zero*

As Daniel Paul Schreber awoke one morning from uneasy dreams, he found himself transformed in his bed into psychoanalysis. God ordered Schreber to transmogrify, and, in response, an automatic writing—paranoia—descended from the sky to plug up that alleged hole in the real. If it's not imagination itself, then, at the very least, paranoia can be thought to have a very good imagination. For God's pleasure and amusement, Schreber's benevolent psychiatric nurses were turned into rapists, the beautiful Dresden sky became a field of screeching rays, pretty singing birds demons that plucked out eyes, the piano a sodomising machine (or a drowning-out machine), the telephone the Führer, and President Schreber a scandalously wanton female. In *Memoirs of My Nervous Illness* (1903), transformation is the engine that delineates the shape of Schreber's body at any given time, not to mention the length of his story and the manner that he performs it.[1] Schreber was a man (half robot), who was prettied up by a force greater than himself, a divine will that, following Schreber, we shall call 'God'.

To observe the hallucinatory proposition, 'Schreber' (as in 'the Schreber case') is understood as a flow of electric, transferential panic downloaded into the amniotic fluid of twentieth-century clinical and critical language (not to mention *Dark City*, a 1998 cinematic feature by Alex Proyas). Freud's influence in stirring up this primordial soup cannot be underestimated, and his is the most over-the-top, prosaic reading, although the story neither begins nor ends with Freud. I started this essay in the hopes of writing about Freud—an essay about Freud and psychosis—but this is also an account of delirium in critical and visual language, which amounts to the same thing, with particular differences. According to his analysis, the 'transformations' that Freud isolates vis-a-vis Schreber (man to woman, love to hate, projection, the gradations of bliss) are the primal currents of Schreber's enunciation.

I am intrigued by the extra-subjective influence of Schreber. 'Schreber' is not a subject anymore, but occupies space, time, and theory in much the same way as his famous rays occupied the sky: dematerialised, dematerialising, and ubiquitous.

> The picture which I have in my mind is extremely difficult to express in words; it
> appears that nerves—probably taken from my body—were strung over the whole

heavenly vault, which the divine rays were not able to surmount, or which at least constituted a mechanical obstacle similar to the way a besieged fortress is protected by walls and moats against the onrush of the enemy.[2]

This is a question, then, of following Schreber's degraded and voluptuous states and divine languages through the life streams of art and criticism, these forms themselves being tinged by ideas of divinity and degradation.

Schreber's lexically consecrated affects, and Freud's treatment of them, have inspired an empirical hollering across books. This isn't entirely the patient's doing. As Schreber himself insisted, everything started right there in his body, in an all-out exhibition of what he tiresomely insisted was 'scientific evidence'. Schreber's manic self grafting to the propriety of science—a really perverse becoming—made him totally available to the wider brotherhood for the purposes of sex, appropriation, and transformation, and literally thousands of intellectuals have theorised on his behalf. Alphonso Lingis pretends he's Schreber while he's writing, and Lingis is hardly the only one—we all want to join in the celestial orgy. The patient and the symptom as public property, reduced to the squalid dimension of the literary or clinical sign. Jean Baudrillard: 'Through the sophistication of its methodology, science annihilates its object: to survive, science is forced to artificially reproduce its object as a model of simulation.'[3] Well, Schreber did this all by himself. On behalf of science and just for kicks.

As Schreber wrote to his psychiatrist Flechsig (himself known for work on the myelination of nerve fibres):

> you, like so many doctors, could not completely resist the temptation of using a patient in your care *as an object for scientific experiments* apart from the real purpose of cure, when by chance matters of the highest scientific interest arose … that a person's nervous system should be influenced by another's to the extent of imprisoning his will power, such as occurs during hypnosis; in order to stress forcefully that this was a malpractice it was called 'soul murder'.[4]

But, of course, there's no cure, no real purpose. No therapy for a corpse. This is why every single critical thought devoted to Schreber is a kind of infernal malpractice. There is a prurience to science and perhaps this is why Schreber liked it so much, or why fellow paranoiac critic Salvador Dalí promoted science and the idea of 'objectivity' over art.[5] Such experiments are frequently sex in disguise. With an abject generosity buckled by accusatory suspicion, Schreber engendered this plague of transformation, an out-of-body, out-of-

medical, and out-of-critical experience. He created a delirium within science and art. In his body, Schreber understood this as a series of physiological affects (transsexualisation), a transformation of the planet (genocide), and a transformation of the universe leading up to his triumphantly masochistic emancipation: 'my soul was handed to [God], but my body—transformed into a female body ... —was then left ... for sexual misuse ... in other words left to rot'.[6] Schreber the avatar is dissolved in a tidal wave of magical and transmogrifying pinpricks of light: rays move information and other bits and pieces from one station to the next. Now—and for a century at least—the intelligent paranoid rays (critics) pick at the carrion of Schreber's astral body, ferrying off the pieces to that great fat vulture in the sky: God. The upper and lower gods of Schreber's cosmology left him for dead and theory has raped Schreber with more vigour and therapeutic goodwill than God could ever have dreamed of. In the process, Schreber's penis retracted and female breasts replaced his male ones.

Paranoia is both the language and the will of God. God hacks away at motifs. The subject is a squealing symptom factory, blending everything with its surrounding furniture, like Dalí's anamorphic mixtures of piano and body. In order to keep on the good side of God and stay in one piece, Schreber had to keep his thoughts in a state of incessant motion, outwitting God. In Schreber, the field must be constantly improved: a thing may be anything at all but a real chair or a real person. Not only a caricature of his thought or a function of his body, such transformations were a duty of the architecture as well:

> I did not know whether to take the streets of Leipzig through which I travelled as only theatre props, perhaps in the fashion in which Prince Potemkin is said to have put them up for Empress Catherine II of Russia during her travels through the desolate country, so as to give her the impression of a flourishing countryside.[7]

Transformation occurs in interstellar space and in the world of humble things:

> I saw even articles of clothing on the bodies of human beings being transformed, as well as food on my plate during meals ... [I saw] a magnificent portico arise, just as if the whole building were going to be transformed into a fairy palace.[8]

What is this process of transformation—a perpetual alteration of motifs or a motif in itself? There is no shortage of theories to tell us what to do here—Canetti's 'atrophy',

schizoanalysis's 'becoming'—but what of the baptismal art, paranoiac criticism itself? Dalí's *Paranoiac Transformation of the Face of Gala*, a drawing of 1932, shows a three-phase disappearance of the artist's muse. Via the paranoiac-critical method, Gala Éluard's profile becomes a conglomeration of Dalí's favourite motifs: the 'agnostic symbol' (long-handled spoon), phallic loaves of bread, soft watches, ink wells, locks of hair, objects speared by skewers, and so on. Is this Gala as he prefers to imagine her—as himself—an inventory of his favourite little things? The drawing is a graph depicting a movement. From one into two into three … even more. However, as each image is separate from the other, there is also the suggestion of three individual subjects: the three Galas, or Gala and two conglomerations of other Dalíesque things. Diagrammatic, linear (composed of lines), and at least suggesting disfigurative movement, Dalí's drawing illustrates the procession of the motif in his paranoiac criticism. It transforms an organic, benevolent 'realism' (the paranoia of abundance, altruism, and femininity) into a 'surrealist' inorganic, malevolent conglomerate (the paranoia of linguistics, lines, miraculating creation, despotics, and machines). All phases involve a multitude, or, at least, invoke a process of desubjectification that leaves the subject behind or alters their surrounding space.

There is a paranoia of loving kindness, just as there is a paranoia of malevolence. Charity, in its contemporary guise, is a variety of paranoia. The wholesome panic associated with altruism and salvation—'giving' and 'eternal love'—is a source of benevolent malice on par with its alleged opposite: eternal persecution and surveillance (which obviously inherit, with hardly any resistance, a theological dimension). In paranoia, the motif cannot make up its mind: it inverts. Or, more to the point, the act of interpretation is psychotic, or, as Dalí describes his paranoiac criticism, 'a delirium of interpretation'. Paranoia decomposes, as Freud said; it miraculates a rotten picture in lieu of the flesh, and then back again, like new wallpaper. In Dalí, it reaches a hideous apotheosis: eternal decoration and the paranoia of gratuitous, commercial, psychoanalytic art, the equivalent of free street-corner therapeutics. Dalí is a 'bad' artist because he produces a distasteful procession of everything that is superfluous and extraneous. There's nothing modernist about him. Nothing expressionistic. Nothing sterile. Nothing worse than amateurish. Dalí is an 'interior' decorator, something that is true of Schreber's critics as well. Schreber's philanthropic argument for his own release from the asylum could have been laid out in a few pages, but it was drowned in an obfuscating surplus of literary and hallucinatory affect: highly appealing décor.

The 'case' of Schreber goes on forever—a kind of eternal life, in much the same manner the authors of *A Thousand Plateaus* describe the afterlife of the Wolf Man, who 'knew that

Freud would soon declare him cured, but that was not at all the case and his treatment would continue for all eternity under Brunswick, Lacan, Leclaire'.[9] Transformation, malpractice, and decoration are still blissfully at work on every level in the Schreber case. Critics, bless their souls, will turn Schreber into anything they like, and usually the opportunities to do this are available in some decrypted, unanalysed section of his *Memoirs*. Schreber is criticism's answer to the entertainment industry. The case is a fantastic procession of decloaking and recloaking fantasies, techniques of rapid aversion and defence, as well as the production of spectacular and colourful theories. Is Schreber the figure 'who detaches himself from the phallic types inherent in all power formations [who] will enter such a becoming woman according to diverse possible modalities [becoming] animal, cosmos, letter, color, music'?[10] Or, in perverting (turning around) the rules blasted out from above, is it the complete sham of misinterpreting the word of God? Beside its own cast of mutating characters, which are now being interpreted at will, the Schreber plague, as it stood at the close of the nineteenth century, was itself a conspiracy of metamorphosis, in that it persuaded readers, altered disciplines, and transformed agents. But paranoia does not simply begin or end with the fantastic aberrations of Schreber and his body—it is a motif for the Schreber case throughout the twentieth century. In other words, God's interdiction—transform the world—is maniacally obeyed by the subsequent criticism. This is what we call, modifying one of Schreber's favourite terms, 'critical soul voluptuousness', in order to acknowledge the fascination Schreber generates in his readers. And to see all of this desire gratified in a body of criticism, we need to look—at least to begin with—no further than Freud.

> [The paranoiac] suffers from the atrophy of transformation; it begins in himself, in his own person, and is most marked there, but gradually it affects the whole world.
>
> —Elias Canetti[11]

Schreber came to Freud by way of Carl Jung. But Schreber did not come to Freud in the form of Schreber. Transmogrified, Schreber took the form of a book—the *Memoirs*. And that book—a bizarre symptom that appeared for the benefit of the theories—was a truly difficult gift from God. It was profane and it was disgusting; it listed names. However, for Freud, Schreber, and their new religions, it would be of great consequence to disseminate and discuss Schreber's text throughout the known universe, despite its glaring improprieties. At different moments but in concert, Freud and Schreber both argued that the latter's writings should finally be scrutinised by the clear light of analysis: 'science'. And, in

accordance with the law, the masochistic *Senatspräsident* donated his body to science. The donation of body and soul is humiliating, in much the same way as latter-day binge giving to charitable organisations is supposed to be ameliorating, but Freud eagerly seconded Schreber's lexical ashes from a diffuse but intense group of psychoanalysts and psychiatrists who had been studying the case, including Adler, Ferenczi, and Jung. He then donated his own case history and interpretation to an adolescent science (psychoanalysis) and Schreber's real notoriety starts here.[12] As Eric Santner has shown, 'psychoanalysis [in 1910] was in a state of emergency, meaning a state of emergence, of coming-into-being, as well as one of crisis and endangerment'.[13] So this exchange of papers between nervous characters moved a young discipline closer to an anticipated acceptance by the public at large. Symptoms, in this case gleaned from the text alone, became like products: they were there for the consumption of discourse and the establishment of a science.

Paranoia, the motif of the whole transgenerational Schreber 'family', is particularly localisable in the theorisation of Freud. It begins in the calamity of God's dictation and is theorised into what Santner calls psychoanalysis's 'remarkable transformational grammar of symptom formation'. Freud:

> The psychoanalyst, in the light of his knowledge of the psychoneuroses, approaches the subject with a suspicion that even mental structures so extraordinary as these and so remote from our common modes of thought are nevertheless derived from the most general and comprehensible human impulses; and he would be glad to discover the motives of such a transformation.[14]

For Schreber, during the 'religious times', this customisation of world and body was a cruel and unusual punishment, something that he constantly berated God about, but the transformation of his ideas by psychoanalysis was just as extreme. Schreber thought that the 'rays' of the authoritarian God had 'the faculty of transforming themselves into all things of the created world': miraculating energies. In the same way, following the jet stream of Freud, theory has continued with this task of transformation—indeed consummation—by observing God's desire to turn the Judge into a theoretical and clinical prostitute: *luder*.[15]

There's nothing to invalidate this procedure—the psychoanalytic appraisal of a book. The book is a good patient because it is quiet and full of details. It serves science because, unlike a chattering and contradictory patient, it offers an objective testament that all future readers may experience and interpret. The book, which remains after the patient is himself consumed by flames, is certainly 'available' to psychoanalysis, just as Leonardo da Vinci was.

The paranoid mechanism, like the book, is a prosthesis extending from the subject. It is, in a particular sense, a plastic manifestation of an internal narrative, a narrative that functions to transcribe the story. The living patient exposes himself in reverse; through the slits in the wall of his bunker, he speaks his true and astral confession. Freud:

> The psycho-analytical investigation of paranoia would be altogether impossible if the patients themselves did not possess the peculiarity of betraying (in a distorted form, it is true) precisely those things which other neurotics keep hidden as a secret.[16]

In this sense, the delirium is an 'autobiography' of sorts: one projects oneself into the surrounding walls and the pages of books, and, as Canetti suggested, this process gradually takes over the whole world. It is also the opposite of an autobiography as the space surrounding one is transcribing one's consciousness, a testament to the dictatorial nature of texts—what Harold Bloom refers to an 'an anxiety of influence'[17] and what Avital Ronell has most intriguingly named 'haunted writing'.

Criticism: it has the ability to love. To love something, at least. Criticism requires an object, and the critic has to live like everybody else. Criticism needs a nice, well-proportioned body to gnaw on, but what are its ideal proportions? Criticism is sex gone wrong. This mysterious object of theory, via the charming manoeuvre of perversion, must be transformed into the appropriate form, i.e., painting into art criticism, and so on. But what, for criticism, is delectable? And how to explain this obscure branch of desire? Schreber is a case in which the sex object is utterly virtual, therefore the process of studying it is, by definition, ambivalent. Schreber was a judge-slash-nymphomaniac, who used writing to protect himself from God—the ultimate judge. Gilles Deleuze complained that 'judging is the profession of many people, and it is not a good profession, but it is also the use to which many people put writing'. Well, for Schreber, criticism was the means to get himself out of prison—his book was supposed to prove his sanity—but it was useful for other things as well: writings and mutterings formed a wall that protected him from the hammering rays. His impromptu compositions for the piano were so loud that they deflected God's radar. Words and music were a kind of analgesic—a kind of sex, or, at least, a dada instrument of pleasure. Having a famously keen skin for pleasure and humiliation, he let the pain get through sometimes. His experiences and services were also of a shameful—a 'bad'—variety. For such services—the production of historically brokerable and visionary symptoms—he eventually allowed himself, after putting up a bit of a fight, to lie back and enjoy the chaotic

movements and noises, psychedelias, trances, erotic mysticisms, perversions, masochisms, and all the other tribes that populated his delirium: little insinuations of fascism, pinches of the New Age, a touch of proto-Internet pornography. Schreber:

> God demands constant enjoyment ... in the form of highly developed soul-voluptuousness ... If I can get a little sensuous pleasure in the process, I feel I am entitled to it as a small compensation for the excess of suffering and privation that has been mine for so many years past.[18]

The disappearance of 'Schreber' into the form of a book might seem to present a critical point in the history of his case, because here he is still being turned over in a harvest of words. This is true, but it is, in fact, just one shift that is representative of the generalised glut of transformation. 'Theory' is a chart of the gradual disappearance of the 'original' subject into the body of theory. This is made visible by Dalí, who painted an incredible portrait of it in his *Autumn Cannibalism* (1936–7). Theory can be thought of as a spectacular end in itself. For another paranoid critic, Joseph Kosuth:

> [Theory's] mission is the production of theory—theory is its 'art'—which is the objective, with 'facts' applied selectively, always in a rhetoric but only where needed to endow the theory with credibility.[19]

The case of Schreber is a story of dissolution and reappearance, evasion and capture. Schreber appears as text to the extent that he may not be addressed as a subject anymore. The personal pronoun is a facetious and derogatory scene because 'he' is no longer a human entity to speak of. When was Schreber human? Embalming Schreber as a subject, in pages and pages of sympathy and XXX-planation, obscures what might have been his subjectivity, just as surely as the autobiography proposed it. Schreber has become-android. First under God, and, following that, under the direction of 'humanist' critique.

1. The original English translation of Daniel Paul Schreber's *Memoirs* was by Richard A. Hunter and Ida Macalpine (London: W. Dawson, 1955). It was reprinted by Harvard University Press in 1988, with a new introduction by Samuel W. Weber. Both editions have long been out of print. The same translation was republished by New York Review Books in its Classics series in 2000. All citations in this essay are from the 1988 Harvard edition.

2. Daniel Paul Schreber, 109.

3. Jean Baudrillard, *The Ecstasy of Communication* (New York: Semiotext(e), 1988), 87.

4. Daniel Paul Schreber, 34–5.

5. 'When the hands cease to intervene, the mind begins to know the absence of blurry digital flowerings; inspiration detaches itself from the technical process, henceforth entrusted to the unconscious calculations of the machine.' Salvador Dalí, 'Photography: Pure Creation of the Mind', in Salvador Dalí, *Oui: The Paranoid-Critical Method*, trans. Yvonne Scafir (Boston: Exact Change, 1999), 12.

6. Daniel Paul Schreber, 56.

7. Ibid., 102.

8. Ibid., 107.

9. 'One or Several Wolves', in Gilles Deleuze and Félix Guattari, *A Thousand Plateaus* (London and Minneapolis: University of Minneapolis Press, 1987), 26.

10. 'Becoming-Woman', in Félix Guattari, *Soft Subversions*, ed. Sylvère Lotringer (New York: Semiotext(e), 1996), 42.

11. Elias Canetti, *Crowds and Power* (New York: Seabury Press, 1978), 453–4.

12. Schreber 'calls for a medical examination, in order to establish the fact that his whole body has nerves of voluptuousness dispersed over it from head to foot'. Sigmund Freud, 'Psychoanalytic Notes upon an Autobiographical Account of a Case of Paranoia (Dementia Paranoides)' (1911), in *Three Case Histories*, ed. Philip Rieff (New York: Collier, 1963), 130.

13. Eric Santner, *My Own Private Germany: Daniel Paul Schreber's Secret History of Modernity* (New Jersey: Princeton University Press, 1996), 24. The principal gesture of Santner's book is to situate both Freud and Schreber alongside 'the background of the issues and questions generated by … institutional and political states of emergency'.

14. Sigmund Freud, 113.

15. In the German-language version of the *Memoirs*, Schreber uses the word 'luder' to designate his state of abject prostitution. From the German, *luder* can designate 'wretch, in the sense of a lost or pathetic figure, but can also signify a cunning swindler or scoundrel; whore, tart, or slut; and, finally, the dead, rotting flesh of an animal, especially in the sense of carrion used as bait in hunting'. Eric Santner, 41.

16. Sigmund Freud, 133.

17. Harold Bloom's term might be usefully flipped: the influence of anxiety.

18. Daniel Paul Schreber, 209.

19. Joseph Kosuth, 'The Historian as Artist and the Crisis of Certainty', in *More and Less*, ed. Sylvère Lotringer and Chris Kraus (Pasadena: ArtCenter College of Design, 1999), 177.

Slave Artists of the Piano Cult: An Introduction

Slave Pianos: A Reader: Pianology and Other Works 1998–2001 (Frankfurt: Revolver, 2001).

> *My Slave, The conditions under which I accept you as my slave and tolerate you at my side are as follows: You shall renounce your identity completely. You shall submit totally to my will. In my hands you are a blind instrument that carries out all my orders without discussion.*
>
> —Wanda von Dunajew[1]

'Blind instrument'. This is how the celebrated German novelist Leopold von Sacher-Masoch preferred to be thought of by his lovely wife, Wanda von Dunajew. The masochistic 'contracts' exchanged between the two, consigning the erudite body of Sacher-Masoch to the will of the other whenever she felt like it, read something like a latter-day employment contract: unambiguous, with a vaguely threatening air, however quite mundane and to the point. Slavery, of course, enjoys many forms, including that of Slave Pianos of the Art Cult, a quasi-conceptualist art-and-music project principally orchestrated by Michael Stevenson and Danius Kesminas. For this project, Stevenson and Kesminas transcribed audio and musical works by visual artists into the form of musical notation, which allowed these works to be played by the blind and listening slate of the piano, aptly named a slave in this case as it is equipped with an electronic device that plays the keys automatically. In what follows, I will attempt to contextualise the Slave Pianos project within a history of piano obsession by a variety of modern and contemporary artists and thinkers. So Wanda returns, once again, to allegorise an unlikely slave—the piano—an instrument that, as we shall see, has tendered the most baroque of humiliations. 'I shall be allowed to exercise the greatest cruelty, and if I should mutilate you, you shall bear it without complaint', as she herself puts it.[2]

Instrument: 'Of the nature of or serving as an instrument or means' (OED). The 'musical' instrument, for its part, is always left in the hands of others; it is fondled and mishandled as well as played in a virtuoso fashion, never knowing what to anticipate, often ignorant of art's strange intentions. The Latin-American destructivist Raphael Montañez Ortiz, for example, took it upon himself to pulverise a beautiful grand piano with a hammer. In 1996, this piano was reinstalled in the lobby of the Whitney Museum of American Art. Philip Corner, with his Fluxus cohorts, Maciunas, Higgins, et al., performed *Piano Activities* (1962), in which the artists, dressed in suits, trampled on a piano in front of a live audience. Never one to miss out, Joseph Beuys notoriously covered a piano in felt. Bertrand Lavier, a Frenchman, smothered his with paint, applied with a palette knife. In 1939, André Kertész

photographed a series of piano distortions. Rebecca Horn, in her *Concert for Anarchy* (1990), suspended a piano upside-down from wires, in mid air, legs pointing toward the ceiling, with keys, strings, and other innards compromisingly visible. *Snail, Snail, Come Out of Your Hole or Else I'll Beat You Black as Coal* (1987) is the title of a work by Walter Marhn. It is a grand piano, on its side and upside down, suspended precariously over a small and helpless gastropod.

What do we hold against the piano? I have already introduced the suspicion that, up to and including the Slave Pianos project, avant-garde artists have treated this instrument in a fashion that more-or-less resembles textbook sadism. This is not always the case. In contemporary Los Angeles, both Stephanie Taylor and Stephen Prina, artists that music has converged upon, have gained reputations for treating the piano and the euphonies that flow through it rather reverently. Carol Irving, an artist practicing in New York City, has persuaded the piano to channel the cryptographic litanies of lie-detector-test scores. In any case, it will be argued that twentieth-century art and the piano have produced a strange union, the piano appearing in so many works of art, across so many genres and disciplines, that it is perhaps sensible to consider the piano a paragenre, an ambivalent motif that flows across different ideological and artistic standpoints.

In many and varied works of art, the piano appears ornamented, polished, sexed (although this instrument does not appear to have a sex), played 'conventionally' (but with biting sarcasm), played 'conventionally' (with disturbing sincerity), dragged, smothered, completely destroyed, and, now, with the contribution of the Slave Pianos group, electronically enslaved. Distinct from questions of musical composition in relation to visual composition, a discussion pertaining to abstraction pursued by Kandinsky for example, the piano as image surfaces regularly and ambivalently in avant-garde movements. The sheer number of times this instrument has appeared in twentieth-century art—a century that declared the 'manual' extinct—obliges one to consider it the equivalent of a compulsively replayed motif, analogous to the landscape or still life. On the occasion of his early-career retrospective (1996), the Los Angeles–based photo-conceptualist Pat Scull remarked to *LA Times* music critic Christopher Knight that both he and the exhibition 'felt empty' without a piano somewhere in the LACMA galleries.[3] Using his modest artist fee and a bit of trust-fund money, Scull, just three days before the opening, purchased a Montabello baby grand once owned by Liberace. Scull simply installed it in the museum's open-air lobby, basking under the diffused LA sun. Art historians have never questioned his motives.

What the gestures of Scull and others have to do with music in the sense of 'listening' is a purely academic question, which I will not address in this essay. In Ortiz's work, for example, the function of melody is absolutely nugatory. One might opine, keeping in

mind the work of Ortiz and others, that it is the suppression or destruction of the piano's once primarily 'musical' function that initiates its appearance in the field of modern and contemporary visual art. This is analogous to Cézanne's apples, unattainable to the bite, or Warhol's soup, never to be warmed on the stove; the fetishised motif is an application of atrophy. One would not argue that the piano itself never had potential for silence or dandyism; for example, the harpsichords and clavichords of the Italian renaissance, smothered as they were in ornamentation, appear to be quite unplayable. In fact, all pianos are silent most of the time. However, the annals of modern art inform us that, at the dawn of the twentieth century, there was a particularly virulent turn against the piano and what it stood for, musically and culturally speaking. Part of a generalised crisis in pianology, one that might be explained by the instrument's obsolescence? Not necessarily. For some avant-garde artists, the piano was nothing but a conservative, sanctioned instrument, capable only of singing the praises of past centuries. In Philip K. Dick's novel, *We Can Build You* (1972), the protagonists, scurrilous interstate peddlers of electronic and player pianos, grow despondent with the slow trade around their 'arcane' instrument and decide to make androids instead. Indeed, this seems to be a fairly standard account: the manual piano becomes electrified, then electronicised, to finally end up as an unrepentant android.

The player piano, or pianola, as utilised by the Slave Piano group, was always a machine under duress. Its baptismal task, slavery. A. Ord-Hume, proselytising in 1820, wrote that the pianola allowed a person 'totally unacquainted with music, for instance a child or a servant, to perform'.[4] This irony was not lost on Sacher-Masoch, who quipped, 'What is the point of having a slave in a country where slavery is a common practice?' There are relative degrees of slavery in relation to music. In nineteenth-century bourgeois culture, where particular forms of music and taste signified the spatial and economic borders of class-inscribed hierarchy, the notion of the slave or servant as functionary of manual labour or aesthetic satisfaction was ubiquitous. Slaves, in an expanded sense, were everywhere. From the absurd ergonomics of excessive patterning to the biological conceptions of son and heir, the anxious notion of the perpetuity of class prevailed, and everything was prop for this continuity. In the living rooms of the middle classes, the prosthetic orchestra known as the pianola stood in for the real one, which was more desirable but lay beyond economic means. The slave or 'self acting' piano, which Dickens referred to as a 'household God', was a domestic robot that emotionlessly transcribed delight—quadrilles, waltzes, minuets, country dances—electrifying the post-dinner slumber, magically producing culture for the cultureless and virtuosity for the inept: a slave for the slaves. And slavery was all the rage. In the US in 1900, 6,000 pianolas were built, compared to 171,000 conventional pianos.

And, by 1925, when surrealism was at its height, 169,000 slaves outnumbered the regular pianos by 32,000.

During a May 1999 Slave Pianos recital in Melbourne, the pianola mechanism corrupted itself. It could not stand the heat and required on-the-spot intervention by Stevenson and Kesminas. Reflecting later, the writer Brigid Shadbolt told Stevenson that the piano appeared to her as a head; strings, keys, and other mechanical components, exposed to the light, became the nerve endings of this cadaverous instrument. Hurried repairs by the Slave Technicians were likened by Shadbolt to surgical intervention, perhaps even a lobotomy. The piano, in this event, was something like a head. In 'Music and Warped Personalities', a chapter of Edward Podolsky's seminal text on music therapy, *The Doctor Prescribes Music: The Influence of Music on Health and Personality* (1939), the author describes the many ways that music may calm the 'troubled soul'. Podolsky, a very psychiatric psychiatrist, reported that, in New York City asylums at the turn of the century, piano music was successfully prescribed to calm the nerves of 'women prisoners' and 'maladjusted adolescents'. Another anecdote taken from Podolsky's book reports that all 1,300 patients of a Connecticut asylum were treated to daily recitals. Podolsky's colleague, Dr Emmett Dent, instigator of musical therapy, proudly wrote that, after years of music at his hospital, he 'continued to maintain an orchestra in the dining room where ... the patients eat their meals ... and we have never seen the time when we deemed it possible to dispense with it'.[5]

'Ebony and ivory / Live together in perfect harmony / Side by side on my piano keyboard / Oh Lord, why don't we?' This is more than we can say for artists. Like slave pianos, artists and psychotics are frequently conducted by a higher force, a more important composer than themselves. The psychotic gives away his body to God like the slave piano gives itself up to performance and the artists give themselves away to influence. Everything returns as a kind of infernal noise. The arrival of 'noise' into the world of music, generally understood as an avant-garde conspiracy, might also be understood around notions of coherence and incoherence proposed by psychiatry and information theory. Pioneer music therapist and ex–high-court judge Daniel Paul Schreber was, in this sense, a leading proponent of noise and improvisatory music, a tradition that can be recognised in the contemporary performances of LA-based artist Paul McCarthy and his ensemble Internal Organ, as well as the LA-based ensemble The Gobbler.

Instrument: 'A person made use of by a person or being, for the accomplishment of a purpose' (OED). Schreber was a blind instrument and a pure one, a slave fiddle. An amateur pianist who called himself 'the Master of Noises', Schreber spoke a lot of nonsense in his time, but not nearly as much as God, who spoke to him in a language of light and sperm. Schreber

was a singer and a pianist, in the regular sense. Held against his will in the Sonnenstein asylum near Pirna, experiencing what Lacan would later call 'full bore' hallucinations and paranoid delusions, he wrote his famous account of celestial warfare and opera, *Memoirs of My Nervous Illness*. Attacked and transsexualised by a God who appeared to him as an exploding package of holy writ, Schreber was victim to the continuing outpouring of noise and divine interdiction. In defence, he wrote music to please and annoy God. Fond of Handel's 'I Know that My Redeemeer Liveth', he would take out his rage on an instrument: 'In 1897 alone the bill for piano strings amounted to no less than 86 Marks.'[6] God forced his orchestra through Schreber: 'my fingers are paralysed, the direction of my gaze is changed in order to prevent my finding the correct keys ... the tempo is quickened by making the muscles of my fingers move prematurely'.[7] Schreber fought back:

> I myself have caused the strings to snap by senseless banging on the piano ... Let anyone hit the keys as hard as he likes, even with a hammer or a log of wood; the keyboard may perhaps be broken to pieces but he will never be able to break a string.[8]

●

'No good musical instrument becomes obsolete', the narrator of Dick's novel defensively mutters. But, by the time we reach the great Beuys's piano—*Homogenous Infiltration for Grand Piano* (1966), an instrument covered in felt, with a red cross adorning its side— we find a totally decomposed machine. If this is not obsolescence, then it is a perversion of music and an allegory of suffocation. In the eighteenth and nineteenth centuries, an imperiously lacquered piano sat for such painters as Fragonard and Renoir, who depicted it absorbing the attention of young bourgeois ladies, daintily fondling its keys in order to mainline the rigours of culture. In 1899, Gustav Klimt pictured Schubert in a spasm of musical recital; Van Gogh (1890) and Cézanne (1869–70) depicted the intense communion between player and instrument, the dissolving corporeal boundaries between human and machine. Matisse's *The Piano Lesson* (1916) and *The Music Lesson* (1917) situated the body of the pianist in a world of colour and space, especially the former work, in which the player's spherical head is but one element in a chromatic, fractured, prismatic field.

In the work of Salvador Dalí, the piano is played, but not by a mistress, by a skull. Why does the artist, in 1934, make a painting of an atmospheric skull sodomising a grand piano? An emblem of the nineteenth-century drawing room and all of its suffocating aesthetics, the curvaceous piano, something less than a full-blown church organ, was seized upon by the vitriolic, anxious tempers of Dalí and friend, Luis Buñuel. With a fanaticism that rivalled that of Benjamin Péret, an artist who liked to spit on priests, Dalí and Buñuel

fetishistically ravished the graven image. This is epitomised in the text Dalí wrote to accompany the film *Un Chien Andalou* (1929):

> We see passing before our eyes on the screen: first, a cork, then a melon, then two Brothers of Christian Schools, and finally two magnificent grand pianos. The pianos are loaded with the rotting carcasses of two donkeys; their feet, tails, hindquarters and excrement spilling out of the piano-cases. As one of the pianos passes in front of the camera lens, a large donkey's head is seen pressing the keyboard.[9]

In *Un Chien Andalou*, the piano joins an anti-Catholic burlesque procession in which it is transmogrified into a wretched procession of anti-bourgeois machinery. It is a decidedly Goyaesque scene, this self-flagellating martyred piano, which is recalled by *Musical Express* (1970), a performance by Giuseppe Chiari, who ceremoniously pushes a piano through the streets of a European city.

In Dalí's work between 1930 and 1940, there are clusters of fleshy organisms and inanimate objects, including, of course, all manner of grotesquely sexed pianos. Pianos are stacked against each other, spreading out through phantasmic convents, landscapes, and littoral zones. Paranoiac criticism, Dalí's artistic 'method', which was appropriated from Jacques Lacan's doctoral thesis, *De la Psychose Paranoïaque dans ses Rapports avec la Personnalité*, concerned itself with hallucinatory composition on a grand scale—the construction of a recreational, artistic psychosis in which it is positively impolite to venture any distinction between thing and being, mother, father, landscape, sky, musical instrument, arsehole, paintbrush—and the piano was the instrument of choice for its soundtrack. Turn on the delirium orchestra and listen to the image fall apart and reconfigure. When Dalí painted *Atmospheric Skull Sodomising a Grand Piano* (1934), he was channelling other paintings, such as those of his favourite artist, Vermeer, whose *A Young Woman Seated at the Virginals* (c.1670) is a photorealistic music-room scene par excellence. Dalí, who swallowed psychoanalysis whole and was suffering from indigestion, desperately and piously exhibited his symptoms for the world to gorge itself on: illness in the service of the psychoanalytic soundtrack industry.

Dalí's overall thesis might well be: Well, the piano is a fingered object—what a scandal! Dalí shows the piano playing out its own fantasies, becoming a pictorial field and a sex object, a reproductive surface from which the conceptually hallucinated image is born. Sherrie Levine's *Newborn*, a 1995 project for the Museum of Contemporary Art, LA, is also a sculpture about the piano as an optical device. In *Newborn*, cast-glass 1:1-scale replicas of Brâncuşi's bronze object *The Newborn* are placed on the French-polished grounds of nine

black baby-grand pianos, as if to suggest these prenatal disembodied heads appeared from the interior of the instrument. The high-gloss, perfect surfaces of Levine's pianos shine like a liquid that never evaporates, bringing to mind Dalí's painting *Six Apparitions of Lenin on a Grand Piano* (1931), in which multiple editions of Lenin's bust spring out from a keyboard, refracting themselves across the glossy, lacquered planes of the instrument's body. Dalí's and Levine's pieces also bring to mind La Monte Young's *Piano Piece for David Tudor 1* (1960), the written score for which was simply: 'Bring a bale of hay and a bucket of water onto the stage for the piano to eat and drink.'

●

The psychoanalyst Theodor Reik, following in the wake of Freud, claimed, in his article 'Mockery in Music', that:

> it is surprising to discover that music, limited by its acoustic character, can express mockery and defiance … we mean 'pure' music compositions in which mockery, contradictions and defiance are expressed by musical means alone, without the help of words.[10]

Mockery, however, does seem to have its place when one considers the piano as motif in twentieth-century art. Involving the sound artists of many creeds and colours, there is no direct evidence of mockery in the Slave Pianos project. It is an inclusive, not to mention elegant, homage to artists who have used the piano or utilised sound. The Slave Pianos project succeeds in bringing together a diverse range of artists' music for the first time, intuiting, on behalf of the theoretical community, intimate ties between diverse artists and composers. This experimental continuity brings to mind the words of psychiatrist Mary Priestley, who, in her book *Music Therapy in Action*, enthuses about the therapeutic properties of music, stating that 'dual improvisation on the piano was the most intimate experience I have had with anyone—excluding infant feeding and sex'.[11] The provocation made by the Slave Pianos project is a gesture toward the conceptualisation and unification of a diverse and perhaps confusing preoccupation—the motif of the piano in twentieth-century art and thought. The project disputes the art-historical separatism that has existed between various tendencies and movements, insisting they be reread in terms of a singular proposition: that, for complicated reasons, the piano and its historical atmosphere have been a significant theme in twentieth-century art. The Slave Pianos project has advanced this paragenre of piano obsession that has engulfed the twentieth century; its more extreme implications will oblige the serious thinker to speculate on the piano's role in the twenty-first.

1. Contract between Wanda von Dunajew and Leopold von Sacher-Masoch, in *Masochism* (New York: Zone Books, 1991), 278.

2. Ibid., 279.

3. Christopher Knight, 'Scull: The Art Recitalist', *Los Angeles Classical Club Newsletter*, no. 3, 1996: 22.

4. A. Ord-Hume, *Player Piano: The History of the Mechanical Piano and How to Repair It* (1820) (New York: A.S. Barnes and Company, 1970), np.

5. Edward Podolsky MD, *The Doctor Prescribes Music: The Influence of Music on Health and Personality* (New York: Frederick A. Stokes, 1939), 23–9.

6. Daniel Paul Schreber, *Memoirs of My Nervous Illness* (1903), ed. and trans. Ida Macalpine and Richard A. Hunter (Cambridge, MA: Harvard University Press, 1988), 143–4.

7. Ibid., 144.

8. Ibid., 144–5.

9. 'Un Chien Andalou', in *The Collected Writings of Salvador Dalí*, ed. and trans. Haim N. Finkelstein (Cambridge: Cambridge University Press, 1998), 131.

10. Theodor Reik, 'Mockery in Music', in *The Haunting Melody: Psychoanalytic Experiences in Life and Music* (New York: Farrar, Straus, and Giroux, 1953), 68.

11. Mary Priestley, *Music Therapy in Action* (New York: Saint Martin's Press, 1975), 30.

Lisa Lapinski: Sculpturicide

Art and Text, no. 76, 2002.

Arthur Rimbaud's 'literaturicide' and his subsequent journeys in North Africa—his semi-enterprising perambulation through the forbidden city of Harar, for instance—are historical events, which have been interpreted in contradictory ways. A principle squabble surrounds the question of artistic intentionality. Was the time Rimbaud spent in this region an extension of his work as a poet or the extinction of it? A kind of pop fable in reverse (as Rimbaud 'failed' to unify art and commerce), it is known that the poet left Europe in the late 1870s to settle and work in North Africa, hoping to 'wander the world and receive a salary for doing so', as one biographer puts it. In early 1880, he travelled to Harar, a frontier town if there ever was one, where he sought to establish a centre of commerce, if not a community. Later in 1880, he wrote to his mother in France, requesting a selection of books, all of them manuals for particular trades; e.g., glassblowing, carpentry, candle making, mineralogy, agriculture, masonry. All of this might suggest that Rimbaud's aim was to proselytise for capitalism in this barren Muslim city built entirely on and from dirt—its main and only edifice a Turkish mosque with two snow-white minarets piercing the desert sky—but the matter has never been adequately resolved.

Judging from her contribution to this ongoing literary debate, we can say that, for Lisa Lapinski, the final chapter of the late poet's life has developed into more of a formal, if sculptural, problem. In last year's exhibition at Richard Telles, however, the references to Rimbaud are not immediately evident. In fact, they are practically invisible in Lapinski's profuse sculptural medley, seemingly lost in the noise of printed graphics, drawings, and objects. 'Noise', that is, in the sense of material excess, indicating an aesthetic positioned somewhere between comprehensibility and, if not nonsense, then an extremely protracted and complicated form of address—one that doesn't rely on puns or other alarmist means, but an internal physical structure that releases information according to its own mood or logic.

Lapinski is a philosopher-turned-sculptor. This gives her no special privilege, except for the fact that, as in Rimbaud's case, the viewer may be tempted to look for traces of the former profession in the latter. For her ArtCenter graduate exhibition, titled *Armstrong Visions Solarian: Regina and Opium Have Dormitive Virtue* (2000), Lapinski became interested in philosophers who made drawings—at least those, including Charles Peirce and Lacan, who made graphic diagrams to illustrate their complicated philosophical systems. The artist designed and built her own diagrams in the form of sculptural objects, but these diagrams were not connected to any systems at all. It is particularly evident in *Clown (Type Face)*

of 1999, which involved the repetitive layering of 'ugly' wallpapers atop each other for six months in a potentially fruitless quest, eventually leading to a photocopy of a 'face' being pasted over the entire thing, and its exhibition as a floor sculpture (accompanied by a can of California Girl hearts of palm). This piece, according to the artist, shifts its developmental seriousness as sculpture to a sort of absurdist caricature of that, recording the tension between what she calls 'the diagrammatic and the concrete'.

Philosophical? Deleuze thought that the problem of philosophy was how to pose questions, and, indeed, the question of sculpture and how it may or may not communicate itself—philosophically or otherwise—is one that is increasingly posed by Lapinski's work. Even its potential incommunicability—as with, say, her most recent show's opaque, overly complicated references to the aforesaid symbolist parable of the ultimate futility of language—is, in the last analysis, itself a form of communication; here one that is filtered through a series of overlapping, mutually abnegating objects. This focus on formal complexity doubtless reflects the artist's difficulty in producing work, and yet, at the same time, it is clearly built into the experience of viewing the work.

Centred on Rimbaud's sojourn in Harar, Lapinski's project was initially intended to be what the artist calls 'téchne-assemblage'. She alludes to a planned (but unexecuted) sculpture based on Rimbaud's inventory of technical books: contemporary versions of these trade volumes were to be literally joined together as a sculptural object—an elaborate pun on assemblage sculpture. But, as the project developed, notions to do with conglomeration, decoration, and diagramming coalesced in such a way as to form their own sculptural logic in the space of the installation; i.e., the simplicity of the initial proposal gave way to a more spatially extravagant expression of ideas in which the master narrative, as it were, is just one part of the conversation.

The result is an exhibition positively crowded with ideas and forms. To negotiate it, one must tread lightly between the sculptures and their densely corrugated references, screenprints, drawings, stainless-steel constructions, as well as mysterious tins of foodstuffs, and 'faux' painted walls, which are intended to resemble the hypothetical Hararean interior. This negotiation is a mind tease, in that having to alternate between textual source and sculptural object (between the one- and three-dimensional, in other words) reveals what seems to be the core investigation, namely, an extrapolation of thinking through the object, and the particularly absurd fate this has had in Lapinski's sculpture to date.

Conjoined to the Rimbaud narrative and accessed via a series of metallurgical diagrams screenprinted onto the plaster base of *All of Rimbaud's Trades* (2001)—a multiple work designed to be installed in separate rooms—is yet another narrative or instructive

parable, that of a man Lapinski met at Kinko's one afternoon while doing photocopying. Upon noticing the metallurgical diagrams she was feeding through the machine, the guy introduced himself and proceeded to tell his story. Twenty years ago, and in the process of applying for a job, he was invited to go to UCLA for an 'industrial psychiatry' test. During the test, he was asked to look at a Rorschach pattern and report what he saw. He saw a paramecium. That he saw this protozoan, apparently, revealed, once and for all, that he was 'incapable of working with others', leading to the rejection of his application, so that he has had to work for himself ever since. If he had said 'paisley', however, he would have got the job. References to this individual's tragic maladjustment come through in the sculptures built out of glued layers of paisley wallpaper, miniaturised versions of those mosques that litter North Africa and other Muslim countries.

Lapinski's 'mosques' are gorgeous objects in themselves. They are at once weird blossoms and figures with personalities. One of them appears as a Gehry-esque belly dancer in an alluring pose; others come across as calligraphic towers or houses of cards with twigs poking out of them, evoking Islamic architecture as much as sandcastles on Venice Beach. Some mosques are paisley adorned, while others are constructed from Moulin Rouge–style posters referencing Rimbaud's days in Paris. They look as if they would fall over if a strong breeze blew through the gallery. But these objects cannot be read simply as 'formal sculpture' (whose conceit is that it is most often a discourse on itself). Ultimately, the material condition of these works might be best described as one of perpetual hesitation—this is especially apparent when such exaggerated flimsiness is contrasted with their arcanely elaborate conceptual structure. The dense readability of this thicket of objects—perhaps even the audacity of its demand to be read (without instruction manual)—could easily lead to a much less successful conclusion. But all of it absorbs the impact of such concentration, and one can take pleasure in the series of haiku-like transpositions it proposes: symbolist poetry turned into sculpture, biography into conceptual art, architecture into wallpaper, industrial psychiatry into a screenprinted sculptural support, and, eventually, Richard Telles's gallery into Harar (by way of Middle Eastern restaurant chic).

Lapinski's exhibition as a whole takes the form of a chattering constellation of objects, held together by thoughts, pulled apart again by the thoughts, the divergent and non-linear progressions. The exhibition is finally an event (in thought and material) that is played out in its objects. The objects don't talk, exactly; rather, they stubbornly but joyfully delineate an arc of concentration, confusion, construction, frustration, completion, satisfaction, and more frustration, which eventually becomes Lapinski's contribution to the incommunicable language of sculpture.

The fate of Rimbaud's North African trek will no doubt continue to be scrutinised. That his business plans were so ambitious, so flawed, has been taken as a sign of his insanity. However, his epic transformation does seem to have something poetic about it, at least in its total absurdity; it was just a poet's way of doing business. Perhaps such a cryptic evolution may also propose a way for Lapinski's project to be read: complex enough to be annoying, original enough to be bewildering, beautiful enough to be utterly frail—an ex-philosopher's way of making sculpture.

Warhol Unbalanced

Art and Text, no. 77, 2002.

Book review: Wayne Koestenbaum, *Andy Warhol* (New York: Penguin Putman, 2001).

Like almost no other artist, Andy Warhol is on a first-name basis with everybody. 'Andy' the people's artist; 'Andy' the fucked-up, sad, celibate man; 'Andy' the great master—these are all things programmed into the profound question of what that figure means to us. Most artists feel some affinity with Warhol or his school, and, the more one thinks about him, the weirder he becomes. There is a ubiquity about Warhol, about academic and non-academic Warholism, with lines of influence bifurcating in all directions, to the point of their own disappearance. Warhol has reached the perpetually enigmatic stature of an artist like Duchamp; the body of work is now so scattered and assimilated that its precise origin seems undetectable. You could well hate Warhol, but who or what would you hate?

This, perhaps, was one of the questions Wayne Koestenbaum asked himself when embarking on his study of the artist, published late last year to great acclaim, making the author himself a sort of 'Royal Koestenbaum'. The result of intense inquiry, *Andy Warhol* is not a cut-and-dried account of the celebrated, celibate 'machine' most of us were taught in art school, but a deeply personal narrative that bounces tiny, intimate details off the harsh and enveloping facts of the market, the artist's interior life, and his surrounding culture. Koestenbaum takes the first-name basis to its extreme: he goes into family names, names of pets, lists, letters, quotes, and many other pieces of apparently significant, sometimes speculative information in order to build his case for what he believes Warhol to be. It seems that the author genuinely tried to interview everyone he could find who met, worked, or socialised with Warhol, as well as read everything ever written about him. He then put all this information together and made up his own version. The advantage of this approach is that Koestenbaum has created a work comparable to Susan Howe's *My Emily Dickinson*, which uses a literary love affair to produce a surprisingly original theory of poetry.[1] But the disadvantage is that Koestenbaum occasionally resorts to dreary, amateurish psychoanalytic techniques to excavate how the artist 'truly' felt about things, including the burning question of Warhol's sex life and how often he did it.

In many respects, *Andy Warhol* is a biographical dossier of a life followed from birth to grave (after all, the book is part of the Penguin Lives series). Yet, far more significantly, it is also an impact study on the effect that Warhol had on the people that surrounded him, the generations that followed, and the subsequent industries that have grown up around his name. Warhol scholars have complained to me about the gross inaccuracies of some

of Koestenbaum's historical facts. But, even if that's true, I don't think it's a major issue, as the book doesn't in any way set out to be a 'life' in the conventional, exhaustive sense. *Andy Warhol* is ultimately a work of literature in which Koestenbaum tries to invent a genre, one that uses his mastery of the English language to celebrate certain things he likes about Warhol, and demean those that he doesn't. There is even an insistence in the book on Warhol's inarticulateness or fear of language, which is tensely poised against Koestenbaum's own illuminating, but utterly controlled, prose style. Koestenbaum uses language, sometimes admiringly, sometimes scornfully, to fill in Warhol's blanks, producing what he refers to as an 'imaginary conversation' with the artist—a respectful apologia for Warhol's 'personality'—which subtly refers to many other works and ideas.

Andy Warhol is a polemical text. For example, in it the films reign over the paintings (this is a worthwhile argument as the latter, in relation to their degree of exhibition and economic consumption, have indeed been over-hyped). Also, some people are just written out or off. The Velvet Underground Koestenbaum does not want to talk about. Paul Morrissey doesn't really figure (probably because Koestenbaum doesn't much like him). And Jack Smith, who has made a convincing critique of Warhol, slamming his slide into abject capitalism, is hardly worthy of a mention. In contrast, Koestenbaum philosophises about Warhol's skill with money, but rarely discusses what people have done with the money they made off of him, preferring instead to describe how Warhol hurt people rather than how he made them happy. (I have been told that Larry Gagosian openly wept at the opening of Warhol's show at the Tate Modern last February.) When all is said and done, *Andy Warhol* ascribes to what criticism should ideally be, that is to say brilliantly opinionated. What Koestenbaum attributes to Warhol's form of 'promiscuous endorsement' may actually be a fair assessment of Koestenbaum's own methodology and the school of criticism he belongs to. I, for one, am quite content with the book's lack of balanced opinion, except to point out that it continually asserts the dominion of writers over every fact or question before them, the results of which are frequently horrible.

Koestenbaum maintains the exclusivity of his own critical purchase by paying close attention to the question of trauma or erasure in Warhol's work. He ingeniously destroys the conveniently manufactured notion of Warhol as a non-person or 'machine'. In addition, his account of the legion of Warhol's friends, lovers, and co-workers who spent their remaining days in perpetual, shell-shocked mourning is sad and beautiful. Leaving aside the doubt any author could ever really penetrate the psyches of his witnesses, Koestenbaum certainly argues a convincing case that Warhol formed an overarching 'proscenium for traumatic theatre' among his cohorts. Koestenbaum describes, for instance, how Warhol used his

camera to 'torture' people, emphasising the humiliating sweat that lay behind the artist's constant photography, and especially the lewd militancy of Warhol's various factories. He lays bare the conspiratorial dichotomy that exists between pornography and art in his descriptions of how Warhol blew this apart in his work, or at least how he muddied it when slinking off to the bathroom to give himself an 'organza'. There are stories about Warhol's traumatic effect on people and their subsequent acts of revenge: Valerie Solanas, finally, has her day in court. Koestenbaum says that Warhol 'had a way of casting light on the ruin—a way of making it spectacular, visible, audible'. Elsewhere, he speaks of Warhol's ability to 'suck the spirit of others', explaining that his nickname 'Drella' was a cross between Cinderella and Dracula. Koestenbaum, who clearly empathises with Warhol's feelings of self hatred, paranoia, and obliteration, even practises a kind of art-historical self empowerment by trying to make the artist feel better about his past actions. At the same time, discussions of Warhol's late works, which have frequently been dismissed by other writers as both commercial and inferior, are interesting but not entirely convincing, since, for Koestenbaum, Warhol, both personally and artistically, can do no wrong.

The theme of trauma has an enormous presence in this book, as does the theme of sex. If there is one passage that encapsulates Koestenbaum's final opinion of Warhol, it is this: 'For Warhol, everything is sexual. Contemplation is sexual. Movement is sexual. Stillness is sexual. Looking and being looked at are sexual. Time is sexual—that is why it must be stopped.' This insight, which may seem self-evident in a cloudy, back-of-the-mind sort of way, has never been spoken with such clarity before.

In the end, whether as the biographer or the reviewer, one is supposed to come up with a balanced, positive-or-negative appraisal of the subject at hand. I will admit that *Andy Warhol*, very much like its subject too, is ultimately a piece of work, a real paradigm. It is a useful exegesis of the artist's life and work, but it is more directly an expression of the power of language, which here flexes its muscle over extremely complex material. It's a prodigious text, but I don't necessarily trust it. Indeed, how far can literary opinion go? How many opinions can be proffered before even opinion itself is invalidated? When will Warholism exhaust itself, and how does this book fit with that question? It is a law of human curiosity that, the more that is said about something, the more will be said about it, and so on. Warholism definitely belongs in this category. All opinion on this artist has now become unbalanced. We should leave it to future Warholian generations to work out their passions and traumas for themselves.

1. Berkeley CA: North Atlantic Books, 1988.

Paid in Full

Art and Text, no. 78, 2002.

Books review: *Hatred of Capitalism* (Los Angeles and Cambridge MA: Semiotext(e) and MIT Press, 2002), and *French Theory in America* (New York: Routledge, 2001).

Jack Smith's acidic remark to Sylvère Lotringer, who was interviewing him in 1978 for his journal *Semiotext(e)*, gave this collection its only slightly ironic title. 'I looked through your magazine', said Smith, referring to an early issue of *Semiotext(e)*, 'and I was repelled by its title. It's so dry you just want to throw it in the wastebasket, which I did. Then I picked it out … Listen: *Hatred of Capitalism* is a good name for that magazine. It's stunning. I'll never admit that I thought if it.'

And so it became, the hatred of capitalism. Faced with the prospect of paying off years of student loans for the privilege of hearing the editors of *Hatred of Capitalism* and *French Theory in America* proselytise on the states of advanced capitalism, I might admit to having a love–hate relationship with this vocation. Pouring money into a Southern Californian private institution in order to learn about French theory—well, there was something odd about that, but this oddness was totally consistent with the many other twists and inversions produced by the material at hand. These two volumes, both retrospectives in a sense, present a kind of history of the spread of the 'French disease', as it has been known, in the US. *Hatred of Capitalism* is a survey of material that was originally published by Semiotext(e), while *French Theory in America* is mostly an analysis of the effect this and related material has had on the overlapping worlds of art and academia; recently commissioned essays by, for example, Sande Cohen and Alison Gingeras circle primary texts by Baudrillard, Deleuze, Kristeva, and others, to track and expose the politics of American reception.

On viewing this selection of texts together, in all their fury and gorgeousness, one is reminded of how seductive and powerful this French incursion has been. Of course, not all of these essays and stories were written by the French, but, in this context, they are understood in terms of the general predicament for reading established by French theory. Having said that, the diversity of the texts and the slipperiness of the idea itself also make it obvious that the term 'French theory' is a knowingly facetious joke, a kind of marketing slogan. Furthermore, there's absolutely no ideological consensus between the writers; in fact, violent disagreement is much more likely to be the case (look at Baudrillard and Virilio, for instance). French theory, though, might be understood in an expanded sense as the proposition of taking complex political thought and downloading it into the unstable popular and art cultures of the 1970s and 1980s. In this sense, it was an amazing and idealistic experiment

in thought, one which spread rapidly and held considerable influence. The juxtaposition of David Wojnarowicz with Georges Bataille, or of Ulrike Meinhof with Eileen Myles, as we have in *Hatred of Capitalism*, politicises academic writing and adds theoretical complexity to the works of artists who were working through the horribleness of the Reagan years and the onslaught of AIDS in the arts community of New York and elsewhere. 'To the memory of an era (1974–2002)' is the inscription in the frontispiece of the above volume, and, to a certain extent, September 11, which occurred when both these books were going to press, necessarily alters the whole relationship between politics, violence, and writing—which isn't to say that September 11 brings this body of thought into an even more pertinent focus.

There is so much life slammed into this slim volume, *Hatred of Capitalism*. Edited by Chris Kraus and Sylvère Lotringer, its contents are roughly divided between first-person-narrative works published by Kraus in her Native Agents imprint of Semiotext(e) and the imported French theory *per se* first published in *Semiotext(e)*, the journal, and in Lotringer's Foreign Agents series. There are some particularly dazzling essays included, notably Baudrillard's 'Why Theory?' (1987), a searing little manifesto in which he insists that theory, in order to speak about sacrifice and excess, must itself become excessive and sacrificial. Baudrillard, a real prick, has given us a lot of laughs with his hobby of accelerating propositions to their breaking point and letting the chips fall where they may; being ideologically irresponsible basically, to irritate a few liberals. Deleuze and Guattari's 'Capitalism: A Very Special Delirium', which appears here in English for the first time, is a text in which the whole body of work produced by the authors is activated by the smallest sentence; it is a kernel of their thought, scattered across a few pages. William Burroughs's 'The Popling' (1981) is an erotic sci-fi tract of comical excess, while Cookie Mueller's 'Abduction and Rape: Highway 31, Elkton, Maryland, 1969' (1990) is a frighteningly real account of redneck practices, as is Black Panther Assata Shakur's interview (first published in 1992) in which she describes her incarceration and treatment by the New Jersey State Police. Again, the strength of the whole operation, and the argument of the book, is that such texts, fictional, autobiographical, or scientific, are able to function analogously with one another; that is, as so many examinations of an event, either in literature or politics.

This tone shifts somewhat in *French Theory in America* (edited by Sande Cohen and Sylvère Lotringer), which is necessarily more traditionally analytical. There is a diminishing vitality to the sometimes self-congratulatory papers by Kristeva and others, who quite patronisingly 'thank' America for their fame while rapping people's knuckles for misunderstanding the finer points of their work. For new readers, French theory can be technically bewildering—this was part of its seductiveness—but the best writers (and

readers) understood that the fate of their American reception would result in all sorts of hysterical events and weird enthusiasms. The Whitney Museum's *Abject Art* show of 1993 was a case in point, in which Kristeva's conceptualisation of the abject was made into a fashionable dog-and-pony show. She may object to this 'commercialisation' of thought, but it was completely symptomatic of American enthusiasm, and therefore exemplary of its times. While it is true that there have been more sinister applications of this language's power (see Cohen's 'Critical Inquiry, October, and Historicizing French Theory' for a surgical dissection of East Coast academic imperialism), it is important to recall Semiotext(e)'s ambition to lever theory out of the academy, offering it the possible destiny of total mess and annihilation in a non-policed forum of public ideas. It is dreary, therefore, and somewhat contradictory, to read pedantic accounts of misreading, or even have it explained to us what effect Lacan had on film theory or whatever. And please, no more about the Sokal 'affair'—a pathetic excuse for scandal that it was anyway! This aside, *French Theory in America*, named after a conference at the Drawing Center, New York, in 1997, includes another astonishing Baudrillard essay, interesting contributions by Gingeras and Eli During, and Lotringer's 'Doing Theory', a personal account of theory's introduction to the US scene. Chris Kraus's contribution, as well as her pieces in *Hatred of Capitalism*, demonstrate a writing informed by theory but hijacked into a new landscape of first-person narration. The writing is a smash-and-grab of theoretical effects, which, like Kathy Acker's work, fulfils Lotringer's ambitions for a fusion of art and politics.

As an experiment in literature and thinking, the possibilities of writing were certainly extended by French theory; in visual-art culture, it's another question. The popular French theorists, like Guattari, idealised visual and musical artists, writing embarrassingly confessional tracts on subjects such as free-form jazz; American artists such as Peter Halley produced equally plodding painterly responses to theoretical notions. The local effect on the visual arts, perhaps, was not to politically radicalise art, but to show just how brilliantly American art can relegate anti-capitalist principles into domesticated, commercial versions of the former.

To read both of these books is to gain some knowledge of the intensity of language and its significance. There are crazy and abrasive passages of language, weird departures from academic form, and vicious, allegorical condemnations of the contemporary world, just as there are precise and startling dissertations. The books are also a history of how art culture got to where it is today, including the question of why French theory has apparently disappeared from the horizon of contemporary-art practice and criticism. Lodged deep in the heads of artists and thinkers, including the graduate students who carried thousands

of pages of Derrida in between apartments and seminar rooms, what was called French theory has gone into stealth mode, waiting for today's love of capitalism to reveal itself as something a lot stranger than it currently appears.

El Gran Burrito!!

Log Illustrated, no. 15, 2002.

There is an unfortunate tendency among New Zealanders to be vegetarian. For no particular reason that I can remember, I was one for seven years. Perhaps this had something to do with the fact that everyone I knew aside from my family didn't eat meat—my family did— and, at the time, this was reason enough. I even tried veganism for while, a few miserable months. Even though I meet the odd vegetarian in Los Angeles, where I have lived for five- or-so years, I associate vegetarianism with New Zealand, an obsession suffered by people of my generation who have or had an alternative inclination. I have completely lost my patience for that attitude, the dietary part of it at least.

As I said, my parents were not vegetarians. My father, who was Italian and quite a good cook, liked to eat meat, and he spent a lot of time thinking about it. The New Zealand side of my family were drawn to the wonders of corned beef: awful, pink boiled blobs of rubbery flesh surrounded by shuddering strips of putrid fat, hacked at with a blunt knife, and served with massively waterlogged cabbage and potatoes bruised by the carcinogenic interior of an aluminium pan. Perhaps this puts vegetarianism into perspective.

I have developed an interest in food and cooking since I have lived away from home, and I think this is for several reasons: getting older, having very little money and wanting to create some sense of material pleasure while living in a shoebox, wanting to think about something else aside from art or do something aside from artworld things (escaping the artworld, in other words), good and bad health, creating opportunities to drink lots of wine, having something else to read about, taking pleasure in something that is not illegal, and so on.

These things apply to cooking and preparing food at home, which I like to do a lot. This is relatively uncommon in LA, as everyone of the sociable generation goes out to eat. It's quite rare to be invited to dinner, unless it's at a restaurant, which is what all the gallerists except us do after an opening, because we cannot afford it. Finding good places to eat out, however, presents its own problems. There's a lot of crap food here, but that isn't the end of it. There are so many stupid restaurants, far too many fast-food joints, and so many nasty people. Having said that, LA, if you know how to find what you need, is a brilliant place to dine—at every gastronomic level. New Yorkers are frequently mean about the food scene in LA, but most of them don't know what they're talking about. Outlets for cheap ethnic food that make people very happy can be discovered by reading Jonathan Gold's tome, *Counter Intelligence*, a guide to the taco stands, Vietnamese noodle houses, Chinese dives,

Korean BBQ restaurants, Salvadorian pupusa trucks, and dumpling houses of this very vast place. Perhaps as a culinary riff on Ed Ruscha's *Every Building on the Sunset Strip*, Gold claims to have dined at every restaurant on Pico Boulevard, a vast street, at least twenty-five miles long, which extends from Santa Monica to Downtown LA, and crosses white/wealthy, Mexican, Salvadorian, Argentinean, Korean, and African-American neighbourhoods. It's this kind of research that can really benefit a food hunter, as without it one would simply be lost.

In any case, Tessa asked me to write about burritos, which is why I started on the subject of meat, probably just to get on her herbivorous nerves. The burrito, a Mexican invention, is all about meat. It is also about rice, salsa, and cilantro—but vegetarian versions are generally boring (more often than not the 'vegetarian' burrito isn't vegetarian at all, as the beans are prepared with animal lard). The most common versions are asada (steak), al pastor (roasted and seasoned pork), carnitas (roasted pork), pollo (chicken), and lengua (tongue). Fish burritos can also be amazing, but stands serving them are generally closer to the sea and I live quite far from it and eat them less frequently. The burrito is like a Mexican hamburger, if you will, and it is frequently served from a dazzling, stainless-steel truck, which will pull up to your street corner when the car wash or whatever closes for the day.

There is one in my neighbourhood that I like called El Gran Burrito. Not a truck, it's a large tent in a parking lot, inside of which is a bunch of burners and grilling racks, salsa stands, pots of boiling beans, scrappy tables, trash lining the bins to their limit, with cars revving outside, babies crying, TV news in Spanish, toothpick dispensers, the continuous ringing of the cash register, fluorescent lights, a lovely warm wind blowing through the whole place. The workers are kind and efficient, and the food, once ordered, takes no time to come.

El Gran Burrito is open all night, always packed with drunk, hungry people of all ages and persuasions piling thigh-sized chunks of smoky meats and bright salsas down their gullets and leaving shortly after often-fruitless attempts to wipe the grease off their faces with a towelette. Sometimes there are mariachi singers, which may or may not aid with digestion. You can have just rice and beans in your burrito if you like, as Tessa did when we were there once, but most prefer the addition of meat, which is roasted, seasoned, and then rolled into frisbee-sized portions of unleavened bread. It's very juicy, this meat, often oversalted to shit, but always slowly cooked and completely tender—with the consistency of a well-grilled zucchini. Condiments include guacamoles and several chile salsas (red, green, golden brown), topped with cilantro, diced onion, and wedges of lime, which are especially delicious squeezed over carnitas. Avocado on charred steak is delicious; verde on

pork is just so amazing. Salsas are free for the taking, which necessitates handwritten signs in Spanish discouraging patrons from being too greedy, but you see people stuffing plastic containers of them in their purses anyway. I have talked with people who have travelled across Mexico, visiting hundreds of taco stands and village restaurants, and, according to these experts, El Gran Burrito doesn't exactly deserve world fame, and I have eaten at much better myself, but this place, which you can smell half a mile away, produces much delight for the mouth and in the stomach. The place serves food at its most elemental; it is the undisguised pleasure of eating meat.

Julia Scher: Pulverised by Light

Julia Scher: Always There (Berlin: Sternberg Press, 2002).

> *Through the light emanating from the sun and the other stars, God is able to perceive (man would say: to see) everything that happens on earth and possibly on other inhabited planets; in this sense one can speak figuratively of the sun and light of the stars as the eye of God. All He sees He enjoys as the fruits of His creative power, much as a human being is pleased with what he has created with his hands or his mind.*
>
> —Daniel Paul Schreber

'Have you looked up at night lately? The universe is going away, gone already for many.' This apocalyptic notion is taken from the website of DarkSkies International, a lobby group of astronomers, scientists, and ecologists who are concerned that artificial lighting, in particular the security lighting that surrounds private compounds, is producing a new kind of environmental crisis. The potential effects of 'light pollution' are both worrisome and absurd: the surplus of electric light flares out into the lower atmosphere and is trapped within it, creating a blanket of 'light trespass' over intensely populated areas.

DarkSkies International has two major concerns, as expressed on www.darkskies.org. The first is that concentrations of light pollution inhibit the perception of distant celestial bodies, making astronomical study difficult. The second is of a more 'spiritual' nature, namely that the 'billion stars' that inspired so many religions have met their match—blown away by the extreme illumination of factories, malls, prisons, and residential properties in the name of security. The irony is that the human desire to create material security on earth threatens to eventually cancel out the consoling security of ultimate distance, the wonder of the night sky. The sky is not falling, but it is having the door shut on it, a door consisting of light itself. The earth is in the process of securing itself from the rest of the universe, removing itself from the ambiance of nature. Two imperatives of security collide: artificial lighting is the 'bright lock' that enforces property-line demarcation, deterring would-be invaders, but this excess of light is produced at the expense of a more holistic relationship with distant bodies. The more electric light is produced, the less we see.

DarkSkies conceals its libertarian agenda in the language of environmental concern, with a dash of right-wing fundamentalism thrown in. While there are explosions of theology and alarmist excess in this discourse, they are moderated by practical considerations:

If we help preserve the dark skies, we see better (and are safer and more secure), we have a more pleasant and comfortable nighttime environment, and we save a great deal of energy and money doing so. What we all want and need is security and safety at night, at home and away from home, for ourselves, our families, our homes and property, and for all others. The task is to be safe, not just to feel safe. Visibility is the goal. We want to be able to see well, rather than lighting the criminal's way.

Transcending ecology, light pollution suddenly impinges on the welfare of homes and families. Security is a concept defined by visibility: one must see in order to protect oneself (and one's family) from that that emerges from the dark. But an excess of light also harbours a criminal component, a supernatural force that steals distance and perspective.

If illumination is the central metaphor for surveillance, then surely Michel Foucault would be the most obvious theoretical reference for Julia Scher's project. Foucault's celebrity coincided with Scher's emergence onto the scene of cultural production; indeed, much American political art of the early 1990s draws on his ideas. But, if there is a celestial basis to paranoia, then Scher's connection to it might better be tracked by way of the twentieth-century's foremost celebrity paranoiac, Daniel Paul Schreber. Schreber's texts describe a position from which power runs amok to produce a hallucinatory empire—power is turned against itself, into a stream of psychic special effects and information pornography. Made famous by Freud, who in 1911 published interpretations of the author's phenomenally paranoiac text, *Memoirs of My Nervous Illness*, Schreber has since become the emblem of paranoia, a kind of poster boy for psychosis. The *Memoirs*, written during the author's internment in psychiatric facilities, detail a grand battle between Schreber, the last man on earth, and an evil and lascivious God bent on 'destroying reason' and repopulating the barren earth—by transsexualising Schreber, inseminating him, and forming a new master race.

Schreber's *Memoirs* are an account of total convergence—the eye of the other hitting the body. He can be seen as an individual pulverised by light, and his account of celestial contact is one written in the language of 'rays'. These rays can be likened to the most immaterial of contemporary communications technologies, in that they transmit information from God to Schreber using the medium of the sky: texts, sensations, thoughts, fragments of bodies, little birds exploding with speech, ideas gone off the rails—all of this hits Schreber's body at extreme velocity. Luminance, as Scher has said, is interchangeable with information, and this luminance, for Schreber, approached the status of the electrical. In describing the rays, Schreber uses the metaphor of the telephone:

It is presumably a phenomenon like telephoning; the filaments of rays spun out towards my head act like telephone wires; the weak sound of the cries for help coming from a vast distance is received … in the same way as a telephonic communication …

Schreber described God as an anxious commander of the human race, one who recognised the former's psychic abilities as a threat and attempted to destroy him through counter-intelligence. God is perpetually involved in the task of surveillance, and it is the very notion of the 'eye of God' that articulates the parameters of the universe.

It is this kind of mysticism, or at least this special branch of the irrational, that drives the sublime opportunism of surveillance. Is security nothing but a thing in the air, a parasitic entity nourished by paranoiacs, private-security companies, and military industrialists, not to mention theorists and artists? Surveillance is not so much a field of study as an addiction or an occupation, one that is self perpetuating. It is not a quantitative thing that can be understood through the sheer mass of its machinic bulk or the hypothetical existence of criminals; the fact that there are an increasing number of surveillance cameras in Downtown Los Angeles only serves as further evidence that more will be required. Is the cultural obsession with security anything but a sign that privacy and safety, the two states that the industry claims to provide, are completely unattainable? Why would a culture so stupidly fixated on celebrity call for total privacy at the same moment? But surveillance is a booming industry, especially in periods of recession, as evidenced by the rapidity with which new wire-tapping powers were granted to American authorities in the wake of September 11.

Surveillance could be seen as being the 'subject' of Julia Scher's art, but I would rather think of her project as a mechanism designed to activate consideration of a number of issues related to this broad subject. In some respects, Scher's project has a dimension of what might be called 'pure' American post-1960s political art: activist in nature and only secondarily aesthetically gratifying. Her work has paralleled the build up of surveillance over the past fifteen years, functioning as a kind of conscience for the hysterical implementation of technologies, from closed-circuit television to biological scanning; it can be thought of as an allegorical scale model of a vaster shift in human thinking. But her project also plays the card of aesthetic delectation—it is a boutique assemblage, a fascinating display of software and hardware in endless manipulations. Entering a practically Warholian domain of pleasure, it thrives on the multiplication of presences and the hedonistic, fetishistic buzz of reproductive technologies. From the very first, Scher has manufactured a comical and corruptible relationship between 'political' and 'pleasurable' art.

Scher's work is a reflection on the act of looking, the malignant thrill of looking across mediated spaces and through the most recent and sophisticated technologies. As she has written:

> The project is intended to enlarge the definition of what is art, to foster a consideration that nothing need not be art, to show the museum in the role of boundless (boundary-less) enterprise, and to make us more aware of ourselves in human relation to technology and to each other.

We are asked to examine the world through new intellectual and technological paradigms, notably those created by video and the Internet. In this respect, she is a modern artist—or, as she once joked, 'two-hundred years ago I'd have been a trompe-l'oeil painter'. Surveillance may be understood as a function of law and social control, but it is also a principle of aesthetics, and it is in the space of work by Scher and other artists—for example, Michael Snow—that one can speculate on its more fantastic implications.

The emergence of European and North American video art in the late 1960s and early 1970s provides a foundation for Scher's project in the senses of electronic activism and the experimental application of technology. In 1973, for example, Frank Gillette had pragmatically observed that:

> the emergence of relationships between the culture you're in and the parameters that allow you expression are fed back through a technology. It's the state of the art technology ... which gives shape to ideas.

The essentialist dilemma 'what is video?' was played out in these decades in a significant body of theory and practice that hoped to establish a conscience to guide the medium's artistic and political future. The 'distinctive features', as David Antin described them, were the instantaneous transfer of live action and the political context that video art inherited from broadcast television. There was also the question of the surveillance of the viewer. Certain works by Peter Campus, Dan Graham, and Bruce Nauman allowed viewers to observe their own motions, subjected to a slight delay, in the space of the work. Viewers literally became the subject and co-producer of the work, just as when they visited a mall or went to the airport. Commercial video surveillance and clinical psychiatry, also deeply implicated in what Rosalind Krauss had theorised as the implicit 'narcissism' of artists' video, quickly established the artificial environment of videography and brought us the

clinical double of video art. 'Audio-visual self-image confrontation' was a therapeutic technique through which patients were made aware of their own behaviour by watching a videotape of themselves, a dubious revelation brilliantly satirised in Atom Egoyan's *Family Viewing* (1987). There were also more untoward investigations that presaged the totalising presence in architecture and consciousness that video enjoys today. In his 1974 essay, 'Video as a Function of Reality', Peter Campus wrote:

> If we are to avoid the problem of creating a visual system that will reduce the capacity of the eye, then it is necessary to disassociate the video camera from the eye and make it an extension of the room.

This suggests that the 'expanded eye' blends and merges with an architectural situation, and that the very walls have the capacity to process information, something not so far from today's reality.

One can think of Scher's work as a response to a sequence of questions that are quintessentially art historical, or one may see it as pointing to the fact that art-historical analyses are in the process of being dethroned by much more powerful optical regimes and that art history can only look on in amazement. Her work is a body of sculpture, certainly, one which magnifies and extrapolates many of the medium's central, historical concerns, but the critical issue is one of non-physical properties. In statements and interviews, Scher maintains a position that separates her from the histories of both sculpture and professional monitoring, while happily appropriating or sabotaging the industrialised tropes of both. In 'Mass Observation', a text published in *Ten 8* in 1991, the artist describes 'the skeleton upon which surveillance images hang'. The conception is McLuhanesque in its assumption that electronic networks are an extension of human physiology, a notion Scher furthers by describing the monitors of surveillance as 'the eyes of a social body gone berserk'. This is the articulation of electronic space from the imagination of pathological delight. The sculptural realisation of such spaces, for Scher, is both a technical and a poetic question: the installations are designed to engulf, to impose their position upon the viewer. 'Surveillance reproduces a landscape that is not only watched, but watches back.'

The vital health of paranoia, its popularity, is something that Scher can only exploit and perpetuate; it's questionable whether one can have a detached or critical relation to such a complex situation. It might be likened to the notion of celebrity in Warhol: a nihilistic infinity. Other branches of allegedly political art, say that of Hans Haacke, seek precisely to demystify or to decloak political corruption, presenting brick by brick the

components of oppression. In Scher's case, though, how can anything extinguish the most ancient of concerns, the guarding of secrets or the protection of borders? What is the point of identifying the oppressor in a landscape of perpetual suspicion when the ideal role of surveillance is to continuously represent nothingness? Thus, hers is a project of complete mystification. Surveillance cameras can occasionally identify criminals, but they are best at depicting voids: empty corridors, desolate parking lots, perfectly safe houses, and businesses in the light of day and the dead of night. They stare at ugly doorways, gates, concealed exits, and other motifs of architectural surplus, plastic lenses mopping up an endless, unpunctuated blankness. Their special skill is to pretend to be architecture and to wait in stealth, anticipating invasion; their psychic predicament is one of absolute boredom combined with the theatrics of readiness.

The metaphors of light and vision are ones that can include invasion, detection, and illumination, as well as the benign pastime of simply seeing. Looking at an empty doorway, a blank wall, or a street implies an idea of simple pleasure. Being looked at introduces a peculiar psychological strain, which may or may not be pleasurable; being watched without one's consent amplifies any possible discomfort that existed. If Scher's work has a theme, then it is the idea and the experience of examination. It propels the basic idea of looking (say, at a painting) into the hysterical frame of mass observation, a diabolical eroticism of space that entertains pleasure and serenity, but also the threat of panic. She is exploring insecurity as it is exploited by the happy industries of surveillance and paranoia.

Scher's work can also be thought of as a study of these industries of private security, applying philosophical pressure to a truly uncanny branch of commerce. In its perpetual projection of safety and invasion, private security is related to other delirious paradigms, such as the art market or the stock exchange, that function on a resolutely emotional basis. To scan the websites of major private-security companies is to bask in primal fear, slightly embroidered by contemporary graphic design. It can be argued that contemporary private security is a fascinating and arcane form of decorative art, in that its modus operandi is the production of visual excess: scanning far more than necessary in order to isolate that which tries to escape detection; taping thousands of hours of parking lots, just to be sure. Private security in America, apparently, is instituted for the benefit of the wealthy and educated; nonetheless, it is a profession marked by the servitude of the disenfranchised, one that remunerates scandalously, trains poorly, and relies most significantly on the power of a plastic badge and a nylon uniform. Scher's work extrapolates this principle in an extraordinary way by making the tawdry prestige of the commercial police more concentrated and paradoxical in, for example, her 'security boutiques', 'surveillance

brothels', and 'electronic dungeons'. At this point, we might think of *Lena* (1997), one of Scher's infant security guards; a child packing a CCTV monitor, wearing a tie, and otherwise sporting the most dandyistic authoritarian chic imaginable. This amazing image, one of the artist's most compelling, amalgamates the innocence of the protected with the flimsiness of protective agency.

Scher's installations in museums and galleries—institutes of surveillance in themselves—radiate a certain phobic curiosity in order to intensify the effect of the signs of 'repression'. These are installations of and about display; display being a sort of optical vivisection. Scher's installations and projects manipulate the audience into the sensation of fear, just as a Disney ride mandates 'fun'. But, whereas fun has its limits in relation to the ride, Scher's machine is a cross between a consciousness-raising apparatus and an electronic cathedral of paranoia, one possessed of a radical ambivalence. The spectacular is further spectacularised in order to be taught a lesson, but there is no point where visuality itself will be extinguished as the result of political pressure: it will only become more mysterious and opaque, more mystical.

In his *Memoirs*, Schreber described a regime of visual power through which God creates the world and then sits back to watch, taking pleasure, and, at the same time, keeping check. It's the corporate life for God, heaven being the ultimate bureaucracy, but it's not a fail-safe system. There will always be someone like Schreber who can potentially destroy everything. God then instigates an attack on Schreber's body and soul in order to terminate the threat, but Schreber sexualises the attack to the point of receiving pleasure from it, an ingenious tactic. As Eric Santner has written, 'Schreber discovers that power not only prohibits, moderates, says "no", but may also work to intensify and amplify the body and its sensations.' Schreber promotes himself to the executive position in a universe that is concerned only with surveillance and the transfer of celestial gibberish. In so doing, he describes a space, what he calls a 'miraculous structure', that automatically rewards and punishes its inhabitants.

Julia Scher fabricates environments that create a synthetic form of insecurity. She orchestrates concentrations of psychic states that are brought to bear upon the viewer, who is engulfed by them. The result is a heightening of the concept of visibility, to the point that the visual itself becomes an intense, imperious power. Humiliation can be transformed into a kind of gratification; it is something of a pleasure to learn of this repression. The whole manoeuvre is presented as a series of immersive events. Or, as Scher says, 'For me, the stage is a place of juicy droplets and bits where people are pulverized.'

LA Politics

Circles: Individuelle Sozialisation und Netzwerkarbeit in der Zeitgenössischen Kunst
(Frankfurt: Revolver, 2002).

Everything you read about Los Angeles is true. The city adapts to its own mythology. It's such a ludicrously discussed place that I always feel slightly idiotic in my attempts to produce a serious discourse about it. Raves in the desert, however, are superb. And ecstasy is a great drug. Also, if you hadn't heard, music sounds better when you're high. And the desert surrounding LA is wondrous. This desert can be boring at first, but then it breaks apart into a spectacular and crystalline abyss, with endlessness and the possibility of death. Steve Hanson and I got to know each other through these circumstances, which LA provided: ArtCenter's graduate programme and the California desert floor. I moved to LA from New Zealand in 1996 to attend graduate school. Steve worked in the ArtCenter Library. He checked out books and erased my numerous fines, but it wasn't until that moment out there in the Mojave (or somewhere), at perhaps eight in the morning, with police helicopters circling over the party—which held about 1,000 people, all high, with speaker stacks and mountain ranges surrounding us all—that we actually recognised each other.

Getting back to LA was always a little tricky after a rave. Not only technically, with the problem of cars, exhausted people, and long, hot drives, but with the mental adjustment that is required. Of course, being in the city all the time necessitates leaving it on a fairly regular basis. So you bounce back and forth between these extremes all the time. We don't rave so much anymore, but the idea for China Art Objects Galleries hit our stoned minds somewhere out there, one of those mornings. The gallery remains a product of our friendship and collaboration.

China Art Objects Galleries was originally going to be called Expressions. We had envisioned a logo with a silhouette of a coyote leaping over the setting sun—very 1970s and very California. I'm only partially sad that this failed to materialise. The name of the gallery came from Chinatown itself, from the sign outside the storefront that we chose to rent in the angelic but dusty Chung King Road, which is presently sweating with magazine coverage and real-estate intrigue. If I remember rightly, it was Steve Prina, an artist whom we adore, who encouraged us to keep that name, China Art Objects Galleries. It was a charming and buckled notion, with its double plurals and misleading pronouncement of ethnicity (actually, one of the original partners, who has since left, Amy Yao, was Chinese). Pae White designed the gallery, including its graphic dimension, and, when the doors finally opened, after much work and the first round of squabbles about money, the place was so

completely beautiful that it almost seemed as if the job was done and there was nothing more to say. When Pae proposed design ideas, they always sounded terrible to me, but, when they were implemented, I couldn't help but be shocked by their gorgeousness, and the space has amazed me ever since. So, the whole thing opened in January 1999, a clean green, white, and yellow gallery, with a little aquarium in the centre of it made by Steve and Pae, which was the first show. The aquarium was a model of the gallery in miniature. Swimming between plexiglass floors were pufferfish and small crabs, mortal enemies who tore each other to threads before the end of the first week. Very LA!

I remember the feeling of annoyance when the first filthy sneaker prints began to appear on the white and yellow walls. Cigarette butts were found everywhere after openings. Turning up on a Saturday morning was harder than we had imagined it to be. Doing consignment business with other galleries was intriguingly shocking. The idea of drinking became more and more appealing. Partnership contracts and business agreements were all new to us. The telephone would ring quite a lot, but, during gallery hours, hardly anyone would show up. Larry and Marvin, proprietors of the local liquor store, sold cigarettes for twenty cents apiece. The small tree given to us as an opening present by the local businesses was watered, talked to, and thoroughly spoilt. We and it would sit there quietly waiting for people to come in.

The shows came up and they went down, rather quickly it seemed. Sharon Lockhart and George Porcari, Jorge Pardo and Bob Weber, Christiana Glidden, Rebecca Quaytman. The first collectors peered into the gallery. We watched them moving over the place and started to learn something about their interests and behaviour. It was lucky that we were adaptable people, and we are lucky to have such great collectors. The traditional—i.e., the anti-institutional—notion of the 'alternative space' that abstained from financial dealing had become redundant, it seemed. Its coordinates—established in the 1960s, with a nod to the 1920s and 1930s, and under entirely different economic and social circumstances—were disoriented by LA's post-graduate-school environment, from which professionally enthusiastic twenty-eight-year-olds emerged from a boot-camp-like education with an $80,000 student debt. The graduate schools in LA were incredible environments, intellectually speaking, with brilliant students and teachers. Underneath this was a layer of pure financial terror substratified with humorous and cunning levels of industrial espionage, competitiveness, and the frequently desperate encroachment of dealers, curators, and critics whose vocation mandated an enthusiasm for young art. Graduate education, nonetheless, provided the perfect vehicle for many people. And, as students spread out into the post-school tundra, some brilliant transformations took place, artists digging in their heels and making great

work. The other, more common fate, was to get an eighty-hour-a-week job for a dot-com company, designing websites.

With shows by Ruby Neri, Eric Wesley, Kim Fisher (all recent graduates of LA schools), a record launch for Steve Prina, a project by Frances Stark, a collaborative painting-and-installation project by Laura Owens and Scott Reeder, readings by Mike Kelley and Eileen Myles, and the aforementioned exhibitions, China Art Objects was inadvertently connected to the graduate-school situation and was thus demonstrating its impact upon art practice. The gallery was also linked to the established reputations of the above artists, making a position within LA art politics. Our strand was significantly connected to ArtCenter as an entity, but, as the gallery developed, it extended its matrix to include artists from other cities (Angus Fairhurst, Jonathan Horowitz, Michael Stevenson, and Daniel Malone, for example), and has since largely abstained from intimate relationships with institutions.

What we took as our political good fortune was too much for some people. It took forever, it seemed, for critics to set foot in the space, and this remains something that perplexes us. While we have received some attention from art critics, it has not significantly transformed our enterprise. The interest from fashion magazines and newspaper journalists has generally been more enthusiastic. Art criticism in LA can be exceptionally fussy and not particularly generous, we have found. That one couldn't rely on local critics to think through the gallery and what it was doing meant that much of this work—raising the visibility of the artists through discussion—had to be done ourselves, and this returned us to the position of the alternative space, existing independently from all of those hypothetical motherfuckers.

The intellectual marketing of LA art since the 1960s has been a regulated but consistent operation, one that is usually geared at promoting LA art to venues outside of LA: New York and Europe. Either that or local interests are shocked into a renewed appreciation of the local scene when the foreign and East Coast press proclaim its importance. Such promotional energy generally suggests that there's an exciting new movement of art in LA and that the writer or curator is the one who discovered it. All the more exciting as the 'new art' comes from such an unlikely place! As far as the alternative-space issue is concerned, it seems that these arguments accrue to the point that LA is not so much a city full of alternative spaces but an alternative space in itself, a perpetual frontier, peripheral to the financial and museological centre of the US art world, New York, but still possessing a vitality that would be embarrassing to ignore. So, one can observe that, since the 1960s, and, alongside the production of sometimes great art, there are bursts of lexical enthusiasm for 'LA art' in the form of emotionally sincere and deliriously subjective marketing literatures, almost identical in their perspectives, appearing every five years or so, almost

like clockwork, heralded by market excitement and the rather disappointing discipleship of certain young artists and galleries. Of course, we will take advantage of this in whichever way seems appropriate or possible at the time, but it's not exactly riding the jock of genius.

It was around this time, the beginning of 2000 or something, that Thomas Riegger, Jochen Meyer, and Christoph Keller, German gallerists and publishers of our generation, came into the gallery and liked it. We liked them as well, and, by chance, their visit was the beginning of a great friendship, through which many exhibitions and projects eventuated, including the *Circles* exhibition in Karlsruhe and a very detailed publication with Slave Pianos. They encouraged us to visit Europe, attend art fairs, and promote our artists, and this was really the first step we took in this direction. I had also felt very close to Roberto Ohrt and the Akademie Isotrop, which provided a vital intellectual example, as well as to the profusion of artists-run spaces in Australia and New Zealand, from which I had emerged. We had also established strong connections with other European gallerists, such as Sadie Coles, Daniel Buchholz and Christopher Müller, Tim Neuger and Burkhard Riemschneider, and Toby Webster, as well as New York galleries, such as Greene Naftali, Friedrich Petzel, and Metro Pictures. Still participating in a local scene, still drinking and smoking a lot, and staying out late, the gallery slowly became a kind of marketing company, through which artists working in LA are introduced to an international scene. But it remains resolutely positioned within the economics and politics of LA. While most of our best artists, collectors, and friends live here, and this is the place we'll stay, the gallery is used as a kind of machine to enable travel, to transform one's life, and to create opportunities for the artists.

Putting on exhibitions and working with artists are always the most important functions. Whether these shows are seen, sold, or talked about is the second function: pure promotion. Some of my favourite exhibitions have been the least appreciated, for example the David von Schlegell and the Julie Becker/Dan Graham shows.

Von Schlegell, the writer Mark von Schlegell's father, was head of the Yale sculpture department for fifteen years. A sculptor from the 1950s until the early 1990s, when he died, his work connected to the Park Place Group (which included Mark di Suvero, Ronald Bladen, Forrest Myers, and Tony Smith) and was rigorously formal, completely idealistic, and principled. Mark von Schlegell and the gallery put together an important exhibition of the artist's final works, virtually-monochrome paintings from the early 1990s, in the front gallery, as well as a basement full of hundreds of documentary photographs chronicling his complete career (from his earliest paintings from the 1950s to his Pace Gallery and Whitney Museum installations of the 1960s and 1970s to sculptures on private estates and in the streets of major cities), portraits, notebooks, maquettes, and other signs of his wonderful

and long life as an artist. The emotional and technical complexity of the exhibition was astounding. The referents it produced extended to the works of younger sculptors like Evan Holloway and Jason Meadows, who were manipulating formalist sculptural tropes. The exhibition also presented the long and mixed career of a deceased, older-generation artist in a gallery so dependent upon the hype around the young. The lesson of the show, therefore, made something of a sobering analogy.

The Julie Becker/Dan Graham show, an odd but canny suggestion of Carol Greene's, was another exhibition that, for me, radiated something close to perfection. The intense thinking of both artists coalesced into a strong, alien energy. Becker's brilliant drawings, which, frustratingly, we were not authorised to sell, were jewel-lined pits of chaos that held attention for long periods. Graham's 1981 video of the straight-edge punk band Minor Threat, which depicted grappling dancers as if they were in Boschean pit of hell, seemed to have a lot in common with Becker's world, but we were not sure why. Collaboration has always been our practice, and this idea has extended into many other projects, including Jennifer Moon's *The Facility: A Multi-Levelled Energy-Producing Machine* and Andy Alexander and Andy Ouchi's *33 ⅓*, the permanent installation in the gallery's basement, which doubles as a DJ room.

A gallery is a complex organisation. It is dependent upon, for instance, the moods, bank accounts, health, predilections, delight, willingness, and happiness of the several hundred people we regularly work with. Obviously, loyalty is something that can dissolve in less than an hour, so one has to be careful. The shift from alternative venue to something more economically opportunistic—from simply exhibiting artists to representing them—wasn't the result of a gradual change in principle, but a conscious adaptation in order to best exploit the potentialities at hand. We have discovered, after years of research, that money doesn't compromise an exhibition programme. If I keep returning to this 'alternative' point, it is because of the pleasure I have taken in betraying its principles. Selling art is a lot of fun. To make money from art is a kind of revenge against the expense of graduate education and the political imperative that suggests it is compulsory for young artists to attend school for extended periods and go into debt. The frequent outcome of this North American regime, which admittedly allows for some exceptions, is that only financially privileged graduates can manage to enter the exhibition domain, which is certainly as unfortunate as it is universal. Having boasted about our enlightened attitude to economics, one might add that our salaries remain at $12,000.

Most days, there's a lot of laughter in our gallery, and it often surrounds the perversion of the art system and our part within it. Because Steve and I came to be gallerists rather late

in life, after being artists, writers, musicians, and other things for extended periods, the art business continues to astonish us: how fast things move, the transportability of critical mass, the shaky and speculative emotional and economic market for contemporary art, the position of influence certain dealers and artists possess, the orchestrated rise and fall of artists' careers, the meanness or generosity of critics, the glorious corruptibility of the magazine world, money—all the standard crap everyone else has been dealing with for years. It was a curious feeling to become implicated in that system, to watch the careers of Jon Pylypchuk and David Korty take off in the ways they did, and to make two exhibitions by Eric Wesley before his position began to sparkle—not to mention the excitement of working with brilliant artists, new to us, like Jennifer Lane, Edgar Bryan, Morgan Fisher, Mason Cooley, and J.P. Munro, who will change the direction of the gallery and keep revitalising it.

Isa Genzken: Skyscrapers about Laughing

Visit, no. 6, Winter–Spring 2003.

There is a foreignness to Isa Genzken's work, particularly for an American audience. It has originated from art-historical concerns, many of them specifically European, and has eschewed the hysterical response that some of her German peers, mostly painters, have so notoriously enjoyed in the United States. Historical subjects, such as, variously, constructivism, the Bauhaus, and other radical modern political movements—and a dialogue with architecture, minimalism, and post-minimalist sculpture—find a place in her field of operation. But this is by no means an academic body of work in any didactic sense, nor does it take a nationalistic position. Despite its formal severity on occasion and its advanced discursiveness, Genzken's work is a weirdly emotional contribution to the language of sculpture. As an extended sentence commencing in 1975, it is a profusion of thought through material; it engages transformation and change, moving between apparently rigid and predetermined methods of construction and dramatically spontaneous ones. From monochromatic or duo-chromatic works in wood, lacquer, and concrete, it has developed into a psychedelic state, with materials including photographs, paper, plastic, and sand.

Genzken's work is sculpture right and proper, and, in this sense, it is hardcore. But in its linear progression since the 1970s, when it was engaged with the optical problems in object perception via minimalism, it has increasingly thrown real moments of chaos into the void of sculpture, introducing comical forms, spastic colours, and structural oddities. Rather than stating that the work is inconsistent, which would be palpably ridiculous, it is better to describe it as 'intense'. Read as a political or social programme, the instinct of the work might translate as a libertarian ideology, as opposed to, say, Donald Judd's strict extrapolation of geometric and materialistic thought, or even the precisionist logic of an artist like Katharina Fritsch. Genzken's work has something anarchistic about it, namely it alters itself and is open to personal narrative and the intoxicating freedom this implies.

Genzken has made a lot of sculpture, much of it originating from her preoccupation with the discipline. However, film, photography, and different notions of sound play significant roles in her oeuvre. I am most intrigued by her exercises in photography, perhaps because I have experienced her work, on the whole, through that medium. It's also true to say that, in the twentieth century, an intimate relationship between sculpture and photography was established—in the name of which, it could be argued, Genzken has made important contributions.

Writing about sculpture through photography is a hallucinatory proposition, and a complete fantasy in a way, but sculpture is particularly photogenic, as it can be recorded well. Photography is also a method of drawing for sculptors, a means of sculpting. For Genzken, the photograph is a kind of spatial practice, operating as an index of, for example, architectural space. The photographic print is frequently used as a material in itself, employed as an element of collage, or, by way of the camera itself, used to record friends or the studio. Constantin Brâncuși's photographs of his studio, a related example, display the language of his sculptures, as they interact with one another in the process of construction. And, though she is without such explicitly surrealist tendencies, the work (and photographed personae) of Méret Oppenheim and Man Ray suggest a precedent for how photography, sculpture, and other media can operate within an artist's oeuvre without generating any notion of sacrilege to the principle of medium—a standard assumption for many contemporary artists.

Genzken's photo essays—such as those documenting her stay in hospital from the early 1990s or the skyscrapers of New York City from the mid 1990s—address spatial confines, the delirium induced by architecture: gravity, claustrophobia, tourism, ecstasy, incarceration, and confinement, among other things. These concerns don't belong exclusively to architecture, art, or life. If these photographs are compared to sculptural works from respective periods, it is simple to see how they function as something much more extreme than 'source material'; there is a direct continuity of affect, one unbroken by the passage between two-dimensional and three-dimensional space. Suffice it to say, the sculptures, particularly the later ones, aren't always sculptures about sculpture either. They are a record of impressions and extrapolations, conceptual propositions, jokes even, that work with material in a similar way that certain forms of photography deal with momentary impulses.

Genzken herself is photogenic. It is fascinating that, throughout her career, she is frequently depicted in catalogues alongside her works. Her resemblance to them is at times uncanny. The *Ellipsoid* and *Hyperbolo* works of the 1970s and 1980s are lean sculptural responses to minimalist dialogues in art. They utilised computer engineering to produce forms reminiscent of spears, totems, military fighter jets. Vaguely biomorphic, vaguely robotic, they exemplified the contemporary sculptural concerns of verticality, horizontality, radical construction utilising industrial materials, colour (albeit subdued in comparison to later works), and the phenomenology of presence. In portraits from the period, Genzken's own form crops out from that of her works, and she appears to be part of them, her body and stern expression virtually mirroring theirs.

In a series of portraits taken between 1993 and the present, her friend and collaborator Wolfgang Tillmans produced a photographic index to Genzken's sculptural concerns. In Tillmans's photographs, she dresses like these sculptures, moves like them. In *Isa Genzken* (1993), Tillmans shows the Dunhill Blue–smoking artist sitting on the edge of a couch, in front of what might be a Blinky Palermo painting and what is most certainly a Genzken skyscraper photograph. There is a prominent flower arrangement in the picture, but it is drowned out by the artist's shirt—its Pollocky pattern of silver and pink appears to have been created with poured paint.

In Genzken's skyscraper sculptures of this period—some of which were shown at the Kunstverein Braunschweig in an exhibition curated by Karola Grasslin in 2000—one observes freestanding towers, often collected in groups of five or six, and adorned. The shimmering silvers of the artist's shirt and bright, primary blocks of Palermo-ish colour find referents in a mix with rough planks of wood, shards of mirror, marble veneer, and collaged photographs that complete something of a tiled, reptilian surface. Named after the artist and members of her circle—*Christopher* (1988), *Andy* (1999), *Isa* (2000)—the works do not divulge any obvious reason as to why sculptures, buildings, and people have colluded in this one form, but the kind of morphic sensibility they instigate makes immediate sense. A similar sensibility can be found in two other Tillmans portraits, *Isa at the Sound Factory* and *Isa Dancing* (both 1995). In the latter, Genzken grooves through an office canyon, bedecked in an ensemble of pink and black and white, a bright pink hat, holding a shopping bag with stuff in it, Walkman blaring. She is dancing in the same way her skyscraper sculptures dance, in their assertive, though slightly awkward negotiation with rooms, such as those of the Kunstverein Braunschweig.

In subsequent rooms of the gallery, her photographic studies of New York (relatives, most fundamentally, of the tradition of street photography) proclaim the 'fucked up' irrationality of such improbable structures, the crazy ambition behind their construction, and the perpetual delusion of their permanence. In his writings on art, architecture, and the corporate arcadias of New York, Dan Graham argues that Bauhaus-inspired functionalism in building, epitomised by Mies van der Rohe, is philosophically similar to aesthetic formalism in mimimalist art, sharing a common link with the Kantian belief in the perceptual/mental 'thing-in-itself'. 'They share a belief in "objective" form and in an internal self-articulation of the formal structure', Graham writes, 'in apparent isolation from symbolic (and representational) codes of meaning.'[1] He additionally reminds us of the fact that the majority of Bauhaus architects settled in the US, eventually initiating the international style and in turn influencing a whole generation of American architects, dramatically affecting the skyline of New York City.

Genzken's skyscrapers and photographs of New York architecture return a European perspective to this dramatically altered landscape; she replenishes it with the social vitality and physical precariousness of a single artist perceiving a mass of buildings.

In 2000, Genzken returned to this theme in an exhibition for AC Project Room in New York, *Fuck the Bauhaus: New Buildings for New York*. Like the European architects before her, she designed a series of proposals for buildings—although these were radically at odds with the corporate functionalism of the international style, and, indeed, much of the city's architecture. Freestanding sculptures on wooden plinths, the works are constructed from organic and inorganic materials, planes of coloured, textured plastic, and foamcore, joined together with tape and glue. They represent buildings of a wild variety: improbable, spindly, and grandiose, slumping or standing tall, seemingly uninhabitable by corporation or resident, ornamented by plumes of structural impossibility. They are obviously sculptures as opposed to proposals *per se*, although they do remind one of models Frank O. Gehry made for a redevelopment of Times Square, in which the architect hot-glued magazine ads to his foamcore building renditions in order to create the impression of giant billboards. Genzken's sculptures are full of joy with their colourful excess, their delirious angles. Adorned with fake flowers and oyster shells, they are somewhat more succinct than the taller skyscraper sculptures, as their intensity is compacted into smaller objects. And while they are no more outlandish than many proposals by contemporary architects, they come across as skyscrapers about laughing, the critical premise of their subject solidifying their intellectual intensity.

The extraordinary two-person exhibition by Genzken and Tillmans at the Museum Ludwig, Cologne, in 2001, further extends Graham's critique of formalism. Composed of one work by each artist, the pieces together encapsulate and transcend many binaries that supposedly separate formal practices from social and utopian ones, and personal narratives from the specifically scientific. Tillmans's *Wake* (2001) is a massive electrostatic print, his largest to date; Genzken's *Ohne Titel* (2001) is two formidable mirror-clad monoliths. Each work is a culmination of the individual artists' preoccupations; in tandem, they are fused by a collaborative energy. It is a physically simple but incredibly rich installation; a discourse on friendship, sculptural instinct, nostalgia, and the Barthesian loss implicit in the photograph.

Two of Genzken's mirrored monoliths, one slightly taller than the other, stand before or directly in front of Tillmans's photograph, which depicts the psychedelic ruin of a party in his London studio. As is the custom, people discarded their party favours wherever they ceased to have use for them, inadvertently producing a kind of scatter installation with

cigarette butts; champagne, wine, and Coke bottles; clothes; plastic cups; and the like. On this occasion, Genzken's objects represent a physical antithesis to this type of composition, and, indeed, each artist's piece is the physical opposite of the other: the figuration of the photograph versus the abstraction of the sculptures; the reflective surfaces contrasting with the matte, printed ones; sculptural mass combined with flat print; minimalism with pictorialism. Yet the synchronicity achieved is amazing. The sculpture cannibalises Tillmans's photograph, folding it into hundreds of replicas of itself, transforming it into an almost cinematic entity. The mirrors cut and dice the image, but also hold a kind of love affair with it, extending its space, magnifying its imagery. These sculptures are massive, but they almost disappear in their absorption of everything around them; as with mirrors, there is a contradictory quality to their sheer presence mixed with their tendency to drink up the space surrounding them.

The installation includes and refers to multiple light sources: the sun coming up in the window of Tillmans's studio, the party lights that are still lit despite the encroaching day, the museum's lighting itself, or a mirror ball high in the rafters of the studio. Genzken's mirrors amplify the effects of light and the work is a radiant entity. Music and dancing are also alluded to, particularly by Tillmans, in the implicit absence of the partying, smoking crowd who produced the 'installation' in his studio. In an excellent essay addressing Genzken's skyscrapers and New York photographs, Diedrich Diedrichsen makes the connection between minimalist art and electronic dance music, stating 'that houses should dance is an ancient longing. These petrified things are perceived as the converse of anything that might dance.'[2] Working through a short history of disco and house, Diedrichsen makes the point that the drugs and psychedelia movements of the 1960s were happening simultaneously with the rise of minimalist sculpture. Genzken's skyscrapers, for him, appear as evidence of this connection. Of course, this observation is further literalised in the collaboration with Tillmans, whose photograph makes explicit references to dance music. And, as in the precarious stability of *Isa Dancing*, Genzken's architectural sculpture, and Tillmans's photograph, Diedrichsen's point is amply proven.

For the Frankfurter Kunstverein in 2000, Genzken made an exhibition titled *Urlaub*. 'Urlaub' refers to the concept of recreation in an extended sense—not simply 'holidays', but the separation from one's routine in order to create perspective-enabling experimentation leading to productive change. 'Artists', Genzken says, 'never take vacations. The entire art system urgently needs a vacation.'[3] Perhaps these works can be read as a critique of the art system in a similar way that the skyscraper sculptures interrogated architectural formalism, although this is opaque and open to interpretation. The exhibition presented nine freestanding architectural sculptures of beach houses on plinths (structures in which

one would change into or out of a bathing costume). There was also a series of photographs of a luxury cruise ship, a videotape of Genzken's grandparents, a photographic sculpture, and a proposal for a more-elaborate holiday home. Again, these architectural sculptures are fragmentary and vital, composed of actual building materials (wood, plexiglass), adorned with tape, logo and cartoon stickers, confetti, stand, photographs attached to or standing in for walls or representing vacationers; precise and cacophonous examples of architectural and sculptural ingenuity.

The *Urlaub* concept interweaves through this body of work. The most extraordinary single piece, *Spielautomat (Slot Machine)* (1999), is a coin-operated vending device that has been transformed into an autobiographical reliquary of photographs. It is a family/ art-historical album of sorts, crowned by Genzken's portrait, but also featuring portraits of her friends and artists, and art-historical images (a postcard of a Man Ray photograph, for instance). Affixed to the body of the vending machine, the prints curl out, subverting and improving the original geometry of the device. At once building, photograph, portrait, shrine, anachronism, and actual vending machine, it is like a minimalist object made to sell cigarettes that has been suffocated by pictures of people and things that defies even that purpose. The vending machine is on holiday from itself, apparently wallpapered by members of the art world. This single sculpture and its meanings are in dialogue with much of Genzken's past work, and it is only through that intensity of thought and activity that this relatively modest piece could have been created.

1. Dan Graham, 'Art in Relation to Architecture/Architecture in Relation to Art', in Dan Graham, *Rock My Religion: Writings and Art Projects 1965–1990*, ed. Brian Wallis (Cambridge MA: MIT Press, 1993), 228.

2. Diedrich Diedrichsen, 'Subjects at the End of a Flagpole', in *Isa Genzken: Sie Sind Mein Gluck*, ed. Karola Grasslin (Braunchweig: Kunstverein Braunschweig, 2000), 37.

3. Isa Genzken, *Urlaub* (New York: Lukas and Sternberg, 2000), back cover.

Obituaries and Tributes

Roberta Smith

Giovanni Intra, 34, a Founder of an Influential Art Gallery

New York Times, 30 December 2002.

Giovanni Intra, a writer and a partner in China Art Objects Galleries, an influential new gallery in Los Angeles, died on 17 December in an apartment on the Lower East Side of Manhattan. He was thirty-four and lived in Los Angeles. The New York City Medical Examiner's office said the cause of death was unknown, pending further investigation.

Mr. Intra was born in Auckland, New Zealand, in 1968, and grew up in Tūrangi, New Zealand, and in Auckland. He began painting and living on his own as a teenager. He attended the Elam School of Fine Arts at the University of Auckland, where he earned bachelor's and master's degrees and began writing for the magazine *Stamp*. During this time he also helped found Teststrip, an alternative space.

In 1996 Mr. Intra went to Los Angeles on a Fulbright scholarship to study at the ArtCenter College of Design in Pasadena, where he earned a master's degree in critical studies in 2001. In 1998 he and Steve Hanson, an artist who, like him, worked at the ArtCenter library, decided to start a low-key artist-run gallery. After scouring Los Angeles, they found a small store in a deserted mall on Chung King Road in the city's Chinatown district. Taking the gallery's name, China Art Objects, from a sign left by the previous tenant, they opened in January 1999 in a space designed by the artist Pae White and built with their friends.

Their shows often featured collaborations between younger and more established Los Angeles artists, including Jorge Pardo, Laura Owens, Steven Prina, and Frances Stark. But they also gave first shows to young unknowns like David Korty, Jon Pylypchuk, Eric Wesley, J.P. Munro, and Mason Cooley, several of whom began showing in galleries in New York and Europe. Other galleries soon followed China Art Objects to the Chung King Road mall.

Mr. Intra was West Coast editor for the magazine *Art and Text*, and helped edit the magazine S*emiotext(e)*; his writing was published in *Tema Celeste*, *Artforum*, *Bookforum*, and *Flash Art*.

He is survived by his mother, Barbara Intra of Te Awamutu, New Zealand, and his sister, Arna Intra, of Auckland.

Tessa Laird

34: A Tribute to Giovanni Intra, 1968–2002

New Zealand Listener, 8 February 2003.

Giovanni Paolo Intra was fond of telling people that he was born in May 1968, the year and month of the famous Paris uprising, when art and anarchy ruled the streets. What Giovanni usually omitted from this romantic tale was that he was raised in Tūrangi. Despite this geographic challenge, Giovanni was a born situationist. He migrated to Auckland as a teenager, where he attended Dilworth boarding school for boys. Though the school upheld strict discipline, he soon fell in with a group of like-minded self-proclaimed freaks (they formed a band called the Negative Creeps). His love affair with glamorous rebellion was born. I first met Giovanni at his twenty-first birthday party. At that time he was studying sculpture at Elam, and was already exhibiting widely. His precocious works were gaining notoriety for challenging the boundaries between art and critical theory. He flirted with media, smashing cameras and painting with spermicidal jelly.

After graduating, he inaugurated an experimental gallery with a group of artist friends called Teststrip, which became the perfect vehicle for Giovanni's elegant radicalism. Hosting group shows with names such as *Blood* and *Suffer*, as well as publishing a series of 'micrographs', Teststrip launched a generation of artists in New Zealand, many of whom left to develop abroad. Giovanni left Auckland for Los Angeles in 1996, with a Fulbright scholarship to study critical theory at the ArtCenter College of Design. His subject was Daniel Paul Schreber, hallucination, and paranoia. Although Giovanni's fascinations were often verging on macabre, he infused everything he wrote with humour, and became a sought-after contributor for numerous publications, including *Artforum* and *Art and Text*, for which he was the LA editor.

In January 1999, Giovanni and a group of friends affiliated through ArtCenter launched China Art Objects Galleries, the first gallery space on LA's Chung King Road. China Art's edgy professionalism attracted revellers and collectors alike, as Chinatown became *the* place in the LA art world, encouraging a host of galleries to set up in close proximity. The secret to China Art's success, apart from artist Pae White's beautiful work with the interior, was an astute combination of established and emerging talents. Young painter Julie Becker teamed up with folk hero Dan Graham; LA legend Steve Prina used the gallery to launch a CD.

Giovanni's entrepreneurial talents (he was on the phone to New York and London all day, every day) meant that China Art went from being a hip local enclave to a recognised international dealership with a booth at every significant art fair. China Art launched

several hot young LA artists, including David Korty, Jon Pylypchuk, and Eric Wesley, whose show at Metro Pictures Giovanni was in New York to support when he died on the morning of 17 December 2002. At the time of writing, the cause of death was still pending further investigation.

Despite his long absence from New Zealand, Giovanni inspired an epic send-off in Auckland. His funeral took place at the All Saints Chapel, Remuera, where his mother Barbara Intra encouraged friends to scrawl heartfelt messages on the coffin. The Hamish McKay Gallery in Wellington is currently exhibiting a tribute to Giovanni, with works on paper by artists including Saskia Leek, Ronnie van Hout, Séraphine Pick, Shane Cotton, and Michael Stevenson.

And in Los Angeles, mourners converged at Hop Louie, Giovanni's favourite Chinatown bar, for an informal wake (a formalised service is being planned at the Museum of Contemporary Art this month). Photos and obituaries were circulated, including ones from the *New York Times* and the *Los Angeles Times*. I neglected to bring the homegrown version from New Zealand's *Sunday Star-Times*, which extolled Giovanni's successes, but lingered bizarrely on the fact that he bought a pair of 'serious' Prada shoes in his last week and wore them everywhere with great glee. It's exactly the kind of irreverent detail that Giovanni would have penned, but makes me sad, given that he lived most of his life excruciatingly close to the poverty line. Despite constant travel and hobnobbing with the wealthy, Giovanni spent year after year in a cramped studio apartment with empty kitchen cupboards and a closet of thrift-store threads. He rarely had a functional car, went years without a personal phoneline, and composed his incisive critiques on a prehistoric laptop.

And yet, Giovanni was never bitter about his lot, except to joke about it ('I should sue myself for slavery', he quipped to his friend Gwynneth Porter when she came to visit). On the contrary, his excitement about living in the US and running China Art was palpable. He loved LA and whenever someone visited from New Zealand (which was often), he would play the gracious host, showing them vistas from the Hollywood Hills or introducing them to the affordable delights of Mexican cuisine. To the New Zealand art world, Giovanni was the prodigal son who refused to come home. He was too happy in Los Angeles, a city big enough to match his ambitions.

Will Bradley
Giovanni Intra 1968–2002
Frieze, no. 73, March 2003.

Giovanni Intra died much too young, on 17 December 2002 in Manhattan. He will be remembered for his achievements as an artist, writer, and co-founder of China Art Objects Galleries in Los Angeles, and equally for his enthusiasm, intelligence, integrity, warmth, and all-around obvious decency in an art world where those characteristics can sometimes be in short supply.

Born in New Zealand, in 1968, Intra was one of a group of young artists who founded the influential artist-run space Teststrip in Auckland in 1992, described variously as 'chaotic', 'ambitious', and 'fun', and known for its commitment both to independence and to a wider context for the work it showed. In 1996 Intra moved to LA on a Fulbright scholarship to study art theory at the ArtCenter College of Design in Pasadena. His thesis focused on Daniel Paul Schreber's paranoid epic *Memoirs of My Nervous Illness* (1903), drawing on texts by artists such as Salvador Dalí and Robert Smithson to suggest ways that art writing might be reinvented. He went on to become a respected art critic: a regular contributor of sharp, individual—but accessible—writing to many journals, including *Artforum* and *Artnet.com*, and LA editor of *Art and Text*. He developed his critical method over the course of in-depth essays on the work of Frances Stark, Diana Thater, Julia Scher, and many others.

Intra was initially surprised at the similarities between the art world of his homeland and that of LA, observing that 'Los Angeles, just like New Zealand, is most significantly intrigued by the development of its own artistic mythology.' Characteristically, he soon added to that mythology when, along with Steve Hanson, Mark Heffernan, Peter Kim, and Amy Yao, he started China Art Objects in LA's Chinatown. Intra and Hanson came up with the idea after an all-night party in the Californian desert, and, with the goodwill and support of well-known figures such as Jorge Pardo and Laura Owens, opened their space in Chung King Road mall in 1999. The gallery was designed by Pae White, while the name was famously taken from the box-sign already attached to the unit, which was too good to change. Since then, China Art Objects has worked with a new generation of LA artists as well as presenting international projects and mini-retrospectives, bringing the energy, community feeling, and innovative outlook of an artist-run venture together with an intuitive understanding of how best to use what Intra called 'the pleasure and idiocy of the free market'.

Since its inception, China Art Objects has tapped directly into what, in LA at least, had been an under-used resource—the commitment of artists themselves to the creation of an

interesting and worthwhile scene. It should be obvious (but for some reason mostly isn't) that artists would want to work in a collaborative exhibition process with a gallery that tries to offer them as much freedom and control as possible. Even successful artists are happy to engage with a venture that's going to support their future rivals, because they know you don't have to perceive the art-world process in these competitive terms. Intra's experience of this situation as an artist himself, his critical understanding, and personal motivation were essential factors in making the equation work. China Art Objects has worked with young artists—such as Andy Alexander, Julie Becker, Edgar Bryan, Kim Fisher, David Korty, J.P. Munro, Jon Pylypchuk, and Eric Wesley—in a way that high-finance-led spaces can't, because it has a commitment to and relationship with a local scene that's about more than simply jockeying for position in the marketplace. Put another way, the gallery has served its young artists so well that it has persuaded the market to adapt, which is about as close to a victory as the economic facts permit.

The gallery's success has been the catalyst for the emergence of Chinatown as the centre of a new LA art scene. Intra and Hanson took the China Art Objects spirit out into the wider world, quickly gaining respect for their astute, unpretentious approach and earning the gallery a reputation as one of the most interesting operations around—a blueprint that is probably inimitable without the personalities involved.

Writing about his LA experiences, Intra said that 'my initial exoticising of America has expired—to become an amazing, endless surface punctuated by friends and art'. It was this open-hearted attitude that made an instant impression on everybody that met him, that made it easy to be his friend and to share his passion for the art that he believed in. A lot of people are going to miss him a great deal.

Joel Mesler

True Confessions of a Justified Art Dealer: Part Two: Forget It, Joel. It's Chinatown.

Art News, January 2015.

Giovanni Intra started China Art Objects in 1999 with Steve Hanson, who still runs the gallery, now in Culver City. The Los Angeles art world in the late 1990s was little more than an unsettled no-man's land where anything was possible. Giovanni used to wait outside the Los Angeles County Museum of Art to get into openings he wasn't invited to with a backpack full of drawings by Jon Pylypchuk, one of the artists he represented at his gallery, and he'd sell them to the trustees in line to inch his way to the front. Giovanni opened in Chinatown when it was still a row of souvenir shops hawking herbal remedies and vases, but he made the neighbourhood into a place where LA artists wanted to congregate. He came from New Zealand, and he was pale and gaunt with a high forehead and too-large glasses. He was always broke. He drove a Volkswagen Golf that was perpetually repossessed by the city because he had so many parking violations, and his friends had to pay to get the boot removed from the car. He hosted dinner parties, requesting that guests bring with them live lobsters. By the time I opened my gallery Dianne Prues in 2000, the neighbourhood was already changing fast. Mike Kelley had designed a wishing well for Gin Ling Way, and it sat in front of the former General Lee's restaurant, a relic of the old Chinatown, which, when I was a child, had been the place where rich Beverly Hills Jews like my parents would go to play Mahjong, have a nice Chinese dinner, and get loaded on liquor and drugs in the back banquet room. It was now an abandoned storefront. An Indonesian security guard named Sean patrolled the wishing well day and night, keeping robbers away from the loose change. He was 250 pounds and seemed like he had simply come along with the memory of the defunct General Lee's as a package deal. I had a hard time reading how he felt about the new faces invading the neighbourhood. But nobody wanted to cross him, and he protected that fountain like it was the old homestead and the surrounding neighbourhood was an encroaching predator.

Galleries were popping up everywhere. A young lawyer named Javier Peres, who wore very tight jeans, carried around a poodle, and talked about growing up with Basquiats in his bathroom, opened his gallery on Chung King Road with a party featuring a slew of leather daddies and a crystal bowl of cocaine casually resting on a glass table. Inmo Yuon had a gallery where he showed predominantly Asian-American artists. Near the end of every day, Inmo would walk down Chung King Road and visit every business on the block. Mine

was near the end of this tour, and my neighbours would call me up and offer fair warning of Inmo's approach, but it hardly mattered. He would always enter the gallery in the late afternoon, walk to the centre of the space, stare up at the ceiling, and hum loudly. When I'd ask him what he was doing, he would either ignore me or say, 'Stop bothering me. I'm meditating.' The artist Jorge Pardo and Steven Hanson, in between making local celebrities out of artists like Eric Wesley and Pae White at China Art Objects, decided to lease the abandoned General Lee's and start a bar there called The Mountain, reopening the back banquet room to a new generation of debauchery.

I was living in the basement of my gallery, which I had also turned into an after-hours speakeasy to make more money. My friend Aaron Turner helped me build a bar, and we'd sell our guests dime bags of various drugs that we purchased in bulk. At the first party, the artist Charles Irvin—at my suggestion—took Viagra, stripped naked, and was breakdancing near the entrance. The idea was that he would be the first thing people saw when they walked in, but he was so nervous the medication had no effect, and he spent most of the evening hiding upstairs. Downstairs, the designers Loy and Ford, who had recently sold a dress to Britney Spears to wear at the Grammys, were running through the crowd with giant pairs of scissors, snipping at people's clothing so that it would fall to the ground in one swift movement before they noticed anything was wrong. Artist Micol Hebron rented a white horse, strapped a horn on its head so it looked like a unicorn, and, sporting a ludicrous blond wig, rode the creature back and forth down Chung King Road for the remainder of the night. All in all, not a bad side business. In June 2001, a *New York Times* article had anointed the neighbourhood a 'bohemian outpost'.

A few months after that first party, I was drinking coffee outside my gallery one morning and I noticed that my mailbox had been ripped off the building's façade. It was sitting in the middle of the street. I looked down the block and saw that a number of mailboxes had been pulled off the buildings and thrown into the middle of Chung King Road.

I thought nothing of this until I ran into Sean later that day. He told me that the night before Inmo had lost his mind. He had been spotted running through Chinatown completely naked, covered in his own faeces, and using a bat to smash the neighbourhood's windows and mailboxes. The LAPD had arrived. After trying and failing to get him to put down the bat, the police started shooting him with rubber bullets. It took eight rounds to bring him down. I never found out what happened to Inmo, but I decided to move my parties to a bar across the street and try to run a more serious gallery.

I made this decision for my own good. Giovanni played no small role in it. Giovanni had problems, but I idolised him. He would barely speak to me for a long time after I met him,

and he never invited me to one of those lobster dinners. I wasn't sure if this was rivalry or simply business, but I confronted him about it once, one night right after Inmo had his breakdown. Giovanni was in my basement, smoking crack that we had bought in MacArthur Park. 'I love you', he said, 'but you're bringing down the professionalism of this. I need to make money.' Of course the irony of this was not lost on me, and, six weeks later, Giovanni would be dead.

Giovanni Intra Writings

1989

'Adventures in Paradise: John Tarlton's Photomontages', *Art New Zealand*, no. 53, 1989–90: 52–3.

'After After McCahon', *Stamp*, no. 1, July 1989: 11–2.

With Mark Webster, 'Posterpolitics: Auckland City: Poster-Free', *Stamp*, no. 2, August 1989: 5–6.

'Artycle: Considering Theory', *Stamp*, no. 2, August 1989: 6.

'An Interview with Pablo Ruiz Picasso', *Stamp*, no. 4, November 1989: 5–6.

1990

'Art: Where Does It Come from?: Art as Second Skin', *Stamp*, no. 6, January 1990: 12–3.

'Comix', *Stamp*, no. 8, April 1990: 11.

'The Bride of Frankenstein', *Stamp*, no. 8, April 1990: 13–4.

'Quality Culture (Art and Wallpaper)', *Stamp*, no. 9, May 1990: 9.

With Darius Harris, 'Slick', *Stamp*, no. 9, May 1990: 18.

'The Hallelujah Picassos Talk Dirty', *Stamp*, no. 10, June 1990: 4–5.

'"Being Brown, Making Flutes, and Dying"', *Stamp*, no. 12, August 1990: 4–5.

'A Choice Artist: Lisa Reihana', *Stamp*, no. 12, August 1990: 5.

'When You Sell Me', *Stamp*, no. 13, September 1990: 4.

'Against Interpretation', *Stamp*, no. 14, October 1990: 4.

'"Where Are All the Bloody Real Men?"', *Stamp*, no. 15, November 1990: 6.

'New Auckland Distractions', *Stamp*, no. 16, December 1990: 8.

1991

'Distinction of Blurrings: Ten Years of Flying Nun Art', *Art New Zealand*, no. 61, 1991–2: 42–7, 87.

'Drone: A Short History', *Music in New Zealand*, no. 12, Autumn 1991: 39–41.

'Rotate Your State', *Stamp*, no. 18, 1991: 22.

'Deathdate', *Stamp*, no. 19, 1991: 13.

With Lucy Macdonald, 'An Interview by Fax with Deborah Lawler-Dormer', *Stamp*, no. 20, 1991: 14–5.

With Susan Hillery, 'Appropriation', *Stamp*, no. 20, 1991: 24–5.

'Making a Gallery that Says Everything', *Stamp*, no. 22, August 1991: 21–2.

With Margot Porter, 'The Unpainted Dream', *Stamp*, no. 23, September 1991: 23.

With Susan Hillery, '(cracked) .VASE: Autobiography of the Artist Cracked .Vase: Life in Paris 1914–1927', *Stamp*, no. 25, November 1991: 14–5.

1992

'Doomed Comedy: Attila the Stockbroker and Punk Language', *Stamp*, no. 28, February 1992: 20.

'Darkness in Architecture: A Mythology of Palazzo Nero', *Stamp*, no. 29, April 1992: 18–9.

'Mondrian after Mondriaan', *Stamp*, no. 30, April 1992: 8.

'Fear Brampton's Codex Naturae', *Stamp*, no. 31, May 1992: 10.

1993

'Artists against AIDS', *Art New Zealand*, no. 66, 1993: 41–2, 97.

'Fresh Fruit: Van Beyeren's Still Life, 1666', *Landfall*, no. 186, Spring 1993: 193–7.

'Subculture: Bataille, Big Toe, Dead Doll', MFA dissertation, University of Auckland, 1993.

1994

'Journalism', *Tony de Lautour: Bad White Art* (Auckland: Teststrip, 1994), np.

'Steroids', *Pose* (Auckland: Crushed Honey Press, 1994), np.

'Mental Health in the Metropolis', *Midwest*, no. 6, 1994: 39–40.

'A Case History: Tainted Love', *Fiona Pardington: Tainted Love* (Auckland: Milk Powder Press for Sue Crockford Gallery, 1994), np. Reprinted in *Fiona Pardington: A Beautiful Hesitation* (Wellington: Victoria University Press with City Gallery Wellington and Auckland Art Gallery, 2016), 249–50.

'Denise Kum: 'In(Continents)', *Localities of Desire* (Sydney: Museum of Contemporary Art, 1994), 59.

1995

'Wendy Bornholdt', *Art and Text*, no. 51, 1995: 72–3.

'Denise Kum: Toxic Taste', *Art and Text*, no. 52, 1995: 42–4.

'Discourse on the Paucity of Clinical Reality', *Midwest*, no. 7, 1995: 39–43.

With Daniel Malone, 'Asian Babes', *Midwest*, no. 8, 1995: 19–22.

'Studies for the Disarticulation of Disease', *Everyday Pathomimesis* (Christchurch: University of Canterbury School of Fine Arts Gallery, 1995), np.

Untitled: The Poetics of Modern Reverie (Auckland: Teststrip, 1995).

1996

'Hangover', *Art and Text*, no. 54, 1996: 92.

'From Rubber with Love', *Midwest*, no. 10, 1996: 45–7.

'Basic Instinct', *Monica*, April 1996: 10–1.

Contribution to 'The Photos We Love', *Monica*, April 1996: 17.

'Fear Factory', *Monica*, October–November 1996: 20.

'TWA 800: A Dada Manifesto', *Monica*, October–November 1996: 25.

'Drive-By Shootings', *Pavement*, no. 10, 1996: 10.

1997

'Charles Gaines', *Art and Text*, no. 59, 1997: 88–9.

'Report from Los Angeles', *Artnet.com*, 17 April 1997, www.artnet.com/magazine_pre2000/reviews/intra/giovanni4-16-97.asp.

'Report from Los Angeles', *Artnet.com*, 29 September 1997, www.artnet.com/magazine_pre2000/reviews/intra/intra9-26-97.asp.

'A Fusion of Gossip and Theory', *Artnet.com*, 13 November 1997, www.artnet.com/magazine_pre2000/index/intra/intra11-13-97.asp.

'Sharon Lockhart, Laura Owens, and Frances Stark', *Flash Art*, no. 197, November–December 1997: 76.

'I Live in Hollywood', *Log Illustrated*, no. 1, Winter 1997: 18–9.

'Pimps for Chance', *Monica*, Summer 1997: 18–9.

Contribution to 'Big Art Moments', *Monica*, Summer 1997: 39.

Callum Morton: Now and Then (New Plymouth: Govett-Brewster Art Gallery, 1997).

'For Paranoid Critics', *PreMillennial: Signs of the Soon Coming Storm* (Sydney: Darren Knight Gallery, 1997), 13–6.

'Gavin Hipkins: Photogenic', *Signs of the Times: Sampling New Directions in New Zealand Art* (Wellington: City Gallery Wellington, 1997), 24–5.

'Pat Scull', texts commissioned for a show by Danius Kesminas, *Trans*, h., Melbourne, 1997.

1998

'True Crime: Forensic Aesthetics on Display', *Afterimage*, vol. 25, no. 5, March–April 1998: 12–4.

'Jason Rogenes: Alien Industry', *Art and Text*, no. 60, 1998: 37–9.

'Frances Stark', *Art and Text*, no. 61, 1998: 82–3.

'Charles Ray', *Flash Art*, no. 198, 1998: 117.

'Out of Actions', *Flash Art*, no. 202, October 1998: 61.

'Billy Sullivan: Ouverture', *Flash Art*, no. 203, November–December 1998: 100.

'Goethe Poem of Goat Misfortune', *Log Illustrated*, no. 5, Spring 1998: 43.

'Jump Sculpture', *Liz Larner: I Thought I Saw a Pussycat* (Vienna: MAK Austrian Museum of Applied Arts, 1998), np.

Span (Auckland and New Plymouth: Artspace and Govett-Brewster Art Gallery, 1998).

1999

'Kevin Hanley', *Artforum*, April 1997: 128.

'Christie Frields/Jack Ono', *Artforum*, Summer 1999: 160.

'Salvador Dalí, "Oui: The Paranoid-Critical Revolution: Writings 1927–1933"', *Bookforum*, vol. 6, no. 2, Summer 1999: 11, 43.

'Isabelle Graw, Anthony Vidler, and John Welchman, "Mike Kelley"', *Bookforum*, vol. 6, no. 4, Winter 1999: 13, 37.

'La Struttura Mobile', *Tema Celeste*, no. 72, January–February 1999: 50–5.

'The Fanatical Scenery of Elizabeth Bryant', *Elizabeth Bryant* (Los Angeles: Works on Paper, Inc., 1999), np.

2000

'Repressionism Is Dead', *Art and Text*, no. 68, 2000: 56–8.

'Spandau Parks', *Art and Text*, no. 68, 2000: 92–3.

'Dave Muller: Free Software', *Art and Text*, no. 69, 2000: 68–9.

'Simon Periton', *Art and Text*, no. 69, 2000: 86–7.

'Daniel Malone: Triple Negative', *Art and Text*, no. 70, 2000: 42–3.

'Departures', *Art and Text*, no. 70, 2000: 76.

'Robert Overby', *Art and Text*, no. 71, 2000: 81–2.

'Daniel Paul Schreber, "Memoirs of My Nervous Illness"', *Bookforum*, vol. 7. no. 2, Summer 2000: 11, 15.

'Contemporary Critical Issues: "Hallucination"', *Log Illustrated*, no. 9, Summer 2000: 20.

'Raymond Pettibon', *X–Tra*, vol. 3, no. 2, Winter 2000: 4–7.

'Lascaux 111', *Kathy Temin* (Épernay: Moët et Chandon, 2000), 49–50.

'Andy Alexander: Séance Fiction', *Andy Alexander: Revolution* (Melbourne: Gertrude Street, 2000), np.

'Leaving New Zealand: The Question of New Zealand

Art Abroad', *Te Ao Tawhito | Te Ao Hou: Old Worlds | New Worlds: Contemporary Art from Aotearoa/New Zealand* (Missoula MT: Missoula Art Museum, 2000), np.

'Too Autopoietic to Drive', *Drive: Power>Progress>Desire* (New Plymouth: Govett-Brewster Art Gallery, 2000), 62–71.

2001

'Miguel Calderón: Letter from the Louvre', *Art and Text*, no. 72, 2001: 41–2.

'Evan Holloway: When Bad Attitude becomes Form', *Art and Text*, no. 72, 2001: 52–3.

'John McCracken: Alienbait', *Art and Text*, no. 73, 2001: 46–51.

'James Welling', *Art and Text*, no. 74, 2001: 77.

'Landscape in David Korty, Paul Sietsema, and Vincent Ward', *The First Auckland Triennial: Bright Paradise: Exotic History and Sublime Artifice* (Auckland: Auckland Art Gallery with Artspace and University of Auckland, 2001), 97–9.

'Paranoia and Malpractice', *Hallucination of Theory: More and Less 3* (Los Angeles: ArtCenter College of Design, 2001), 155–66.

'Slave Artists of the Piano Cult: An Introduction', *Slave Pianos: A Reader: Pianology and Other Works 1998–2001* (Frankfurt: Revolver, 2001), 37–48.

2002

'Project: De Rijke/De Rooij', *Art and Text*, no. 76, 2002: 30–5.

'Lisa Lapinski: Sculpturicide', *Art and Text*, no. 76, 2002: 51–3.

'Warhol Unbalanced', *Art and Text*, no. 77, 2002: 28–9.

'Liz Larner', *Art and Text*, no. 77, 2002: 90–1.

'Paid in Full', *Art and Text*, no. 78, 2002: 26–7.

'El Gran Burrito!!', *Log Illustrated*, no. 15, Summer 2002: 14–5.

'Pulverised by Light', *Julia Scher: Always There* (Berlin: Sternberg Press, 2002), 35–41.

'LA Politics', *Circles: Individuelle Sozialisation und Netzwerkarbeit in der Zeitgenössischen Kunst* (Frankfurt: Revolver, 2002), 133–9.

2003

'Paul Sietsema: Empire', *Flash Art*, no. 228, January–February 2003: 82–3.

'Isa Genzken: Skyscrapers about Laughing', *Visit*, no. 6, Winter–Spring 2003: 12–4.

The Editing

Giovanni Intra wrote for a variety of publications,
from xeroxed booklets to esteemed journals of record.
His words were edited into a variety of house styles.
For this collection, I have endeavoured to format
his writings consistently, applying British spelling,
making grammar and punctuation consistent, and
occasionally breaking sentences and paragraphs for
readability. I have corrected errors, misspellings,
and misquotes when I found them. I have checked
and corrected footnote references where I could, but
I haven't added them where they didn't originally
appear. Noise reduction has been my goal.

—Robert Leonard

Contributors

Andrew Berardini is a writer, editor, and curator from California. He has curated exhibitions at Museum of Contemporary Art, Los Angeles; Palais de Tokyo, Paris; and Castello di Rivoli, Turin; and co-curated the Estonian Pavilion at the Venice Biennale in 2019. Known for his poetic and corporeal writing, Berardini has been a longtime contributor to *Artforum*. Since 2008, he has been faculty at the artist-run free school The Mountain School of Arts in Los Angeles and has occasionally run a residency for art writers at the Ban Centre in Canada. A past contributing editor at *Momus, Art-Agenda*, and Mousse, he is the author of *Danh Vo: Relics* (2015) and *Colors* (2022). He lives in Los Angeles most of the time, with his daughter Stella.

Chris Kraus is an American writer and critic. She spent her formative years in New Zealand and is now based in Los Angeles. Her novels are *I Love Dick* (1997), *Aliens and Anorexia* (2000), *Torpor* (2006), and *Summer of Hate* (2012). Kraus has also published three collections of art and cultural criticism and a literary biography, *After Kathy Acker* (2017). In 2016, *I Love Dick* was made into a television series starring Kathryn Hahn, Kevin Bacon, and Griffin Dunne, and *Aliens and Anorexia* was recently adapted for the stage in New Zealand by Eleanor Bishop and Karin McCracken.

Robert Leonard is a curator and writer. He has held curatorial posts at Wellington's National Art Gallery, New Plymouth's Govett-Brewster Art Gallery, Dunedin Public Art Gallery, Auckland Art Gallery, and City Gallery Wellington, and directed Auckland's Artspace and Brisbane's Institute of Modern Art. His shows include *Headlands* for Sydney's Museum of Contemporary Art in 1992, *Mixed-Up Childhood* for Auckland Art Gallery in 2005, and *Iconography of Revolt* for City Gallery Wellington in 2018. He curated New Zealand representation for the Venice Biennale in 2003 and 2015. Back in the day, he commissioned, edited, and published some of Intra's key essays.

Mark von Schlegell is an American science-fiction writer and cultural critic who lives in Germany and the US. His novels include Venusia (2005), *Mercury Station* (2009), and *Sundogz* (2015). His stories and essays appear regularly in underground newspapers, art books, and periodicals the world over. He holds a PhD in English and American literature from New York University.

Acknowledgements

Thanks to
Arna Intra and the original
publishers for permission
to reprint Intra's writings.
And to other contributors and
their original publishers for
permission to reprint theirs.

And to
Monty Adams
Andy Alexander
Jim Barr
Mary Barr
Victoria Boyack
Tracy Burgess
Brian Butler
Jon Bywater
Kirsty Cameron
Joyce Campbell
Rachael Churchward
Creative New Zealand
Hayley Dabell
Judy Darragh
Samantha Doherty
Megan Dunn
Cathy Folgate
Paul Foss
Graham Frost
Jeff Gibson

Jeremy Gilbert-Rolfe
Vaughan Gunson
Bruce Hainley
Catherine Hammond
John Hurrell
Danius Kesminas
Emi Kuriyama
Caroline McBride
Arch MacDonnell
Daniel Malone
Victoria Munn
Zak Penney
Fernando Ramirez
Anna Rankin
Meredith Robertshawe
Marie Shannon
Ann Shelton
Allan Smith
Michael Stevenson
Karen Turnbull
Isha Welsh

Giovanni Intra: Clinic of Phantasms:
Writings 1994–2002

Published by Bouncy Castle, Auckland,
and Semiotext(e), Los Angeles, 2022.

Distributed by the MIT Press, Cambridge
MA and London.

Edited by Robert Leonard.

Designed by Neil Pardington Design.

Printed in China through Colorcraft Ltd., Hong Kong.

© The publishers and contributors

ISBN 978-1-63590-165-8

Bouncy Castle
Publishers Bruce Qin, Robert Leonard,
and John McCormack
Art Director Neil Pardington
10–14 Lorne Street, Auckland
PO Box 293, Shortland Street, Auckland

Semiotext(e)
Publishers Sylvère Lotringer, Chris Kraus,
and Hedi El Kholti
Los Angeles
info@semiotexte.com
semiotextes.com

Set in Tiempos Text, Tiempos Headline, and Calibre,
typefaces by Kris Sowersby, Klim Type Foundry,
Wellington.

Frontispiece: Giovanni Intra *Untitled* c.1991,
photocopy. For decades, T.J. (Terry) McNamara
was the conservative art critic for the Auckland
newspaper, the *New Zealand Herald*. Here, Intra
used the header for McNamara's column as
letterhead. Hilda Scum was Intra's pseudonym.

Semiotext(e)